Sir John Boardman
was born in 1927, and educated at
Chigwell School and Magdalene College, Cambridge. He
spent several years in Greece, three of them as Assistant
Director of the British School of Archaeology at Athens,
and he has excavated in Smyrna, Crete, Chios and Libya.
For four years he was an Assistant Keeper in the Ashmolean
Museum, Oxford, and he subsequently became Reader in
Classical Archaeology and Fellow of Merton College,
Oxford. He is now Lincoln Professor Emeritus of Classical
Archaeology and Art in Oxford, and a Fellow of the British
Academy. Professor Boardman has written widely on the
art and archaeology of Ancient Greece. His other books in
the World of Art series include *Athenian Red Figure Vases:
The Archaic Period*, *Athenian Black Figure Vases*, *Greek Art*
and volumes on *Greek Sculpture* covering the Archaic,
Classical and Late Classical periods.

WORLD OF ART

This famous series
provides the widest available
range of illustrated books on art in all its aspects.
If you would like to receive a complete list
of titles in print please write to:
THAMES AND HUDSON
30 Bloomsbury Street, London WC1B 3QP
In the United States please write to:
THAMES AND HUDSON INC.
500 Fifth Avenue, New York, New York 10110

Printed in Singapore

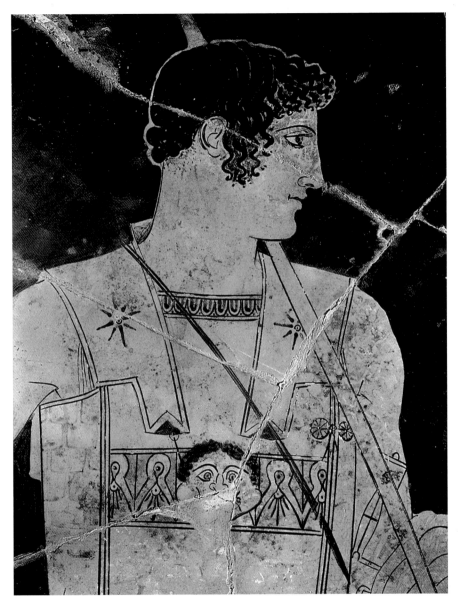

Achilles, by the Achilles Painter. See 109

ATHENIAN
RED FIGURE VASES
The Classical Period
a handbook

JOHN BOARDMAN

566 illustrations

THAMES AND HUDSON

© 1989 Thames and Hudson Ltd, London
Reprinted 1997

ISBN 0-500-20244-3

Printed and bound in Singapore by C.S. Graphics

CONTENTS

1 INTRODUCTION 7

2 EARLY CLASSICAL 11

3 CLASSICAL 60

4 WHITE GROUND AND LEKYTHOI 129

5 LATER CLASSICAL I 144

6 LATER CLASSICAL II 190

7 THE SCENES 217

 SCENES OF REALITY 218
 Everyday life; Fighting; Work and play, public and
 private; Religion

 SCENES OF MYTH 222
 The Gods; Big fights; Herakles; Theseus; The Trojan
 Cycle; Other heroes and cycles; Other figures

8 TECHNIQUES, PRODUCTION AND MARKETING 231

9 SHAPES AND USES 237

Abbreviations 241

Notes and bibliographies 242

List of illustrations 245

Index of artists and groups 250

Index of mythological subjects 251

General index 252

Chapter One

INTRODUCTION

This volume is the successor to *Athenian Red Figure Vases: The Archaic Period* (1975; here abbreviated *ARFH* I) and it carries the survey of Athenian decorated pottery down to the time when painters finally abandoned the red figure technique, during the second half of the fourth century B C. A comparable study of the earlier, black figure vases appeared in 1974 (*ABFH*), and Dale Trendall has recently published a companion volume on South Italian red figure (*RFSIS*). In the earlier handbooks some attention was given to questions of technique but it has seemed appropriate to devote a separate chapter to it here. The word 'Classical' suffers a great variety of meanings. In this title it means simply post-Archaic, through the fourth century; in Chapter Three it is restricted to Beazley's use of 'Classic' which means roughly the period of the Parthenon.

The general scheme follows that of the other volumes, dictated by the successive groups formed by the works of individual painters and workshops, as they have been defined by Sir John Beazley in his great books, which form the cornerstones of all studies of Athenian red figure. In the early editions of his books which listed red figure painters, in 1925 and 1942, Beazley had stopped short of the fourth century, an omission he made good in 1963, but without bestowing upon the later vases quite the same loving detail that he had on the earlier: understandably, since the quality is generally lower, though Beazley was no elitist and he is fuller in classifying the worst of the fourth century than the best, for much of which he would (he explained) have required a closer study of the later vases in Leningrad than he had been able to give them.

We start with works of high quality, and standards are generally maintained by some painters to the end of the fifth century. Thereafter there is still good work to be found, but in decreasing proportion although there is a diversity of subject matter which is highly informative about myth and cult, wholly Athens-centred. An important element is the 'Kerch style', represented by rather flamboyant vases which seem to indicate a new phase of activity in the Athens potters' quarter. It is debatable, however, whether it is a new phase rather than a resurgence of interest in styles never really abandoned. The term has perhaps outlived its usefulness, and new studies should be able to demonstrate continuity more clearly.

To the end, Athenian red figure remained virtually the only figure-decorated pottery in the Greek homeland. Some other parts of Greece paid it the

compliment of imitation, in a humble way: north Greece, Boeotia, Corinth, Sparta. Its appeal overseas was undiminished, and indeed its markets grew, deliberately or casually. Its decline in quality – and this is not an altogether subjective judgement, as a glance through the pictures in this book should show – has to be explained in other ways. In the Archaic period the drawing styles practised on pottery were as fine as in any other medium known to us, and we may legitimately assume that the best artists enjoyed a competence also in other media of painting which have not survived, and perhaps in other arts. But in the first half of the fifth century new styles of 'major painting' were introduced. Those associated with the name of the muralist Polygnotos of Thasos introduced new schemes of composition which the vase-painter could take up and adjust to his field. But the painting styles that followed introduced shading, chiaroscuro and subtleties of colour which the vase-painter could never hope to match, and inevitably the abler hands were attracted away from the craft to other media. The custom provided by the well-to-do may have declined at the same time, especially once vessels in precious metal became more accessible (from Persian loot and the perquisites of empire), and a growing market for fine plain black vases met humbler needs. But it would be wrong to think that the Athenians thought much the less of a craft in which they had long led their world. In the later fifth century the Athenian poet Critias listed the most distinguished products of various states – the furniture of Chios and Miletus, the gold cups and decorative bronzes of Etruria, the chariots of Thebes, the alphabet of the Phoenicians, and – from Athens, the victor of Marathon – the potter's wheel and the child of clay and the oven, the finest pottery, the household's blessing.

Most of the material has been set out here following Beazley's attributions to painters and schools, with minor adjustments to suit presentation. I have not named in the text every painter whose work is illustrated – there are so many, and those omitted in the text rate a picture either because they or the vases shown deserve neither more nor less. Principles of attribution were discussed briefly in *ARFH* I p. 8, and a further word may not be amiss since there are doubters. Beazley had adopted a version of the Morellian system of analysing the rendering of detail, especially anatomical, by which a painter's 'handwriting' might be detected, whether that rendering be unconsciously repeated because trivial, or consciously adopted and then sustained. The trivial is often the more informative – notably on the backs of the larger vases which are often, in our period, filled with two or three 'mantle figures' – draped youths, men or women – sketched quickly by the painter and therefore readily betraying his 'hand'; cf. [*182, 343*]. (This criterion on South Italian red figure is demonstrated by Trendall in *RFSIS*.) In this and other respects Beazley's material was even more readily susceptible to such analysis than the drawings and paintings studied by Morelli; it was strictly linear and so more easily definable, much of it was not consciously 'artistic', it did not to any notable degree depend on drawing 'from life', while bare bodies and a limited range in dress offered many more reliable

and repeated renderings for analysis. (The signed work of Japanese print-makers or of many modern cartoonists, neither influenced much by 'study from life', confirm the validity of the technique of attribution.) The nexus of renderings in one artist's work is such that repetition of them in other works almost certainly indicates the same hand, and fresh evidence (sometimes of signed works) reinforces truth rather than sanctifies error. And there is so much more to it than the Morellian study of rendering of forms: composition, ornament, favoured shape or subject, go to confirm a system which is nearer to being 'scientific' than almost any in art history. The opportunity it offers to discern in detail the contributions of individual craftsmen, their interrelationships, their icono-graphic and even social preferences, their role in the trading of their products, is unparalleled in antiquity until the days of stamped Roman wares. Beazley's work on the connoisseurship of Athenian vases has rendered possible serious progress in a whole range of new studies to engage the interest of archaeologists and historians.

Dates

The development of style in Greek art, and especially in Athenian art to the end of the fifth century, is readily definable in terms of datable sculpture (see *GSCP passim*), from the temple sculpture at Olympia, through the fairly closely datable phases of work on the Parthenon and other monuments. Echoes of known works can sometimes be detected on vases, which are thereby given a terminus post quem – e.g., the Athena and Marsyas of *GSCP fig.* 64, and many rather vaguer echoes of Parthenon figures. The development is not so readily defined in the fourth century, partly because it is less marked in works that might be compared with the vase-painting of the day. Record-reliefs dated to the year (cf. *GSCP figs.* 177–9) carry fairly simple figures. Panathenaic prize vases can be dated to the year from the archon's name that they carry in the fourth century (*ABFH* p. 169), but the black figure drawing on them is less readily comparable with red figure than it had been in the Archaic period, though at least one artist practising both techniques may be identified, in the mid-century.

There are several archaeological dating points or contexts which confirm our view of the general sequence. Grave contents 'purified' from Delos in 425 were reburied on the nearby island of Rheneia and include much Attic pottery. The mass grave for the battle of Delion in 424 at Thespiae contained little decorated pottery, and that Boeotian, but comparable with Attic. The grave of the Corcyraeans in Athens (433/2) has black pottery relatable to red figure. There is a distinct break in imports to Cumae in Italy, destroyed in 421/0. Himera in Sicily was destroyed and razed to the ground in 409 and several fifth-century tombs and houses with Attic pottery have been excavated. There is also pottery in the Athens cemetery from the Tomb of the Laconians (403; related to Semele and Suessula Painters) and from the presumed tomb of Dexileos (394; minor,

9

unattributed vases). *Kalos* inscriptions praising handsome youths who might be identifiable are less common but still useful for suggesting synchronisms in the work of different painters, especially around the mid century (see *ARFH* I p. 213): notable are Glaukon, son of Leagros (ibid.) and Euaion, son of the poet Aeschylus (born about 525), but Euaion may be praised for his acting rather than youthful bloom; he is known to have been a playwright.

In the fourth century the flow of Attic pottery to Cyprus dries up at about the time of the death of Euagoras, king of Salamis and ally of Athens, in 374/3, but it does not cease entirely, it seems; the full-blown 'Kerch style' is not represented. Olynthus, in north Greece, was destroyed by Philip of Macedon in 348; the complete vases found on its house floors are a good indication of current styles, including 'early Kerch style', but part of the site was soon reoccupied. The Theban piper Pronomos [323] and the Spartan Sparte [365] are unlikely to have appeared on Attic vases until after the end of hostilities with Thebes and Sparta at the end of the fifth century. In south Russia, and to a minor degree elsewhere, Attic vases have been found in tombs with dated Panathenaics (see above) or with less easily datable coins. In south Russia some of the coins run to the end of the fourth century at least but need not carry the production date of the vases anywhere near so late. Alexandria was founded in 331 and its early cemeteries have been well robbed but so little Attic red figure has been found (e.g. [428]) that it is difficult to escape the conclusion that finer ware was no longer in production in the 320s. Reported finds in Athens of red figure with Panathenaics of the 310s may represent its last appearance in significant context.

This volume, therefore, covers a period more than twice as long as that in *ARFH* I, comprising some two-thirds of the vases in Beazley's red figure lists; but despite decline in the quality of the drawing on the vases there is at least as much that is handsome, memorable and significant to discuss and illustrate.

Chapter Two

EARLY CLASSICAL

In Athens the second quarter of the fifth century is a period of wealth, a period of empire and of frequent expeditions overseas, a period in which the new democracy is reshaped and stabilized and its methods of choosing its leaders better defined. The end is marked by peace with Persia, which made no more territorial demands on Greek lands, and by the planning for the rebuilding of Athens and its temples. We know little of the major arts of Athens in these years, indeed they were partially stifled by the decision not to rebuild straight away the temples ruined by the Persians. The humbler craft of vase-painting, however, allows us a glimpse of the effects of other arts visible in the city, and continues to be highly informative about many aspects of Athenian life and society, not least of relationships and behaviour within its potters' quarter.

After the brilliance and variety of Late Archaic vase-painting, the new phase has to be explained partly as lingering or sub-archaic in mood (well demonstrated by the so-called Mannerists, discussed in *ARFH* I pp. 179–93 – a 'movement' which continues: see Chapter Three), partly in terms of the apparent influence of a different medium. Previously, there is no reason to suspect that 'major painting' on panel or wall was much unlike vase-painting, except that it probably did not use incision (like black figure) and preferred a pale background (unlike red figure). What we see and learn about Late Archaic painted wooden panels suggests compositions like those on vases and not particularly larger nor of finer quality than, say, the drawing of the Pioneers (*ARFH* I ch. 2), some of whom are likely also to have been panel-painters; indeed, the practices of panel-painting might even lie behind the very invention of the red figure technique. Nor is finer engraving apparent on metalwork, indeed there seems to have been some decline here after the seventh century in favour of modelled (cast) decoration.

From the second quarter of the fifth century, however, we have descriptions of the wall-paintings of Polygnotos of Thasos (working principally in Athens and Delphi) and of the Athenian Mikon. These paintings are clearly quite novel in composition, being major friezes with figures at least half life size and disposed up and down the frieze, which was itself one-and-a-half or two figures high. There was no question of perspective in these pictures, and the upper figures were not smaller or deemed to be further away, or even less important, but the

introduction of varied ground lines within the composition offered the possibility of, e.g., cutting off some figures, as behind rocks or a hill crest, and of introducing new relationships between figures and within groups, no longer bound to a single ground line. This opened up the possibilities of new conceptions of space in figure compositions. We know the paintings only from descriptions by later writers, notably Pausanias' figure-by-figure account of those at Delphi; none have survived, nor were they to the taste of later copyists and collectors, however highly the name of Polygnotos was rated.

The new compositions were observed and imitated by the vase-painters from about 460 on, seldom and in a limited way, though with important implications for the composition of later vase scenes. The earliest example, and perhaps the one that comes closest to the appearance of the wall friezes, is on the name vase of the Niobid Painter [4], where we see the frieze of one-and-a-half figure height and the cut-off figures.

Some believe that the new paintings also introduced new poses for figures but this is not borne out by the descriptions, although the enlarged field and the new perception of space if not depth which it offered, probably encouraged some bolder foreshortenings; but there is no dramatic change. The rather old-fashioned anatomical detail shown for some figures on this vase (the emphatic belly-patterns), and on slightly later vases which also seem inspired by wall-paintings, has been thought a feature of the major paintings, copied by the vase-painter. If true, this would be interesting and surprising since there is every reason to believe that the vase-painter did not copy wall-paintings, line for line or figure by figure, but that the influence was far more generalized and the new style drastically adapted to the different medium which could offer long frieze compositions only by wrapping the scenes around the larger crater shapes.

The early drawing styles of the Early Classical soon abandon the Archaic obsession with pattern in anatomy and dress, and with it some of the delicacy of draughtsmanship: 'the man who draws outlines on pots becomes a humbler, more mechanical person' (Beazley). The mood is more dignified, almost austere, and the parallel expression of it in sculpture is aptly named the Severe Style (GSCP ch. 2) typified by the sculptures of the Temple of Zeus at Olympia. Athens has little to offer in sculpture until towards the middle of the century, which is when many think the fine Riace bronzes were created (ibid. figs. 38–9), in an Athenian studio. In detail, we see the pattern of dress shaken out into looser, more realistic folds; where there are stacks of folds these are no longer defined by zigzag hemlines but simply grouped in parallel lines often with a dot pattern between. The heavier woollen peplos worn by women in preference to the looser and more ornate chiton abets this impression. Anatomy is rendered somewhat more impressionistically, but still with careful observation of pattern, and a proper profile view of the eye is gradually achieved, pupil to the front, long upper lid. Real foreshortening is attempted and the three-quarter view,

even of a face, is no longer a novelty. Facial expressions explore subtleties beyond the mere grimace of pain, and postures abandon the formulae of the exercise book, although each painter will develop and exploit his own favourites; the painter contrives 'to include in his art more of nature's manifold phenomena than before' (Beazley). Colour and pattern become subordinated to the expression of mood.

Some painters of this period have been discussed already in *ARFH* I ch. 4 – the Mannerists, some pot-painters, and followers of some of the Late Archaic cup-painters – all in varying degrees dependent on the old tradition. Here we concentrate on the new, but the Archaic constantly intrudes.

The NIOBID PAINTER [1–8] is the prime exponent of the new style. We have discussed his name vase [4] and its demonstration of the influence of wall-painting, but must note that it is so far unique in his work and appears late in his career. A variety of this composition, with only a slightly rising or fluctuating ground line, is found in the work of his contemporaries, e.g. [12, 13], but not (so far) on his vases. It too probably derives from major painting and in its way is more effective at suggesting depth of field though almost as restrictive as the old friezes in the number of figures it can accommodate. Our painter does, however, offer some fine large-figure friezes on a single groundline [2, 3], often encircling the vase, and perhaps also echoing more conventional narrative styles on larger friezes in other media. He likes the large vases for such subjects – volute, calyx and bell craters, with some of the medium-sized – pelikai, neck-amphorae, hydriai – for more modest groups. Another way to answer the interest in major friezes and many figures was to split the crater fields into two narrower friezes, a device we find also in the Niobid Painter's work [5, 6].

On his name vase the ground lines are in white (and so barely visible in photographs) and this is to be the rule except where painters dispense with them altogether. Some modest floral embellishment of the ground may be seen: hardly 'landscape' though this too has been attributed to the influence of landscape elements in major painting, which the descriptions show to have been minimal. His figures have a fine, solid presence to them, scrupulously drawn and with a lot of dress and armour patterning in the Archaic manner, although this more probably does reflect the greater colour and detail possible in major painting. He has a fine, almost antiquarian eye for the detail of dress, and for

nuances of narrative. There is a monumentality about his work which escaped his predecessors, except, perhaps, the Kleophrades Painter (*ARFH* I *figs*. 129–42), and this is a quality to which more vase-painters will now aspire, with varying degrees of conviction. He likes the epic fighting scenes, of Amazons, giants or centaurs, as did the wall-painters, while his smaller vases carry divine pursuits or departures of warriors, heroic, or Athenian, or heroised Athenian, which become increasingly popular. The heroic atmosphere of a departure scene such as [7] is apparent when we compare it with Hector's arming for departure by Euthymides, fifty years earlier (*ARFH* I *fig*. 33, and cf. 45), and on [5] the number of women present has suggested to one scholar that this should be Achilles preparing to leave the ladies of Skyros for Troy, and not an Athenian subject. The formulae for such scenes had been long established; when a new one is sought for a mythological occasion, as on [8], we may be surprised by the apparent naivety in showing how Apollo deflected Paris' arrow to Achilles' heel.

Of the Niobid Painter's companions the ALTAMURA PAINTER [10, 11] is calmer, more old-fashioned, but not for that reason literally his senior and only temperamentally his 'elder brother', as Beazley calls him. Indeed he decorates the 'new' shape for the volute crater, with moulded neck [10], which the Niobid Painter does not. He decorates stamnoi too, a shape also favoured by the painters of large pots (but seldom a field for the Niobid Painter), while the old-fashioned bell crater with lug handles is not forgotten [11]. He seems not to be taken by the new compositions. For these we turn to a crude but bold follower of the Niobid Painter, the PAINTER OF THE WOOLLY SATYRS. [12] is a good example of a composition with the fluctuating ground line and it neatly demonstrates both one of the distinctive cut-off figures and a daring group of Greek dispatching Amazon in a combination of postures unthinkable earlier. Amazonomachies are favoured for such scenes: a subject popular too on walls, serving as parable to Athens' successful defence against the Persian invasions. His volute crater [13] with its single narrow frieze and figures on a variable ground line offers a richer texture of figures than most conventional red figure, and exploits well the fine black of the vase walls, as had most black figure volute craters. [14] is no less original: this seems to be a weary Herakles with the dead lion (which looks more asleep than dead). The seated figure should be Eurystheus, the youth Iolaos, Herakles' companion, but he seems already to have a lion-skin.

A third treatment for the new compositional style is to increase the height of the frieze relative to the figures, as in the early examples by the PAINTER OF BOLOGNA 279 [15, 16]. When this is combined with more overlapping groups and activity ranging up and down the field, the general effect may be confusing, and if wall-paintings were really like this we must imagine that their greater size improved the effect. It seems barely appropriate on a clay vase, and later, better painters who are attracted to such compositions will space the figures more effectively, while poorer painters will range them in separate but undefined

registers, seduced by the high fields offered by some shapes. Otherwise the desire for a proliferation of smaller figures on the large vases, and the narrative possibilities they offer, is answered by putting two tiers of figures on craters, usually with unrelated subjects, a device we have met already with the Niobid Painter [5, 6]. None of these variable-ground-line or up-and-down compositions need be earlier than about 450, and they look appreciably later than the Niobid Painter's name vase. [17] and [19] offer other painters' treatments of the two-tier and variable-ground-line compositions, and [18] a different use of the narrow, single frieze on a crater. It is clear that the frieze, whether or not it is developed in height, has become a more important element for narrative display than the panel, and it is likely that the new styles of major painting are the inspiration for this shift of emphasis.

A closely related but more academic group of painters saw no need for such bravura. Only their leader, the VILLA GIULIA PAINTER [20–25], will regularly attempt the larger craters for his work; for the others pelikai, stamnoi and hydriai suffice, with smaller vases. The most characteristic compositions are, in Beazley's phrase, 'quiet and harmonious', to the point of being boring except where the subject matter can hold us. The reverses of the vases are more regularly now filled by lay figures (the Villa Giulia Painter often has a 'king' and two women), banal groups of some value, however, in identifying artists' hands, since in these figures (commonly 'mantle figures') the artist relaxes and reveals his 'natural' and individual handwriting – his signature. Our painter also occasionally works on white ground, as in the tondo on [20] with the goddess (Kore) holding a jug tinned over to imitate silver. The CHICAGO PAINTER [26–29] is a more engaging personality. These artists initiate an interest in scenes of worship and dance at a pillar image of Dionysos [24], often associated by scholars with the Lenaia festival, or with an episode in the spring Anthesteria; these have a short but vigorous vogue. The Persian being attacked on [29] reminds us that such contemporary encounters with the barbarian had been given a degree of heroic status in Athenian art since the Persian wars (ARFH I figs. 279, 303).

1 *Volute crater by the Niobid Painter. Sack of Troy: rescue of Aithra, rape of Kassandra*

2 *Volute crater by the Niobid Painter. Above, Herakles greeted by Pholos. Below, Amazonomachy*

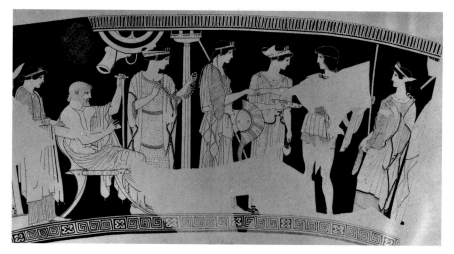

3 Volute crater by the Niobid Painter. Warrior departs (Achilles from Skyros?)

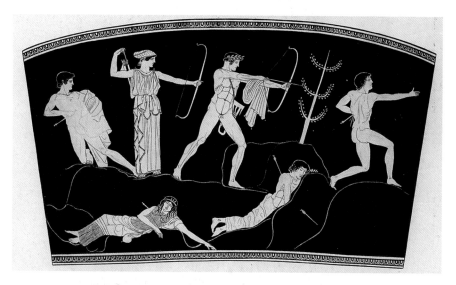

4.1 (above and left) Calyx crater by the Niobid Painter (name vase). Apollo, Artemis and the Niobids.

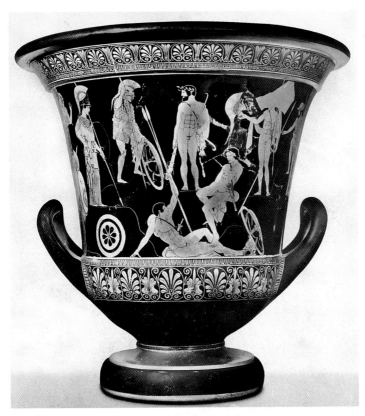

4.2 *Reverse of 4.1 Gods and heroes before Marathon? H. 54*

5 *Calyx crater by the Niobid Painter. Above, the gods create Pandora. Below, a Pan/satyr chorus*

6 Calyx crater by the Niobid Painter. Gigantomachy: Ares, Zeus, Artemis, Apollo. Below, Dionysos.

7 Neck amphora by
the Niobid Painter

8 Pelike by the Niobid Painter.
Death of Achilles

9 (below) Calyx crater in the manner
of the Niobid Painter. Gigantomachy:
Zeus, Herakles, Athena, Artemis

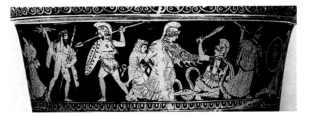

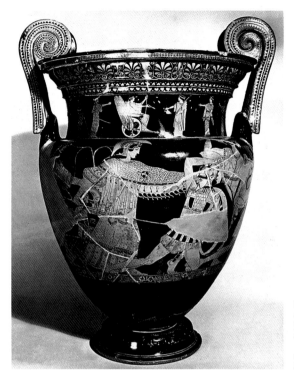

10 *Volute crater by the Altamura Painter. Above, Triptolemos. Below, Gigantomachy: Dionysos, Athena, Zeus. H. 70*

11 *(below) Bell crater by the Altamura Painter. Herakles enters Olympus*

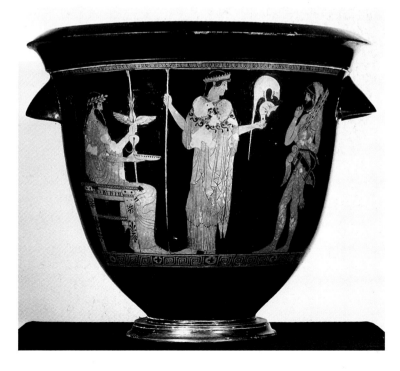

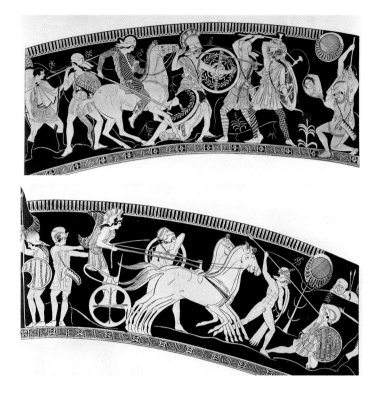

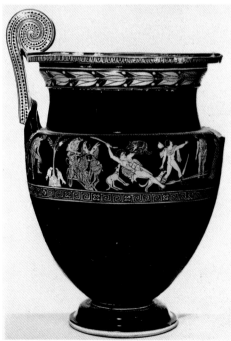

12 (above) Volute crater by the Painter of the Woolly Satyrs. Amazonomachy

13 Volute crater by the Painter of the Woolly Satyrs. Death of Aktaion

14 *Calyx crater by the Painter of the Woolly Satyrs. Herakles and the dead lion*

15.1 *(below) volute crater by the Painter of Bologna 279. Above, Herakles and Busiris. Below, the Seven against Thebes (Amphiaraos, below). H. 72.5*

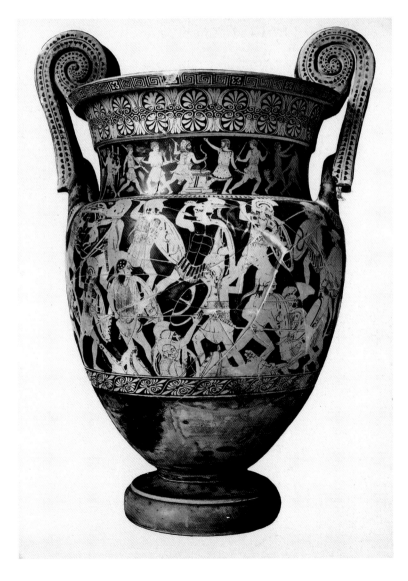

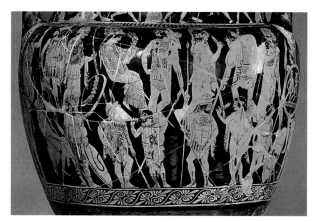

15.2 *Reverse of 15.1 Athena and Argonauts?*

16 *(below) Volute crater by the Painter of Bologna 279. Amazonomachy*

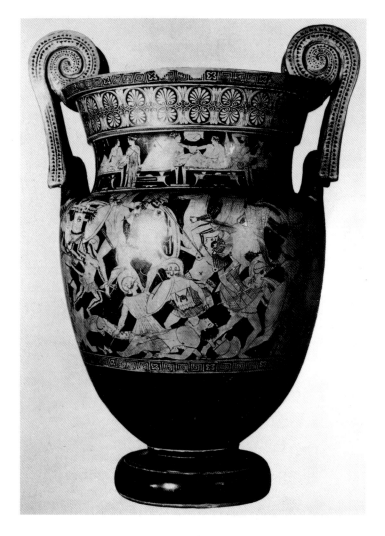

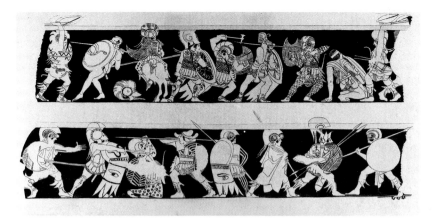

17 Calyx crater by the Geneva Painter. Amazonomachy

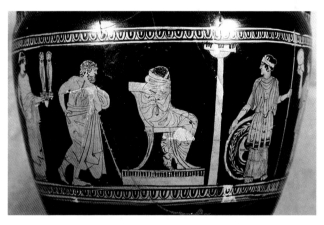

18 Volute crater connected with the Geneva Painter. Achilles receives new armour

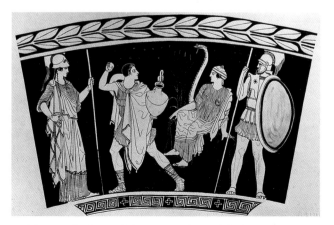

19 Calyx crater by the Spreckels Painter. Kadmos and the dragon

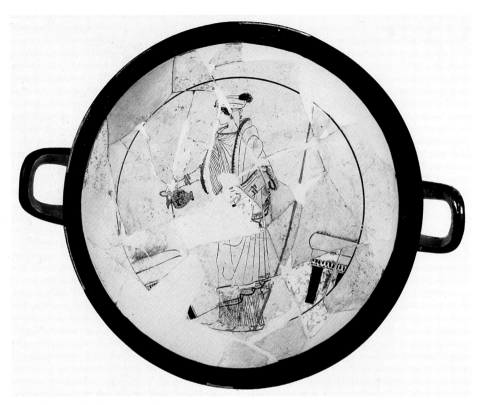

20 Cup by the Villa Giulia Painter. Kore. Diam. 24.5

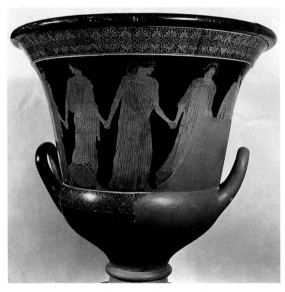

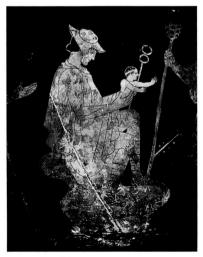

22 Bell crater by the Villa Giulia Painter. Hermes and infant Dionysos

21 Calyx crater by the Villa Giulia Painter

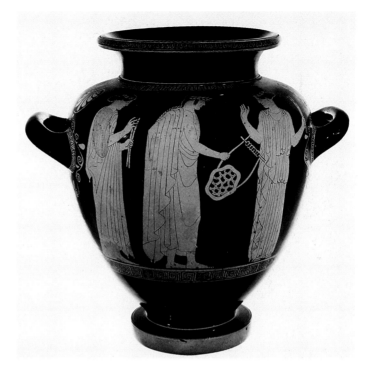

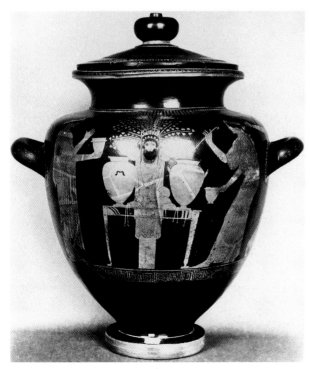

23 (above) Stamnos by the Villa Giulia
Painter. Apollo and Muses. H. 34.4

24 Stamnos by the Villa Giulia Painter.
Worship of Dionysos (pillar image with
mask), wine-tasting. H. 48

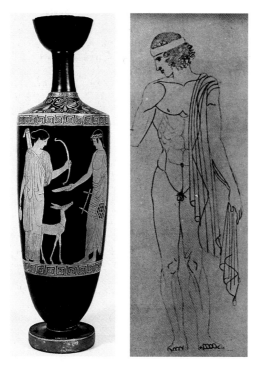

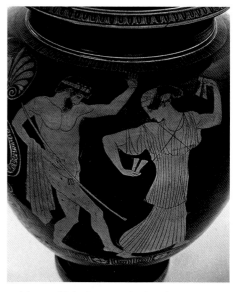

25 (above left) Lekythos by the Villa Giulia Painter. Apollo and Artemis. H. 47.3

27 (above and below) Stamnos by the Chicago Painter

26 (above right) Stamnos by the Chicago Painter. (Beazley drawing)

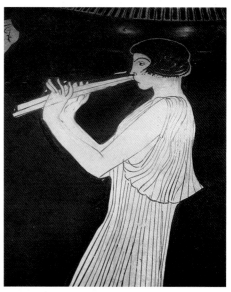

28 Pelike by the Chicago Painter. Polyneikes bribes Eriphyle

29 Oinochoe by the Chicago Painter.
Greek and Persian. H. 23

30 Pointed amphora by the Oreithyia Painter. Boreas and Oreithyia

31 Pointed amphora by the
Copenhagen Painter. Achilles
receives new armour. H. 47.2

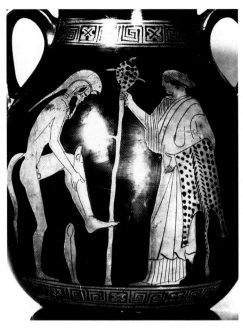

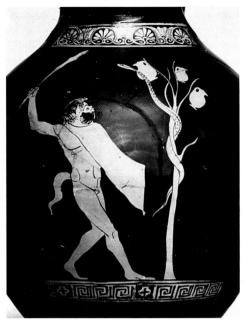

32 Pelike by the Deepdene Painter. A satyr arms (to fight giants?)

33 Oinochoe of the Group of Berlin 2415. Satyr attacks tree of jugs (parodying Herakles and the Hesperides serpent). H. 27.5

34 Hydria by the Painter of the Yale Oinochoe. Judgement of Paris. H. 33

35 Calyx crater by the
Aegisthus Painter. Apollo,
Tityos and Ge. H. 50.5

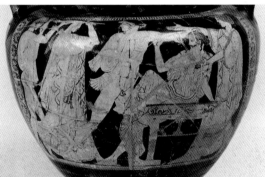

36 Column crater by the
Aegisthus Painter (name vase).
Orestes threatened by
Clytemnestra kills Aegisthus

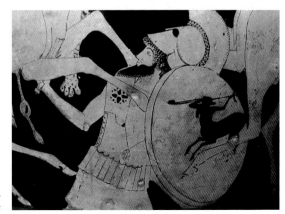

37 Column crater by the
Cleveland Painter. Kaineus

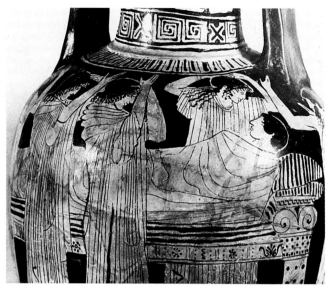

38 (left and above) Loutrophoros by the Syracuse Painter. Prothesis. H. 66.5

39 Column crater by the Syracuse Painter. H. 41.1

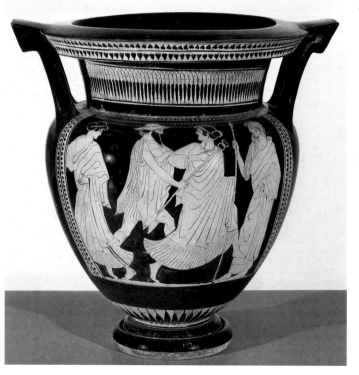

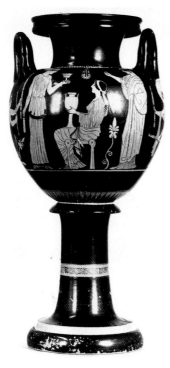

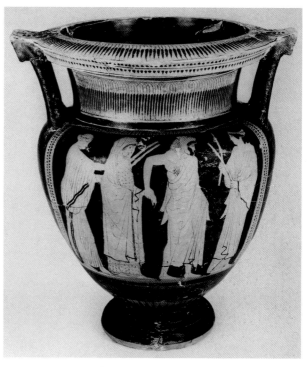

40 *Lebes gamikos by the Mykonos Painter* 41 *Column crater by the Orchard Painter. Wedding of Herakles*

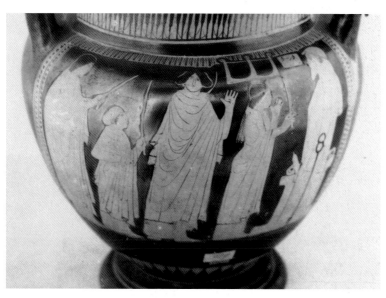

42 *Column crater by the Orchard Painter. Sacrifice to a herm*

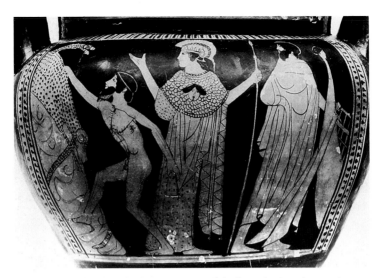

43 *Column crater by the Orchard Painter. Jason and the fleece; the Argo ship to right*

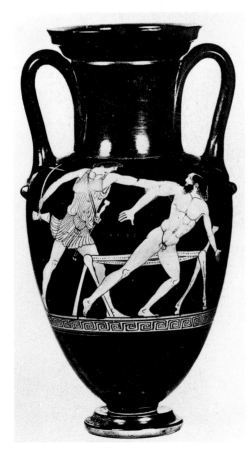

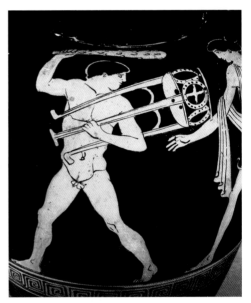

45 *Neck amphora by the Alkimachos Painter. Herakles and Apollo*

44 *Neck amphora by the Alkimachos Painter. Theseus and Prokrustes*

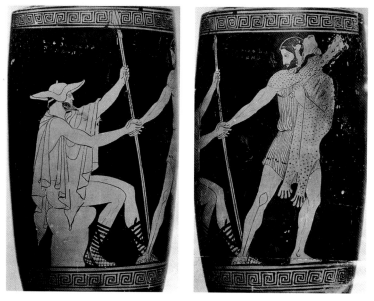

47 *Lekythos by the Alkimachos Painter. Herakles and Peirithoos in Hades*

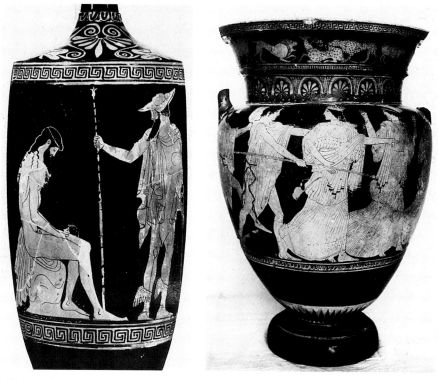

46 *Lekythos by the Alkimachos Painter. Birth of Dionysos from Zeus' thigh*

48 *Volute crater by the Boreas Painter. H. 64*

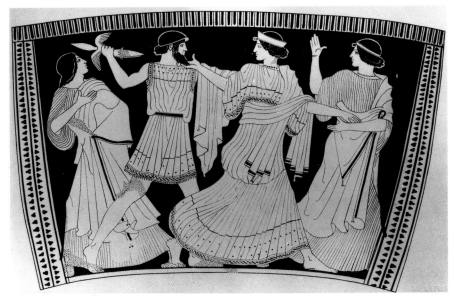

49 Column crater by the Boreas Painter. Zeus and Aigina

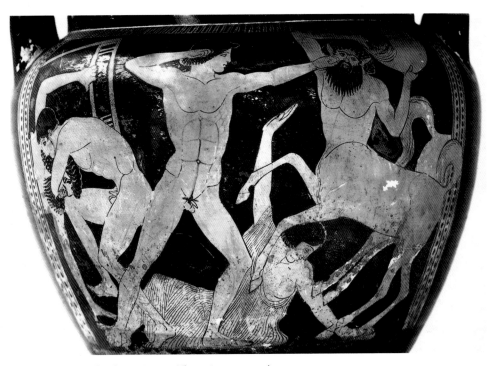

50 Column crater by the Florence Painter. Theseus in centauromachy

Other pot-painters of the period are memorable generally for individual treatment of particular subjects, and many favour the column crater, a shape often preferred by the second rate; it is more easily potted, more easily carried, and certainly more robust. The OREITHYIA PAINTER [30] conveys still some Archaic verve and grandeur, and must be early in the period. Notice the fine, icicled beard and hair of the North Wind (Boreas), and the three different ways the forelocks of the girls are shown – realistic curls, and the Archaic wavy locks and relief bobbles. The AEGISTHUS PAINTER also has clear Archaic origins (at the Copenhagen Painter's bench; *ARFH* I *figs*. 199–201; and here [31]) and attempts the grander craters [35, 36]. Others [32–34, 37–43] can prove competent and instructive, occasionally with some vigour in drawing, occasionally with no more than a scratchy directness. They indulge some minor specialisation in loutrophoroi and lebetes gamikoi [38, 40] – concentration by some painters on these funeral and wedding vases will be a feature of the coming generation. The ALKIMACHOS PAINTER [44, 45] recalls some of the Pan Painter's quieter moments on Nolan amphorae and lekythoi (*ARFH* I *figs*. 335–49, esp. the lekythoi, *figs*. 347–8). Lingering Archaism can be seen everywhere in the work of these secondary painters but the BOREAS and FLORENCE PAINTERS [48–50] are the doyens of the inferior column crater, though the former rises to finer work on a volute crater, perversely demoting the neck floral in favour of an old-fashioned animal frieze [48].

There are many other painters devoted to the smaller pots, notably lekythoi and the small 'Nolan' neck-amphorae, with their big black necks and tight ovoid bodies, generally not inviting more than one or two figures per side. This is ground occupied in the same years by the early Mannerists and others whose debt to the Archaic studios is more readily apparent and whose work has been admitted to *ARFH* I ch. 4.

Some of the lekythos painters deserve attention for their contribution to the new popularity of an old technique – white ground – which is further studied below, in Chapter Four. The SABOUROFF PAINTER [51–53] is a busy cup-painter of some merit, offering pleasing if unambitious figures of youths and women on cups and some better work on larger vases. He painted a few red-figure lekythoi, but many white ground which are discussed elsewhere and he has a good white ground tondo with Hera [51]. The TROPHY PAINTER's pensive Athena sitting on her aegis is puzzling [55]. The BOWDOIN PAINTER [56–59] was thought by Beazley to be 'very likely' the same man as the Athena Painter who had an interesting career in black figure early in the century (*ABFH* pp. 113–4, 148). If so, his change of technique and advancing years seem accompanied by a definite change of mood. Most of his lekythoi are red-figure, but there are some white ground, with the same simple subjects, mainly single figures of women or Nike, and the old black-palmette shoulders. The AISCHINES PAINTER [60–62] and the CARLSRUHE PAINTER [63] have a similar range of subjects in a finer style.

The Early Classical cup-painters working still in the old tradition were discussed in *ARFH* I. The new style is dominated by two names which typify the best and worst of the period. The PISTOXENOS PAINTER [64–69] carries much of the delicacy and quality of the Late Archaic into the new period; aptly, he praises Glaukon on his vases, son of the Pioneers' darling, Leagros (*ARFH* I p. 213). We met Pistoxenos as the skyphos-potter who adopted the name Syriskos (ibid. p. 114). The painter has another potter-link with the Late Archaic in his decoration of one (or more) cups made for him by the now elderly Pioneer Euphronios (who had turned from painting to potting in the early fifth century; ibid. pp. 32, 133): they are distinguished in their painting too by the choice of a white ground for the tondo carrying delicate but vigorously composed outline drawing with a strong Archaic flavour. He has an original way with story-telling; a major artist of the period. His white-ground tondi must be early, 470 or little later, with strong action [64, 65] or single-deity studies [67]. There is a subtlety of coloration and detail here which escaped most of his contemporaries. Of his companions the TARQUINIA PAINTER will also try white-ground tondi [73] but is generally satisfied with repetitive youths and athletes. His subject matter is still strongly Archaic. There is other interesting work of this flavour in this area [75–79]. Observe the black cupboy on [75] who intrudes into the plain band of still-lifes which replaces the couches in the symposion (as *ARFH* I *fig.* 305).

The second cup-painter works later and is important as both artist and entrepreneur (if he was indeed master of the workshop that we associate with his name): the PENTHESILEA PAINTER [80–86]. On his name vase the figures fill the tondo [80.1] and are therefore as big or bigger than most on craters (the cup is 43 cm across). One senses that the composition would have better suited a rectangle than a circle, which does not mean that it was copied from a frieze or panel, though it clearly follows that style of composition which we associate with major painting. It is a good example of the inadequacy of the medium and field for such drawing, but individually the figures are impressive, helped by rich touches of white and gilt relief. The technique is that of the white-ground vases (indeed precious little black background is visible). There are opaque washes of colour on dress, overpainted with white or black lines. A pale wash shades the interior of 'Achilles'' (the identity is not certain) shield; his body is reddish, the others brownish. We glimpse here the appearance of major Early Classical painting probably more clearly than on any surviving white-ground work. But

he has other, more conventionally imposing masterpieces. Another even bigger cup (72 cm across) from Spina [81] fills its interior with a frieze around the tondo – the deeds of Theseus – and with Trojan scenes outside; the technique this time is conventional red figure and these 'full-insides' are tours-de-force rarely attempted by vase-painters. The border to the tondo of his name vase was a colourful ivy frieze, a device that will not be forgotten by painters (and see his skyphos [86]), but on some other big cups with large tondo scenes he puts an olive-wreath border [82].

The other side to his career is demonstrated by the exterior of his name vase [80.2] where there are trivial scenes of big-headed youths and their horses. These, and comparably dull groups of youths and girls, people the majority of his other cups [83]. The style is slick, not quite careless, sometimes a mite charming, but this is his weekday manner above which he rises only in the larger tondo cups and the rather laboured excellence of his name vase. The exterior of [82] has these boring figures, but painted by another hand. Beazley detected some fifteen different painters sharing the work of decorating cups in this 'workshop', indifferently doing tondi or exteriors, whatever was passed to them along the bench once the other side had dried off. We need not dwell on individuals, but some occasionally rise to better things, some copy the ivy-wreath tondo-border of the master's vases [87, 88] or attempt a full-insides [90], even if sparsely populated. Pyxides are another favourite shape [89]. The number of identified vases from this workshop number nearer a thousand than five hundred; by now this is what the bulk of Athenian red figure vase production was about, taking over from the even less inspired, very late black figure which it was replacing (*ABFH* pp. 150–1).

The potter Pistoxenos seems to have inaugurated a fashion for specialist skyphos production and decoration. The LEWIS PAINTER [92–95], who, no doubt for purposes of advertisement or self-esteem, borrowed the name of his more distinguished contemporary Polygnotos (and so is called Polygnotos II; for I see the next chapter), painted many small skyphoi in a pleasingly unassuming manner, generally with just one or two figures on each side, favouring pursuits and studies of gods, often lavishing some care on the detail of the rather stiff drawing. OWL-SKYPHOI belong to the second and third quarters of the century and present the Athenian owl and olive sprig on either side, often on a skyphos shape (the *glaux* = owl) with one horizontal, one vertical handle (like a beak and tail); they are rather like holiday souvenirs, with the local coat of arms [96, 97]. SAINT VALENTIN vases, mainly skyphoi or footless kantharoi, are patterned only with chequer, feather/scale and similar textile-like designs [99], which will sometimes appear also on the outsides of otherwise figure-decorated cups. And in these years there is a short-lived new kantharos shape with stumpy foot and low handles, decorated by various hands [98]. We turn with some relief to the last of the great names of this period.

SOTADES was a potter of imagination and delicacy. He and his entourage made

a number of novelty figure vases with red-figure decoration on the vase mouths. Some are in the shape of animal heads (rams, dogs, boars [107], donkeys) copying a type long familiar from precious-metal Persian spoils and imports from the East; others are whole figures (sphinxes [106]) or groups (a Persian leading a camel [101], a negro boy caught by a crocodile [104], a mounted Amazon), or oddities (an astragal [105]). A more colourful imitation of an eastern shape is the fluted (white, black and coral red) phiale, white within, with a cicada perched on its navel [100]. His delicacy is displayed in the small cups with merrythought handles, decorated by the artist we call the SOTADES PAINTER [102–106]. The outline drawing is executed in palest gloss paint, but the added colours are mainly now lost. Three fine cups in London (two are [102, 103]), with the phiale [100] and other ribbed cups were found in one tomb in Athens. The subject matter of the tondi is original and attempts have been made to find a common factor which might explain the purchase and deposition of the group in one tomb. Coral red is used on the outside of one, and in the grooves of the fluted cups; it also appears on other cups, around the tondo [108] or on the outside, the last important use for this unusual colouring technique.

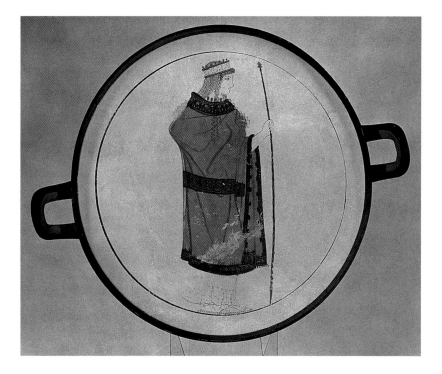

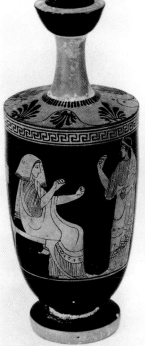

51 (above) Cup by the Sabouroff Painter. Hera

52 (left) Lekythos by the Sabouroff Painter. H. 15.9

53 (below) Cup by the Sabouroff Painter. Apollo

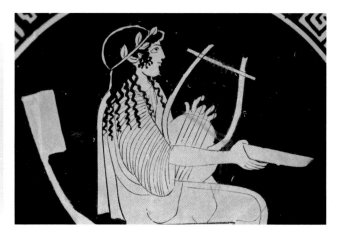

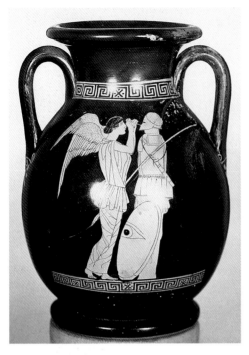

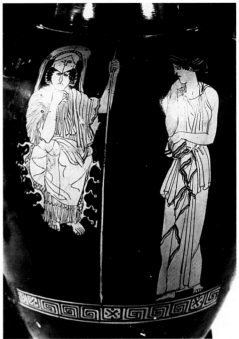

54 (above left) Pelike by the Trophy Painter (name vase). H. 25.5

55 (above right) Nolan amphora by the Trophy Painter

56 (far left) Lekythos by the Bowdoin Painter. H. 31.1

57 (left) Lekythos by the Bowdoin Painter. H. 25.1

58 *Lekythos by the Bowdoin Painter. H. 18.5*

60 *Lekythos by the Aischines Painter*

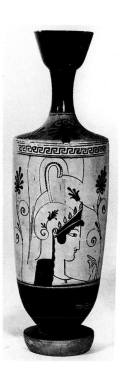

59 *Lekythos by the Bowdoin Painter. Athena H. 27*

61 *Lekythos by the Aischines Painter. Eos and Tithonos*

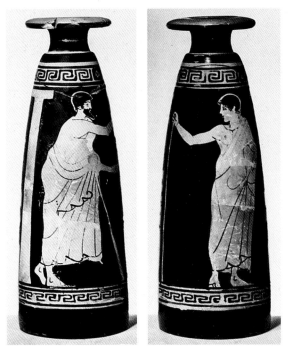

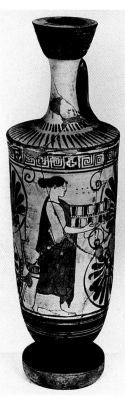

62 Columbus alabastron by the Aischines Painter

63 Lekythos by the
Carlsruhe Painter. H. 21.5

64 Cup by the Pistoxenos Painter. Death of Orpheus

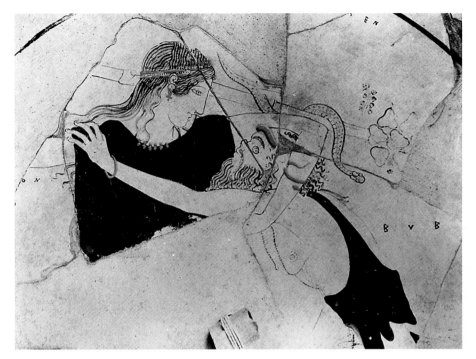

65 *Cup by the Pistoxenos Painter*

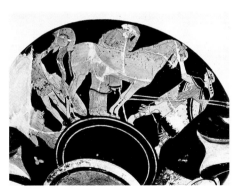

66 *Cup by the Pistoxenos Painter*

67 *Cup by the Pistoxenos Painter.*
Aphrodite

68 Skyphos by the Pistoxenos Painter. Herakles and Geropso

70 Lekythos in the manner of the Pistoxenos
Painter

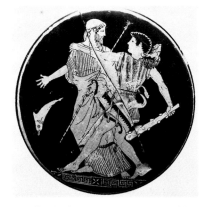

69 Bobbin by the Pistoxenos Painter. Herakles
and Nereus

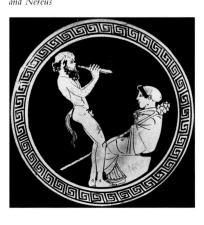

71 Cup by the Painter
of Athens 1237

72 *Cup by the Tarquinia Painter. Diam. 34*

73.1 *Cup by the Tarquinia Painter. Athena and Hephaistos adorn Anesidora. Diam. 31*

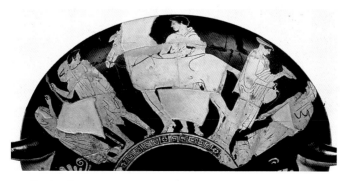

73.2 *Exterior of 73.1*

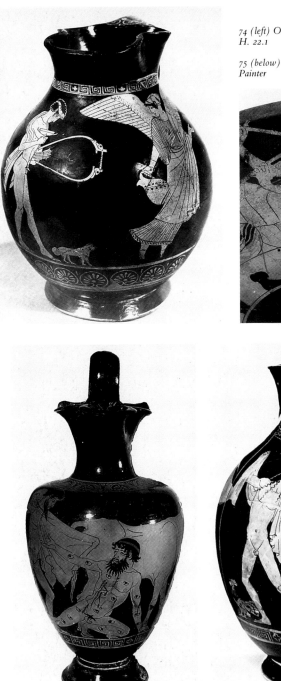

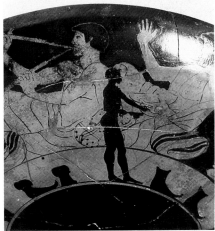

74 (left) Oinochoe by the Tarquinia Painter.
H. 22.1

75 (below) Cup in the manner of the Tarquinia
Painter

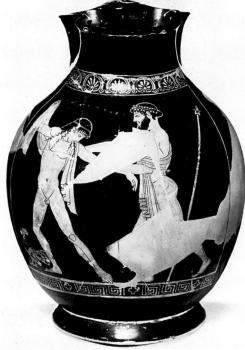

76 Oinochoe by the Painter of Florence 4021.
Hermes and Argos

77 Oinochoe by the Painter of Florence 4021. Zeus and
Ganymede. H. 21.5

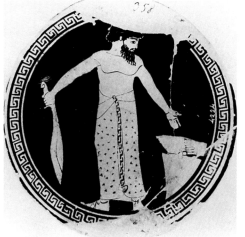

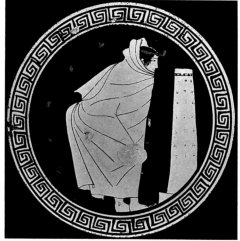

78 Cup by the Ancona Painter. Butcher

79 Cup by the Ancona Painter. Youth reads stele

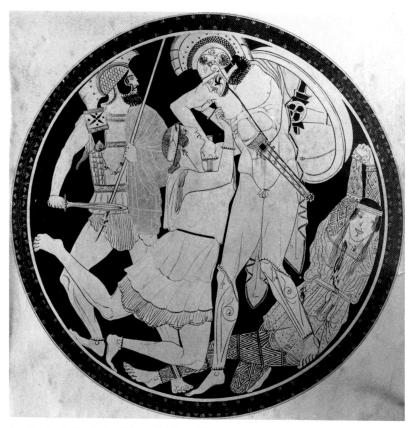

80.1 Cup by the Penthesilea Painter. Achilles and Penthesilea? Diam. 43

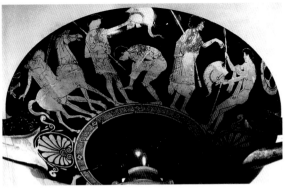

80.2 Exterior of 80.1

Detail of 80.1

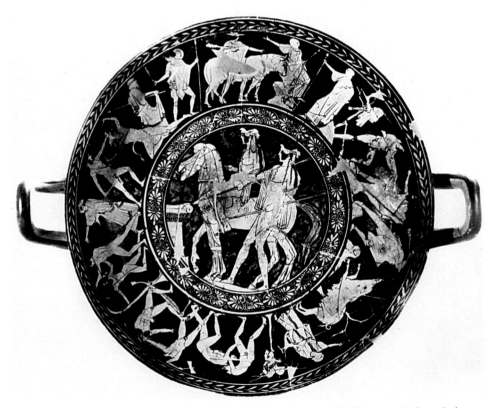

81 Cup by the Penthesilea Painter. Frieze, deeds of Theseus: clockwise from top, bull, Skiron, sow, Kerkyon, Prokrustes, Sinis, Minotaur, recognition. Diam. 72

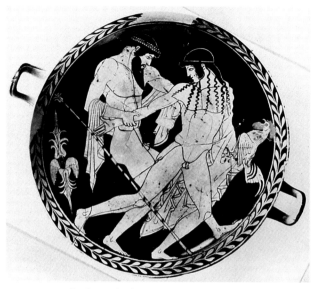

82 (above) Cup by the Penthesilea
Painter. Zeus and Ganymede.
Diam. 36.5

83 (above and below) Cup by the
Penthesilea Painter

84 Cup by the
Penthesilea Painter

85 *Acrocup by the Penthesilea Painter. The foot is restored. Diam. 22.4*

86 *(below) Skyphos by the Penthesilea Painter. Anodos of a goddess (Aphrodite?) with Pans. H. 22.8*

87 *Cup by the Aberdeen Painter. Apollo. Diam. 22.5*

88 *Cup by the Aberdeen Painter. Peleus and Atalanta*

90 Cup by the Curtius Painter. Diam. 23

91 Pyxis by the Painter of London D 12. H. 12

89 Pyxis by the Wedding Painter. Wedding of Peleus and Thetis

92 Skyphos by the Lewis
Painter. Zeus and Athena.
H. 18.7

93 Skyphos by the Lewis
Painter. Eos and Tithonos

94 Skyphos by the Lewis
Painter. Amazons. H. 19.5

95 Skyphos by the Lewis Painter

96 Owl skyphos. H. 8.5

97 Owl skyphos.
H. 7.6

98 'Czartoryski'
kantharos

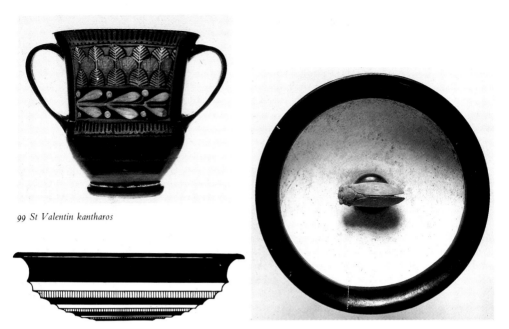

99 St Valentin kantharos

100 Phiale with cicada by the potter Sotades

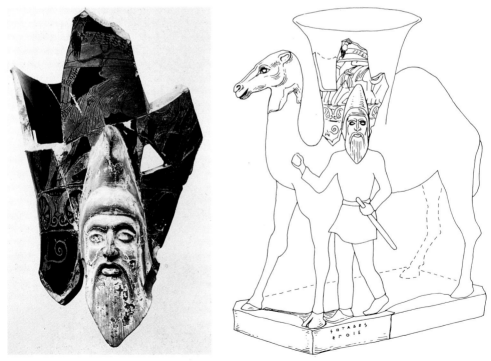

101 Figure vase by the potter Sotades

102 Cup by the Sotades Painter. Apple picking. Diam. 13.5

103 Cup by the Sotades Painter. Hunter and snake. Diam. 13.5

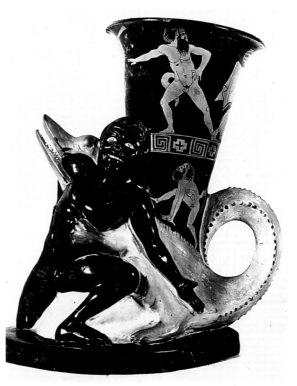

104 Figure vase by the Sotades Painter. H.26

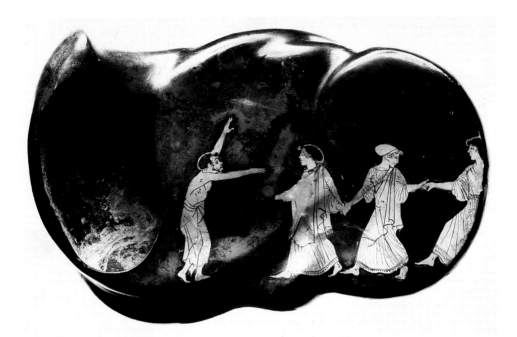

105 *Astragal by the Sotades Painter. L. 17*

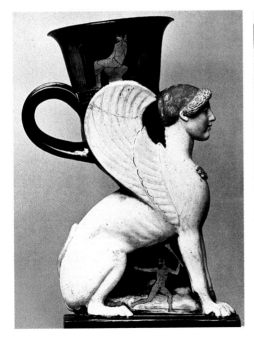

106 *(above and left) Figure vase by the Sotades Painter.
Mouth, Kekrops and Nike. H. 29*

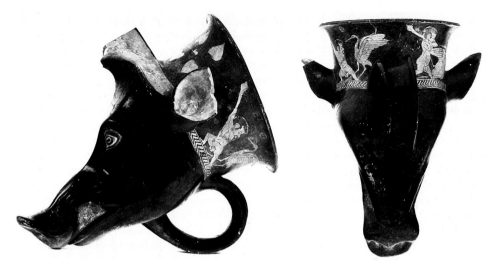

107 *Rhyton in the manner of the Sotades Painter. Mouth, pygmies and cranes. H. 24*

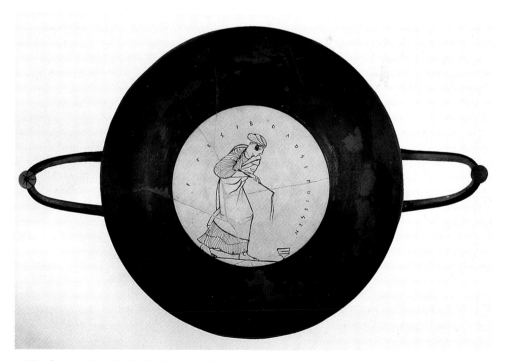

108 *Stemless cup akin to the Sotades Painter (coral red round tondo). Diam. 13.9*

Chapter Three

CLASSICAL

The Parthenon was being planned in the mid fifth century; in 438 the temple was dedicated and in the following six years the pedimental figures were installed. It was a building rich in marble sculpture, and in relief metalwork and painting (on the cult statue). The surviving sculpture typifies for us Athenian art of the period, its Classical, idealized style. In vase-painting we rightly look for echoes of this, but it is elusive, although we may readily detect scenes which appear to aim for the same idealized, heroic atmosphere, and scenes of civic display. The way the craft develops can be understood almost wholly in terms of the medium and its techniques, paralleling rather than copying higher arts.

This chapter deals with 'the Parthenon period', years of prosperity and power for Athens, down to the 420s when war and events which were to lead to defeat signalled for some painters a surprising change of mood. I have deferred to the next chapter one or two artists whom Beazley included in his 'Classic' phase, not in any attempt to improve on his classification, but to isolate here that work which is truly 'Parthenonian' and to keep together the work of artists who express more fully the new, more florid styles of later in the century. There is something of the appearance of these new styles already in the latest Parthenon sculpture (the pediments), but not of their mood as it is expressed in vase-painting.

From this point on, drawing styles develop more slowly than they had in the past hundred years. In time some painters achieve a new mastery of space and the relationship between figures, or successful depiction of mass and motion in line drawing, but for the most part determination of date and of the work of individual artists is still dependent on observation of details of draughtsmanship and shape. The connoisseurship becomes more difficult and there is no space here for detailed and personal comparisons. We might have expected the influence of major painting to grow, introducing new ornament or even a degree of polychromy, but we have only the increasing use of white ground for a limited if numerous class (the white lekythoi, Chapter Four), while the up/down compositions or use of a variable ground-line remain quite rare despite the attention they inevitably attract in text- and picture-books. Generally the good artists are totally competent in anatomical renderings, though still strictly formulaic in their use of stock poses and groups, and their awkward medium ties them still to mainly profile views of heads and to well-spaced compositions.

The Berlin Painter, master of the Late Archaic period (*ARFH* I pp. 91–111) worked on into the second quarter of the fifth century and had a busy if not always distinguished following (*ARFH* I pp. 193–5). The ACHILLES PAINTER [*109–118*], at work by about 460, seems his natural successor and may even have been his pupil. He shares the master's delight in figure drawing for its own sake, favouring therefore big black vases (like the old-fashioned belly amphora, his name vase [*109*]) or the smaller Nolan amphorae which display well the one- or two-figure subects [*111, 112*]. Like his master he is not much interested in complicated story-telling but is satisfied with studies of gods, Nikai, pursuits, leave-taking. He appreciates pure black, putting the tiniest vignettes on some black stamnoi, and it may have been much the same preference which led him to paint the increasingly popular squat lekythoi, with their simple heads and busts for decoration. When he decorates the bigger craters the figures are tied to the ground, not disposed up and down in the 'modern manner' learned from walls.

Like his master, he perhaps paints in black figure too, for prize Panathenaics (*ABFH fig.* 303). His 'sober beauty' is best expressed on white ground lekythoi, to which we turn later, though he admits some of the funeral scenes onto red figure lekythoi [*118*], and his 'battle loutrophoros' [*113*] is a notable and noble essay. The characterization of the old warrior on [*114*] is unexpected in this period of idealization. He worked on to at least 430, it seems. His early vases share *kalos* names (Kleinias, Lichas; while Diphilos and Dromippos are his favourites on white ground) with Early Classical cup-painters; his later, with names to be mentioned below (Euaion and Axiopeithes; with the Phiale and Lykaon painters). The DWARF PAINTER [*119, 120*] and PERSEPHONE PAINTER [*121*] were counted followers of, and akin to, the Achilles Painter by Beazley. Dwarfs had attracted the sympathetic attention of Athenian painters before (*ARFH* I *fig.* 377). [*119*] makes a nice attempt at drawing an Archaic kouros as a cult statue.

The Achilles Painter's pupil, the PHIALE PAINTER [*122–128*], 'an artist of true charm, and, in his larger works, nobility', has similar preferences but perhaps more heart for narrative. He decorates very few white ground lekythoi but chooses the technique for two striking calyx craters [*125, 126*] which, with their tall straight walls, must take us close to the appearance of the elusive major painting of the day. Their subjects and compositions seem not to be derived

from or inspired by the famous wall-paintings but possibly from smaller panels, or are the painter's own original interpretations of stories, perhaps made popular on the stage. [125] praises Euaion, the playwright son of Aeschylus. He has several large two-tier calyx craters in red figure too; he seems to have 'thought bigger' than his master, at least in terms of pots if not of figures. He is named for the phiale [128], a shape rarely painted with figures.

Of the three vase-painters who borrowed the name of the famous muralist the most prolific stands at the core of a major group of artists. POLYGNOTOS [129–138] follows in the steps of the Niobid Painter for his style and choice of subject. Ready enough to attempt the larger craters and one of the first to favour the bell crater, he nevertheless does not follow his master in experimenting with muralist compositions, and the most characteristic work of the group is seen in what appear to be excerpts from the big Amazonomachies and similar major battle scenes (centaurs, etc.) from which they extract typical three-figure scenes.

The Amazonomachies are particularly varied, including not only the fights in Attica [133–135] but the Trojan, with Achilles, and the Amazons themselves are treated well with scenes of arming and riding [132], lacking any especial aggressive intent. The girl acrobat and sword-dancer on [138] are a fair indication of the degree to which life is becoming the model for some artists. Within the Polygnotan Group there are some important individual painters. On the MIDAS PAINTER's name vase [139] the Phrygian king preserves his dignity with his donkey ears.

Beazley's Peleus Group includes work of the HECTOR and PELEUS PAINTERS [140–144] who do attempt the grander friezes with variable ground-lines, which are barely hinted at in Polygnotos' more modest compositions. They achieve a certain dignity too which seems generally to have escaped the more workmanlike master (if that was indeed his role). Only the inscriptions on [140] distinguish Hector's departure from an Athenian scene, and old Priam pipes an eye in a fine study of dignified sorrow. Fragments of a crater with scenes from the Games for Pelias give us a hairy athlete, perhaps Herakles, beside a tripod, and the sporty Atalanta wearing a wrestling cap and an advanced design of brassiere [143]; cf. ARFH I fig. 369. The COGHILL PAINTER's Sunrise [145] has plunging naked boys as the fading stars, and the EPIMEDES PAINTER an extraordinary evocation of a kitharode's success in major competitions of the

Greek world [*149*]: the four Nikai personify the Games at Athens, Nemea, Marathon and Isthmia. The LYKAON PAINTER [*150–153*] comes closer than usual in a vase scene to a literal illustration of lines from Homer, though he adds a figure that the poet ignores, Hermes, a natural attendant for the interface between earth and the underworld, where Odysseus sits over the blood pool to question his lost comrade Elpenor [*150*]: 'as we exchanged these words of sorrow, we stayed sitting opposite each other, I apart, with my sword drawn over the blood, and my comrade's ghost on the other side, telling his long-drawn tale' (trans. Shewring). In his work, too, we see an early intimation of what is to become a feature of the following generation, the use of white paint for the flesh of a girl [*153*]. Personifications of the abstract are familiar in Greek art. Rage (Lyssa) urging on Artemis' dogs to tear an Aktaion, already sprouting stag's antlers on [*152*], is one of the oddest – a huntress with a dog's head emerging from her own – rabid. The CHRISTIE PAINTER's komos [*154*] recalls an Archaic subject, to be picked up by other Classical painters. The PANTOXENA PAINTER has a fine Priapic image of Hermes, with satyr and maenad [*155*]. But these are a minority of hands distinguished by Beazley in the 'Polygnotan Group'. On many other vases of the Group [*156–165*] we see subjects, more epic than trivial, often treated with considerable delicacy: the strange deities (Sabazios and Cybele?) on [*157*] – worshippers before them, an ecstatic dance behind; an excellent Amazonomachy [*159*]; Theseus confronting the guilty Medea with her poisoned jug and phiale [*164*]; a weak-kneed Andromeda with her black attendants being led to her stake and the tryst with the sea-monster [*166*]; the Pan and satyr on [*168*] molesting a sleeping maenad disguised as a housewife. The unassigned [*169*] shows how the red figure technique could deal with a black, and [*170*] has an unconventional birth of Pandora.

The KLEOPHON PAINTER [*171–176*] may not be the best artist of his period but he is the easiest to appreciate. He learned from Polygnotos. Beazley was generous to his 'figures . . . full and fleshy, his drapery loose and flowing' and in his best works 'a simplicity and amplitude which, joined with the grave beauty of his heads, gives it a touch of grandeur'; 'the best of his time in his kind'. He decorates a full range of the larger shapes. The most characteristic of his subjects take us back to the Archaic, the *komos* of men and youths, dancing deliberately and quietly, it seems, their distinctive features in classic composure [*173*].

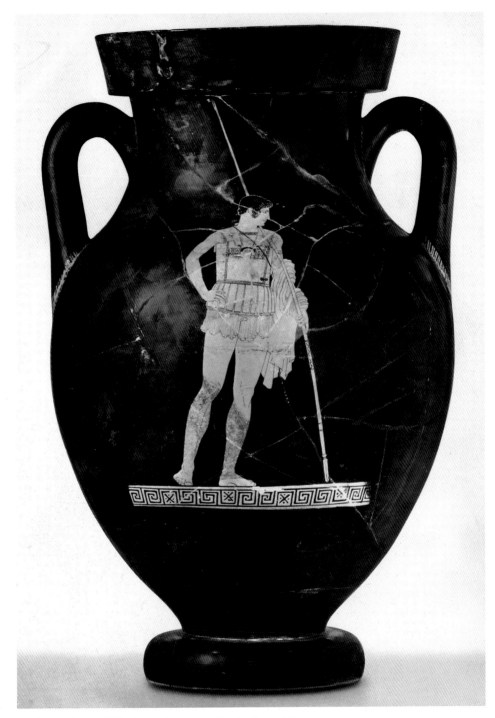

109 *Amphora by the Achilles Painter (name vase). See also Frontispiece*

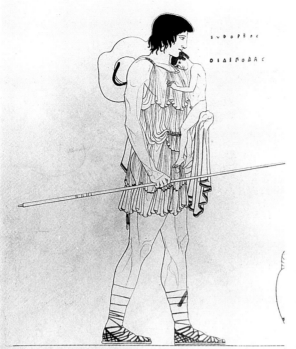

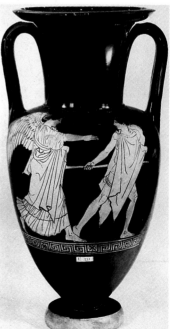

110 *Neck amphora by the Achilles Painter. Euphorbos and the infant Oidipus*

111 *(below left) Nolan amphora by the Achilles Painter. Oidipus and the Sphinx. H. 33.2*

112 *(below right) Nolan amphora by the Achilles Painter. Eos and Kephalos. H. 34.5*

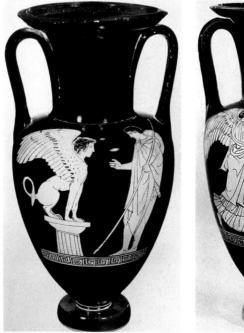

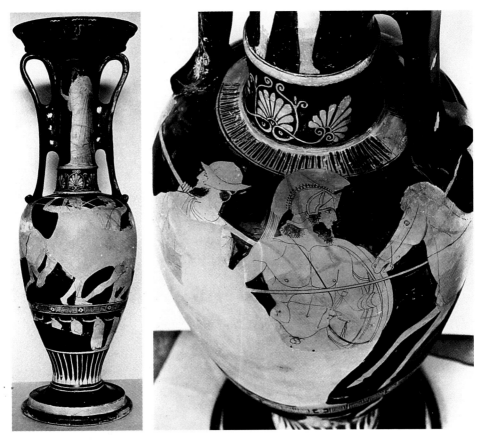

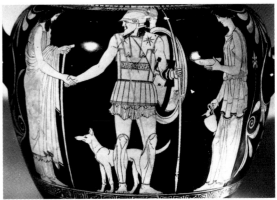

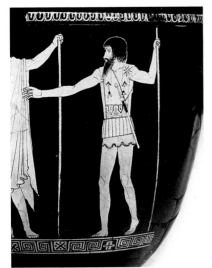

113 Loutrophoros by the Achilles Painter

114 (left) Bell crater by the Achilles Painter

115 (below) Stamnos by the Achilles Painter

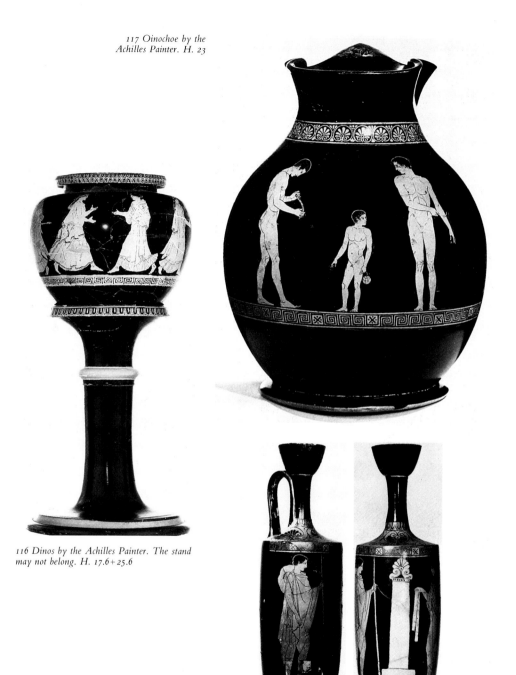

117 Oinochoe by the
Achilles Painter. H. 23

116 Dinos by the Achilles Painter. The stand
may not belong. H. 17.6 + 25.6

118 Lekythos by the
Achilles Painter. H. 38.3

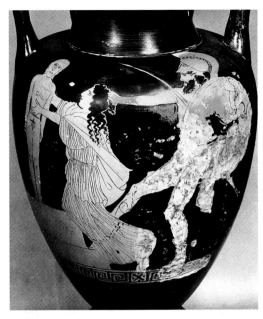

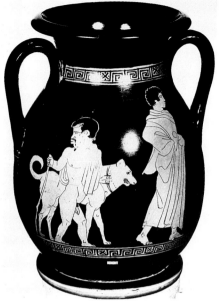

119 Nolan amphora by the Dwarf Painter. Helen and Menelaos

120 Pelike by the Dwarf Painter (name vase). H. 24.1

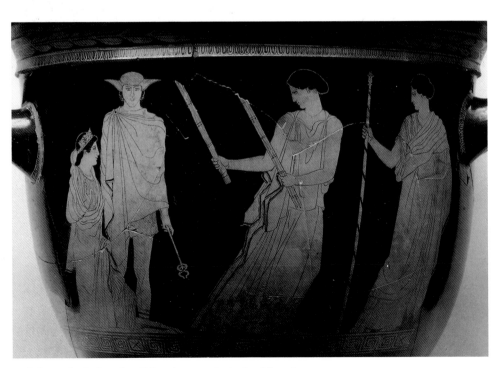

121 Bell crater by the Persephone Painter (name vase). Anodos of Persephone

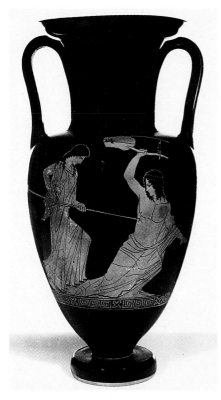

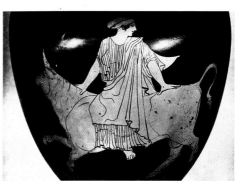

123 Nolan amphora by the Phiale Painter. Europa

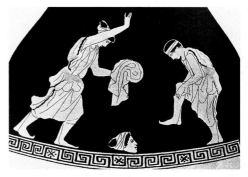

122 Nolan amphora by the Phiale Painter. Death
of Orpheus. H. 32.5

124 Pelike by the Phiale Painter. Actors dressing

125 Calyx crater by the Phiale Painter. Perseus and Andromeda

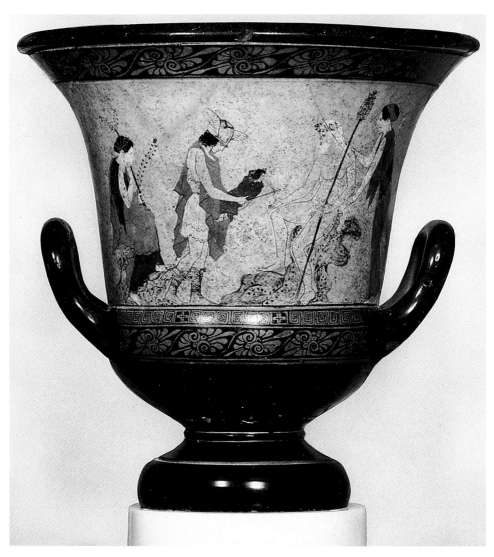

126 Calyx crater by the Phiale Painter. Infant Dionysos taken to Silenos by Hermes. H. 32.8

127 Bell crater fr. by the Phiale Painter. Danae and
Perseus in the chest

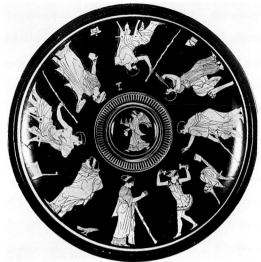

128 Phiale by the Phiale Painter
(name vase). Diam. 24.9

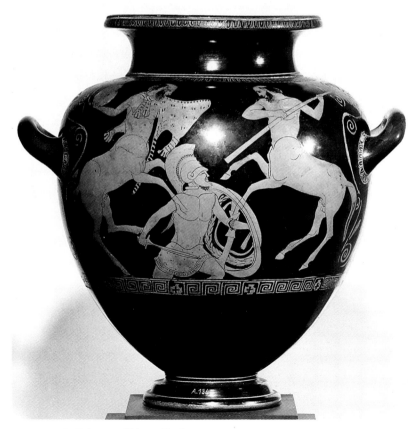

129 Stamnos by Polygnotos. Kaineus. H. 36

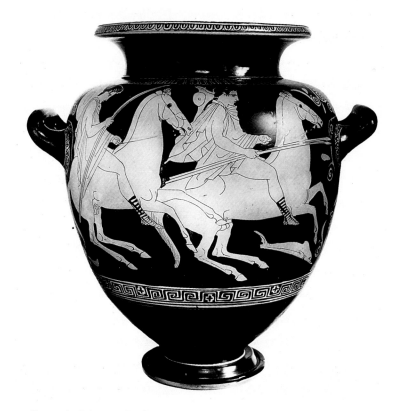

130 Stamnos by Polygnotos. Dioskouroi. H. 39.2

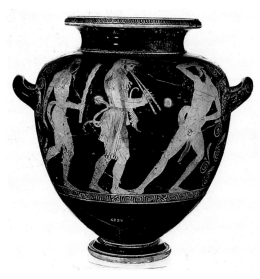

131 Stamnos by Polygnotos. Herakles and satyrs

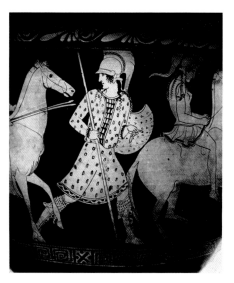

132 Bell crater by Polygnotos. Amazons

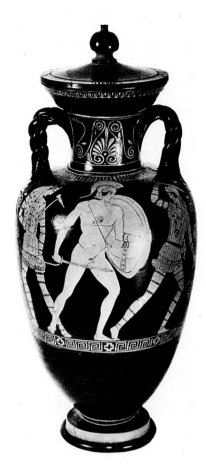

133 Neck amphora by Polygnotos. Antiope,
Theseus, Amazon

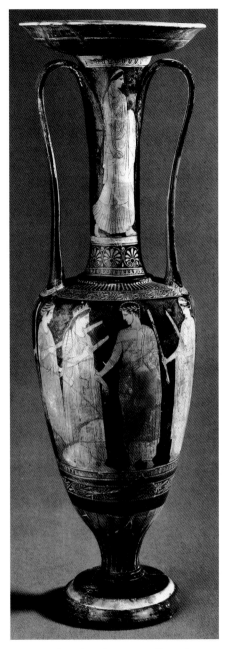

134 Loutrophoros by Polygnotos. Wedding. H. 78.1

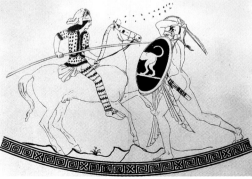

135 Pelike by Polygnotos. Amazonomachy

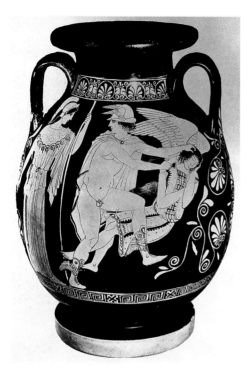

136 Pelike by Polygnotos. Perseus and Medusa. H. 47.8

137 (below) Hydria by Polygnotos. Peleus and Thetis

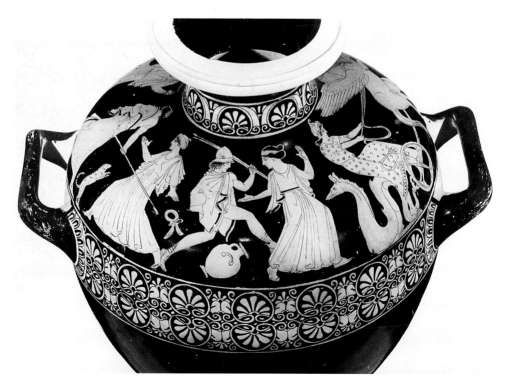

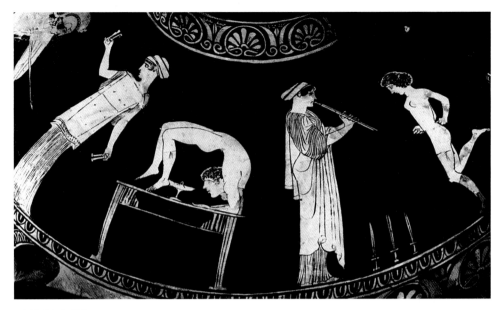

138 Hydria by Polygnotos

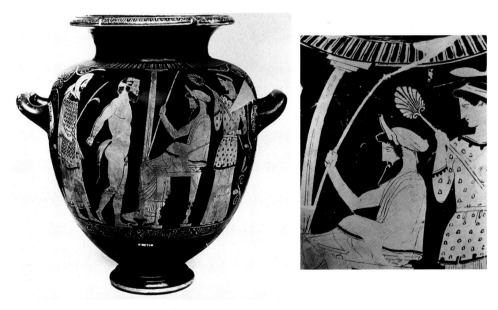

139 Stamnos by the Midas Painter (name vase). Silenos before Midas. H. 37

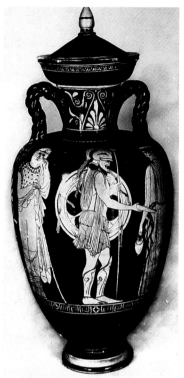

140 (above and left) Neck amphora by the Hector Painter (name vase). Priam, Hector departs

141 (below) Stamnos by the Hector Painter. Nike watering a bull

142 Calyx crater by the Peleus Painter (name vase). Wedding of Peleus and Thetis

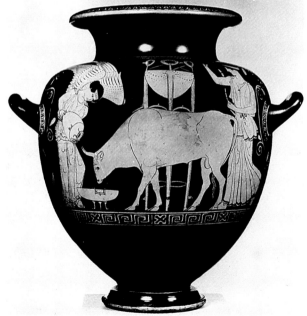

143 Volute crater frs. by the Peleus Painter. Athletes at the Games for Pelias: Atalanta and Hippomenes (probably meant for Peleus); Herakles? at a tripod

144 Neck amphora by the Peleus Painter. Melousa, Terpsichore, Mousaios. H. 58.5

145 Hydria by the Coghill Painter. The sun (Helios) rises; stars set

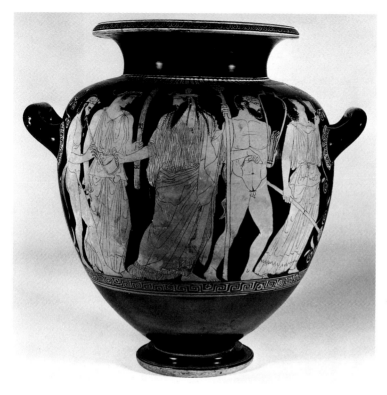

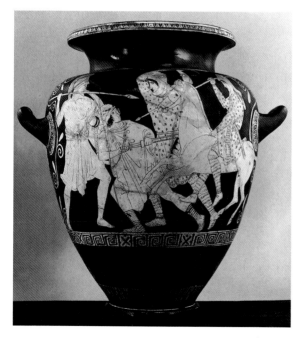

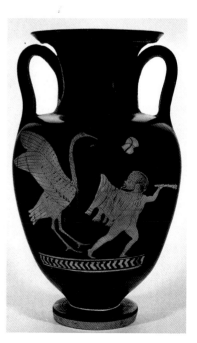

146 Stamnos by the Curti Painter. Dionysos' procession. H. 45.4

147 (below left) Stamnos by the Guglielmi Painter. Amazonomachy

148 (below right) Neck amphora by the Epimedes Painter. Pygmy and crane

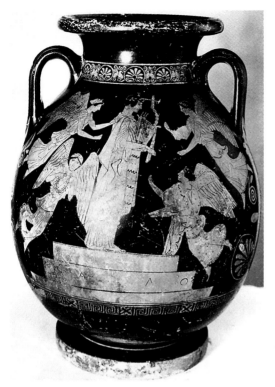

149 Pelike by the Epimedes Painter.
Kitharode and Nikai of Games

150 (below) Pelike by the Lykaon Painter.
Odysseus meets Elpenor at the pit of Hades

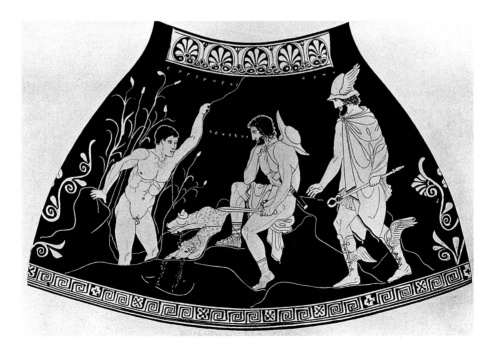

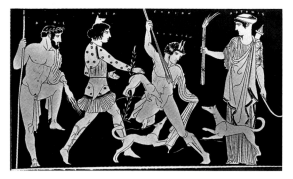

152 Bell crater by the Lykaon Painter. Death of Aktaion, with Zeus, Lyssa (Frenzy) and Artemis

151 Bell crater by
the Lykaon Painter
(Beazley drawing)

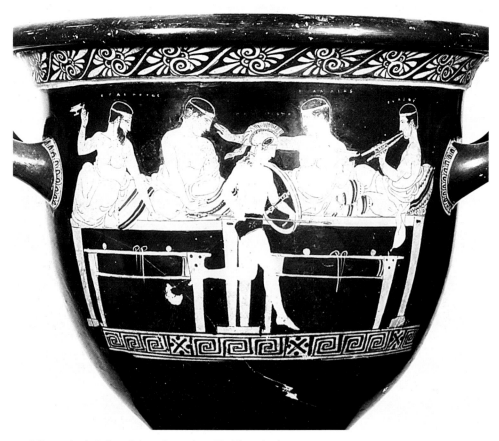

153 Bell crater by the Lykaon Painter. Symposion with girl-warrior dancer

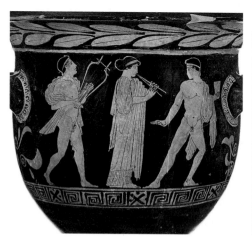

154 *Calyx crater by the Christie Painter*

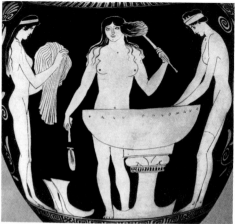

156 *Stamnos of the Polygnotan Group*

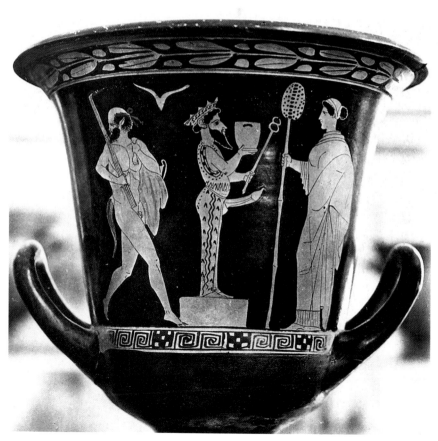

155 *Calyx crater by the Pantoxena Painter*

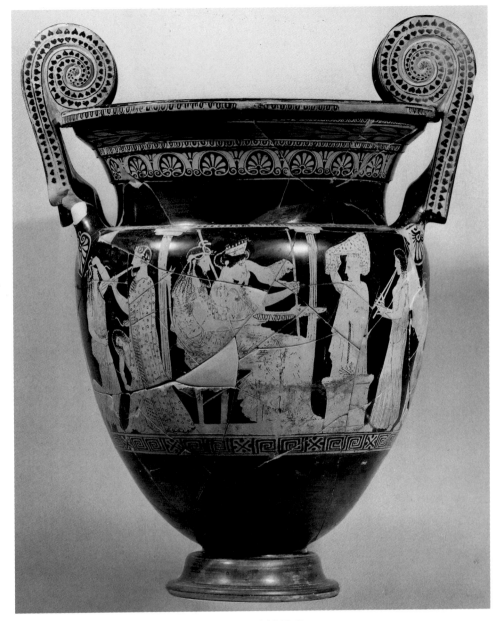

157.1 Volute crater of the Polygnotan Group. Sabazios and Kybele? H. 66

157.2 Detail of 157.1

158.1 Volute crater of the
Polygnotan Group. Gigantomachy:
Zeus, Athena

158.2 *Detail of 158.1. Dionysos.* 159.2 *Detail of 159.1*

159.1 *Dinos of the Polygnotan Group. Theseus in Amazonomachy*

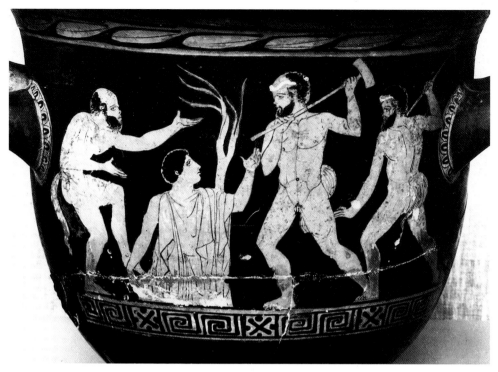

160 Bell crater of the Polygnotan Group. Anodos of a goddess

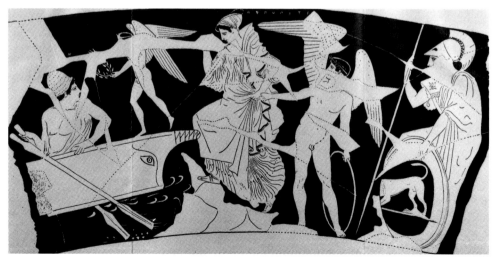

161 Calyx crater of the Polygnotan Group. Aphrodite and Phaon

162 Calyx crater of the Polygnotan Group. Return of Hephaistos to Olympus

163 Calyx crater of the Polygnotan Group. Dionysos and Basilinna?

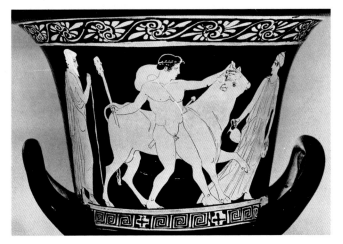

164 Calyx crater of the Polygnotan Group. Theseus and the bull, with Aigeus and Medea

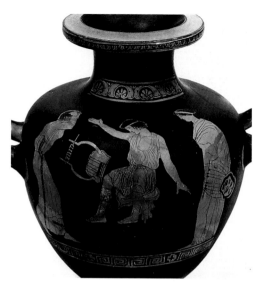

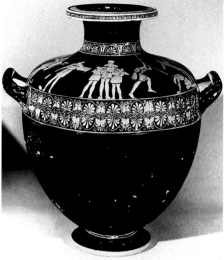

165 Hydria of the Polygnotan Group. Thamyras blinded

166.1 Hydria. Andromeda. H. 45.7

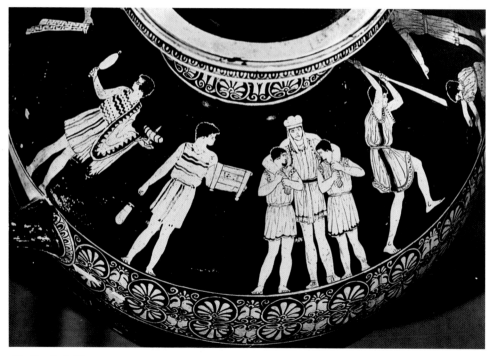

166.2 Detail of 166.1

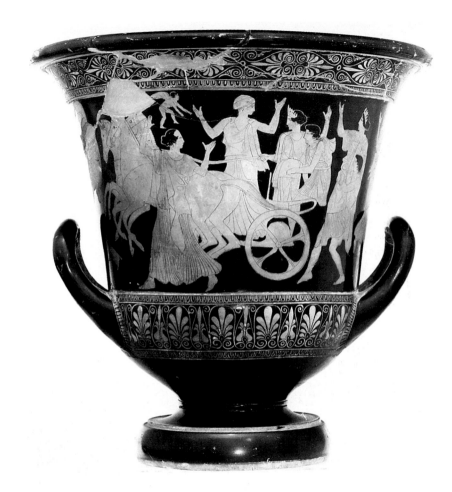

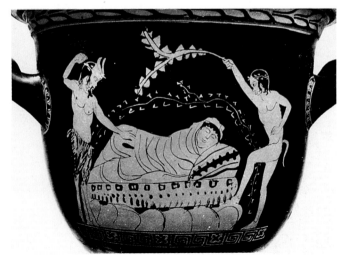

167 (above) Calyx crater.
Dioskouroi carry off the
daughters of Leukippos.
H. 54.8

168 Bell crater

169 *Pelike. Andromeda and a black.*
H. 44

170 *(below) Volute crater. Zeus,*
Hermes, Epimetheus and Pandora.
H. 48.2

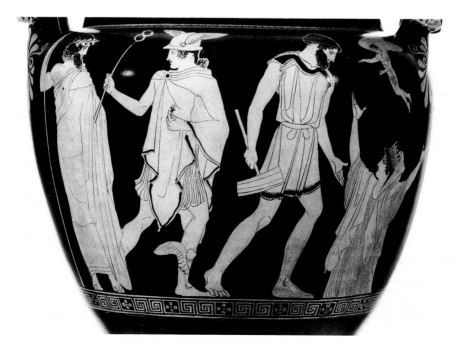

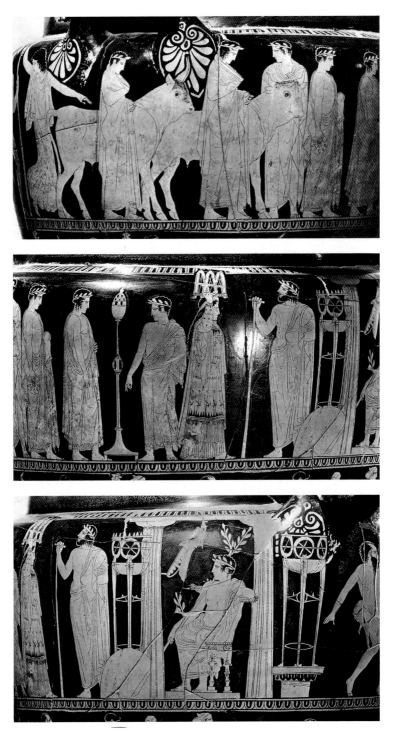

171 Volute crater by the Kleophon Painter. Procession to Apollo

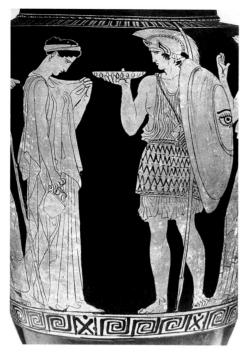

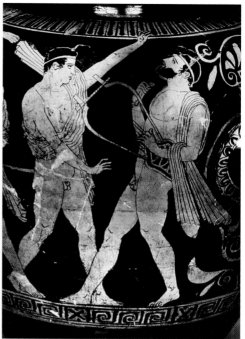

172 Stamnos by the Kleophon Painter

173 Stamnos by the Kleophon Painter

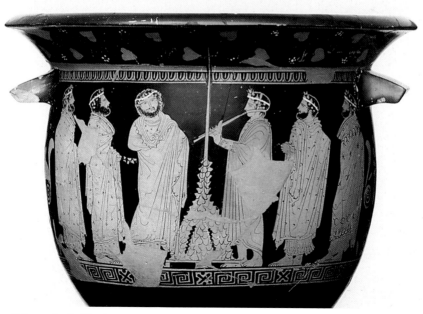

174 Bell crater by the Kleophon Painter. Chorus at a maypole

175 Pelike by the Kleophon Painter. H. 35.6

176 Loutrophoros frs. by the Kleophon Painter.
Warriors at gravestones

177 Stamnos by the Dinos Painter.
Worship of Dionysos

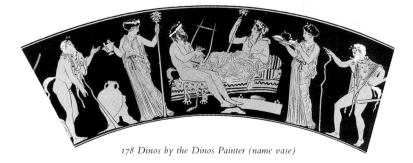

178 Dinos by the Dinos Painter (name vase)

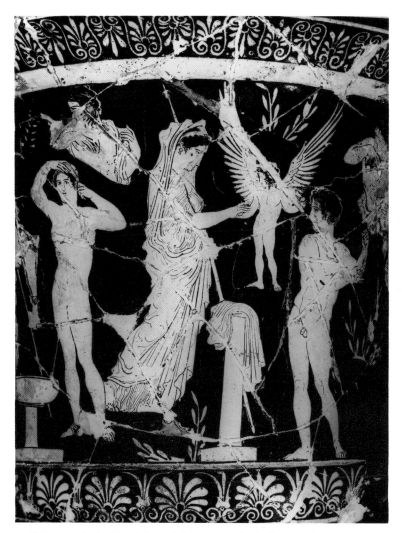

179 Calyx crater by the Dinos Painter. Atalanta prepares for the footrace; Hippomenes receives
the apples from Eros and Aphrodite

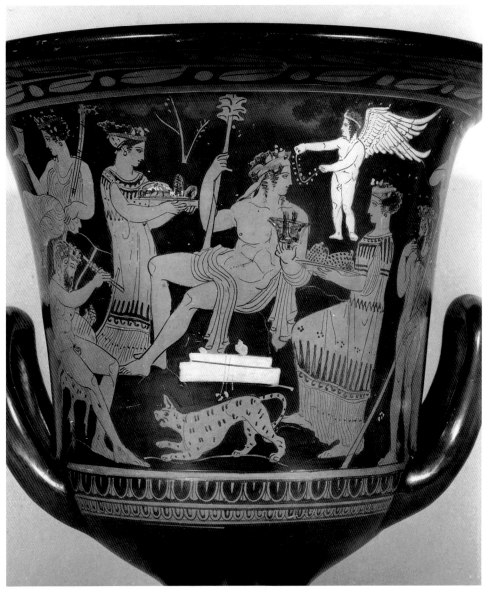

180 Calyx crater by the Dinos Painter. Dionysos

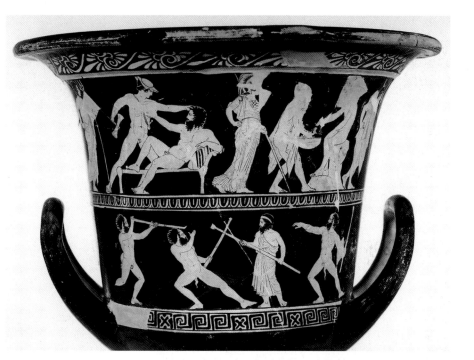

181 (above and right) Calyx
crater by the Dinos Painter.
Above, deeds of Theseus:
Prokrustes, Skiron. Below,
satyrs greet Prometheus bringing
fire from heaven. Detail,
Theseus and Sinis, lifting the
rock. H. 39.5

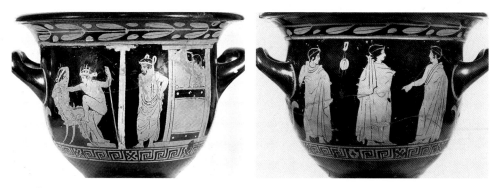

182 Bell crater by the Dinos Painter

Foreheads tend to the lofty and straight with hair dressed high above a headband. His most formal composition, on a grand volute crater from Spina [171], presents an Apolline version of a procession to sacrifice which inevitably recalls the near-contemporary Parthenon frieze (*GSCP figs.* 93–6), while the Maypole on [174] evokes an Athenian festival. He is free with white on the odd scene of warriors in a graveyard on the loutrophoros [176]. The DINOS PAINTER [177–182] follows him in a less solemn vein and stands right at the end of the period chosen for this chapter, with elements, indeed, of the next generation already apparent in his work. He leads a renewed if restricted interest in the grand, multi-level compositions, but not for the epic fights, rather for the Dionysiac or narrative groups which are soon to regain popularity, and which focus on one or few central figures rather than develop a theme along the frieze.

His style of drawing approximates to the floridity of the succeeding generation, and on some vases he can also be generous with white paint, for an Eros or furniture, which is another novelty soon to become an obsession with vase-painters.

There are many other pot-painters of this period, a few of whom go beyond a variable ground-line in composition, and most of whom are memorable for individual pieces of interesting content. On bigger vases two tiers are still preferred to anything more exacting by way of composition. The NEKYIA PAINTER offers some highly unusual scenes, the Underworld group on his name vase [184] and some original groups and figures in a Centauromachy [185]. The column crater has become well established again, retaining its old-fashioned pointed buds on the neck, and sometimes even a silhouette frieze of animals on the lip: we seem hardly to have moved away from the Archaic. The column crater painters [186–193] have occasional scenes of narrative novelty, usually on other shapes – on a hydria [188], and can turn to wedding vases [191]. The panels of the column craters commonly retain their frames in the old manner, especially among the LATER MANNERISTS who continue their predecessors' (*ARFH* I pp. 179–93) interest in old styles and old themes (e.g., the old-fashioned birth of Athena on [199]) but without their flair for pattern. I do not name here all the painters illustrated in [194–204]. The NAUSICAA PAINTER was another who bore the name Polygnotos. His name vase [194] has an epic theme, with Odysseus' nakedness hidden by exiguous branches and Athena from

Nausicaa and her companions: gaunt, awkward figures attempting realistic poses but telling the story well enough. The features of his Medusa on [*197*] are almost human; cf. [*136*] and contrast *ARFH* I *fig.* 153. The HEPHAISTOS PAINTER takes us back to a popular Late Archaic subject, Ajax and Achilles dicing [*200*], perhaps recalling a damaged Acropolis monument (cf. *ABFH* p. 231; *ARFH* I *fig.* 2; *GSAP* p. 87). The PAINTER OF MUNICH 2335 (no Mannerist) we shall meet again for his work on white ground [*268*], but he decorates many larger shapes [*205, 206*]: 'There is a shocking difference between this artist's best and his worst' (Beazley).

One subject which has increased enormously in importance throughout the period has been the feminine: the life of women and their role in cult or in preparation for marriage. A specialist in this is the WASHING PAINTER [*207–211*], who decorates many wedding vases – lebetes gamikoi and loutrophoroi – with wedding scenes or related subjects of women in their quarters (the *gynaikeion*). He is named for trivial small hydriae with women washing. His style might seem to qualify him for inclusion in the following chapter and he is certainly one of the youngest artists mentioned here. He is, by the standards of the day, a good draughtsman. His relative lateness is demonstrated by the close-set undulating lines on women's dress, and the way in which, on some figures, the lines even begin to break into curlicues, hallmarks of the florid style to come. He has followers [*213, 214*], and among the independents decorating large vases we may notice the EUPOLIS PAINTER's use of personification [*218*]: Athena was disgusted by Tydeus who had eaten the brains of his foe Melanippos and so she denied him immortality, demonstrated on the vase (now lost) by her leading Immortality (Athanasia) away from him. The BARCLAY PAINTER [*216*] decorates a bell crater with an unusually elaborate lip moulding.

Among the smaller vases of the day another shape, largely ignored since late black figure, comes to rival the cup in importance – the oinochoe. It is decorated by a distinguished series of specialist artists. At their head stands the MANNHEIM PAINTER [*219, 220*], an elegant draughtsman much of whose work stands quite close to the better Polygnotan but is far more delicate. The shape encourages delicacy, offering a field for relatively few figures and a goodly display of floral around the handle. The SHUVALOV PAINTER [*221–224*] follows him, in the more advanced Parthenonian period, with clear intimations of what is to come, and himself probably working into the 410s from about 440. His sprightly small figures, with their intent gaze, whether they are playing myth or life, are among the most pleasing of the age. He delights in the life of women and, as commonly in the work of painters now, an Eros is often promoted to mortal company. He displays a controlled prettiness in which it is not difficult to read the promise of mere vapidity. Some of his companions and followers, of the ALEXANDRE GROUP [*225*] and others [*226–228*], are made of somewhat sterner stuff. Between them, and with the Eretria Painter, they will inspire what will prove to be the best of the succeeding age.

The ERETRIA PAINTER [229–237], contemporary of the Shuvalov Painter but more influential, is the most interesting of the cup-painters, although his best work is not on cups but on oinochoai and some imposing squat lekythoi [229, 230] which are persuaded to carry multi-figure groups up and down the field, and on occasion are stretched to something nearer conventional lekythos proportions, as in the fine example in New York [231] where a central zone is white ground, and decorated with an appropriate funereal theme, Achilles mourning by dead Patroklos while his Nereid aunts bring him fresh armour overseas. The painter decorates odder shapes too, figure vases and head-kantharoi. The cups are ordinary in their decoration, all athletes or satyrs with maenads, but his other vases have a good range of myth and many scenes with women, carefully observed and varied in composition and the behaviour described. On [235] – a knee cover for wool-working – only the names reveal that the wedding preparations are for immortals, not contemporary Athenians. The Eretria Painter is something of a miniaturist and his style of drawing is more influential with successors in the florid style than that of the Shuvalov Painter, who is more economical, less passionate.

The CODRUS PAINTER [238–241] is a cup-painter of different temperament, expansive and bold in disposition of major myth on the comparatively small field offered, ready to fill insides of cups [240], careful with anatomy and posture for athletes; old-fashioned, we might judge, were it not for traits in drawing which make clear where his work is to be placed. He is strong in scenes of Athens' myth-history [238, 240]. The MARLAY PAINTER's cups, more often stemless now, a preference which will grow, are dominated by symposia, but he decorates large vases too [242, 243] and indulges the monumental, variable ground-line, compositions of predecessors. With the LID PAINTER, he allows 'textile', Saint Valentin patterns on to the outsides of some cups. The elaborate [244] is exceptional at this date, and [245] has some original ways with traditional Herakles scenes.

The tradition of the Early Classical skyphoi is maintained by the PENELOPE PAINTER, a Homerist on his name vase [247] and on another with Odysseus slaying the suitors [246]; a patriot on others with unusual scenes of Athenian cult [249] and myth-history (the building of Athens' walls by Athena and a giant [248]) rendered in a dignified style. On [249] satyrs intrude on Athenian ritual, swinging a girl, and escorting a lady, perhaps Basilinna, for her sacred marriage to Dionysos at the spring Anthesteria festival. The ERICHTHONIOS PAINTER is named for his treatment of another Athenian theme [250], and the PAINTER OF THE WURZBURG CAMEL provides an amusing envoi for this chapter [251].

The problem of definition between chapters is nowhere more acute than here. Several of the painters discussed already have moved from a Parthenonian classicism to a version of the ornate and florid styles which typify the last decades of the century (or, more accurately, in terms of Athens' history, the years of the city's decline and defeat). Beazley himself changed his mind about who to place

where, and in this book, the convenience that dictates the insertion of a separate account of white ground vases in the next chapter should not allow the reader to overlook the intimate connection of vases discussed above with painters and styles saved for Chapter Five.

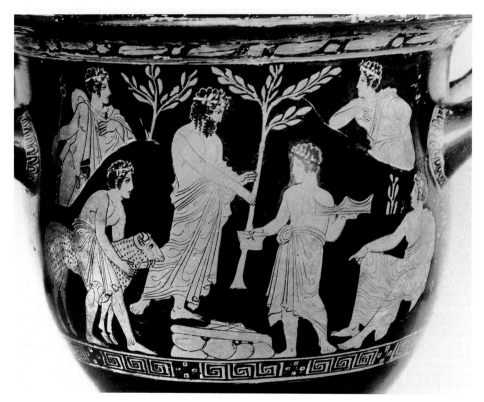

183 Bell crater near the Chrysis Painter. Sacrifice of a ram

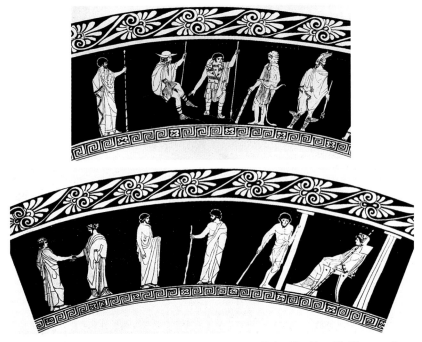

184 Calyx crater by the Nekyia Painter (name vase). Scenes in Hades: Herakles with Theseus and Peirithoos, Hades to left, Hermes to right; a youth and dead woman (chin bound up for burial), Elpenor, Ajax, Palamedes and Persephone

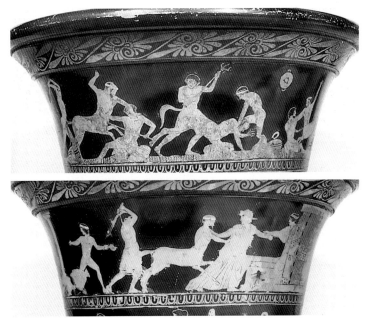

185 Calyx crater by the Nekyia Painter. Centauromachy

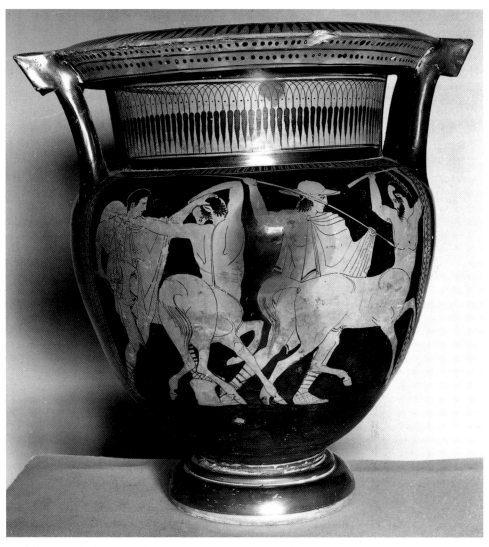

186 Column crater by the Painter of the Louvre Centauromachy (name vase). H. 43

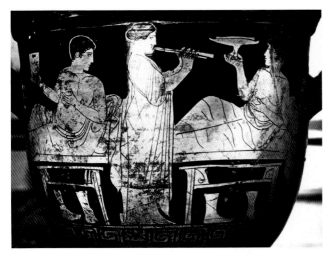

187 Bell crater by the Painter of the
Louvre Centauromachy

188 (below) Hydria by the Painter of
the Louvre Centauromachy. Landing
of Danaos, his daughters bearing gifts

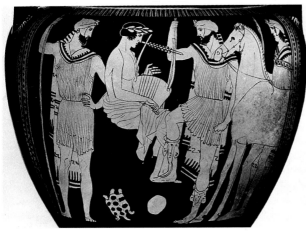

189 Column crater by the Naples
Painter. Orpheus among the Thracians

190 Pelike by the
Naples Painter

192 Column crater by the Orpheus Painter

191 Loutrophoros by the Painter of
London 1923. Wedding. H. 56

193 Hydria by
the Orpheus Painter

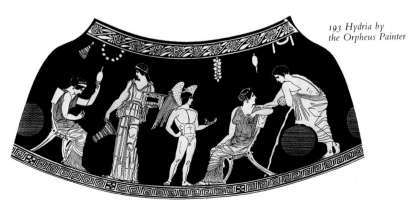

194 (above and below) Neck amphora
by the Nausicaa Painter (name vase).
Odysseus and Nausicaa

195 Neck amphora by the Nausicaa Painter

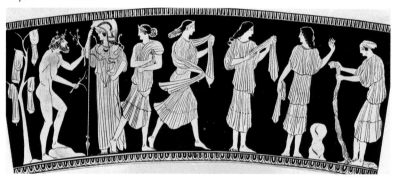

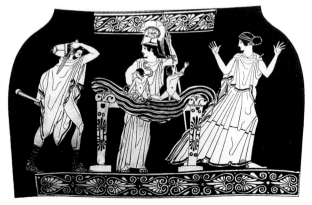

196 Hydria by the Nausicaa
Painter. Infant Herakles and
snakes, with Amphitryon,
Athena, Herakles' brother
Iphikles, and a nurse

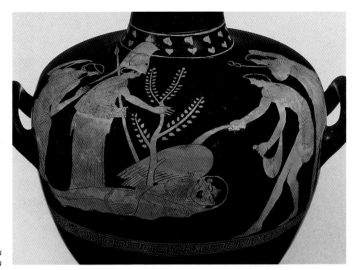

197 Hydria by the Nausicaa
Painter. Perseus and Medusa

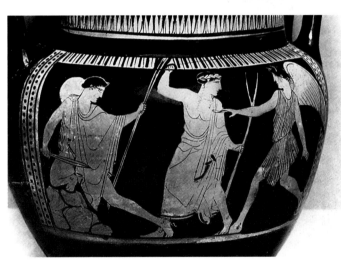

198 Column crater by the
Orestes Painter (name vase).
Orestes at Delphi with
Apollo and a Fury

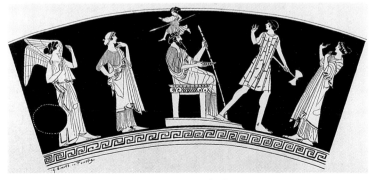

199 Pelike by the Painter of Tarquinia 707. Birth of Athena

200 Column crater by the
Hephaistos Painter. Achilles
and Ajax play

201 Column crater by the
Hephaistos Painter. Death of
Prokris

202 Column crater by the
Hephaistos Painter

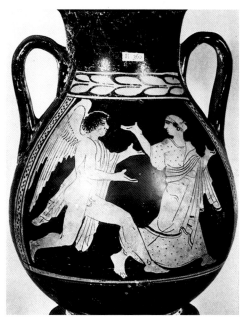

203 Pelike by the Hephaistos Painter

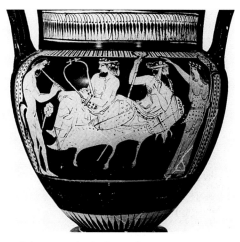

204 Column crater by the Duomo Painter

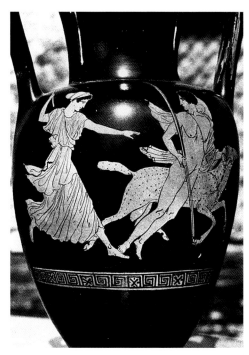

205 Neck amphora by the Painter of Munich 2335. Ino and Phrixos

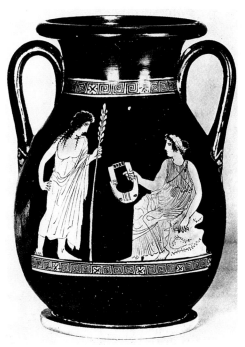

206 Pelike by the Painter of Munich 2335. Apollo, Muse. H. 23

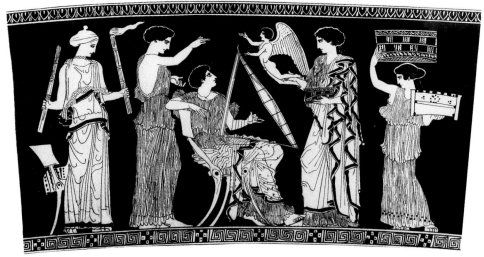

207 Lebes gamikos by the Washing Painter

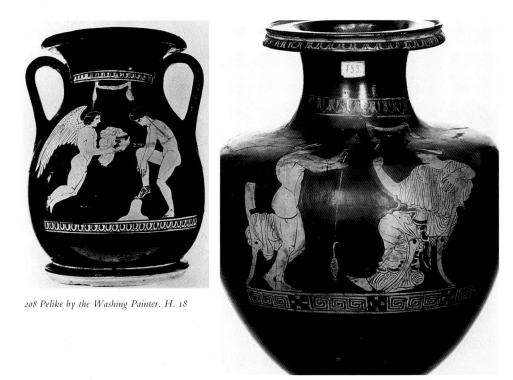

208 Pelike by the Washing Painter. H. 18

209 Hydria by the Washing Painter

210 Hydria by the Washing Painter

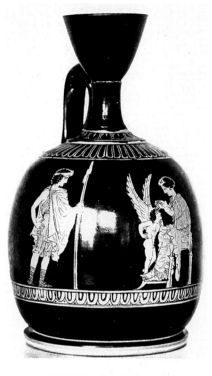

211 Squat lekythos by
the Washing Painter

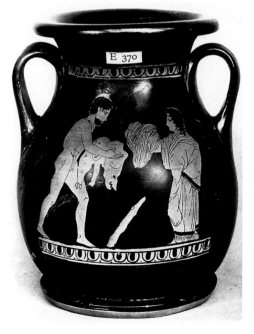

212 Pelike in the manner of the Washing Painter. Herakles
and Deianeira? H. 14.5

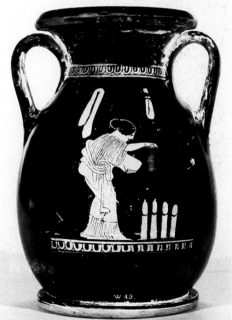

213 Pelike by the Hasselmann Painter. Woman planting
phalli. H. 17.5

215 *Lekythos by the Klugmann Painter. Winged Artemis*

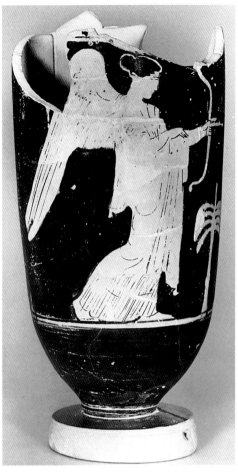

214 *(above and below) Cup by the Xenotimos Painter. In, Peirithoos. A, Leda's egg*

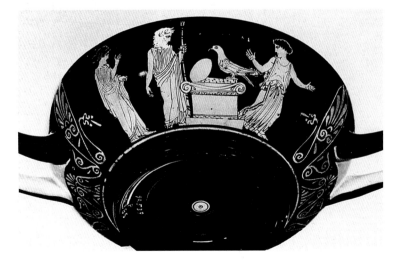

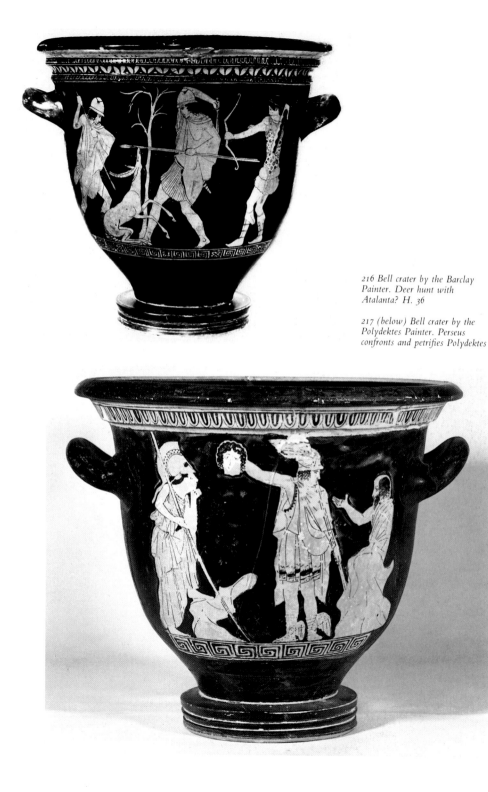

216 Bell crater by the Barclay
Painter. Deer hunt with
Atalanta? H. 36

217 (below) Bell crater by the
Polydektes Painter. Perseus
confronts and petrifies Polydektes

218 Bell crater by the Eupolis Painter. Athena leads Athanasia (Immortality) from Tydeus

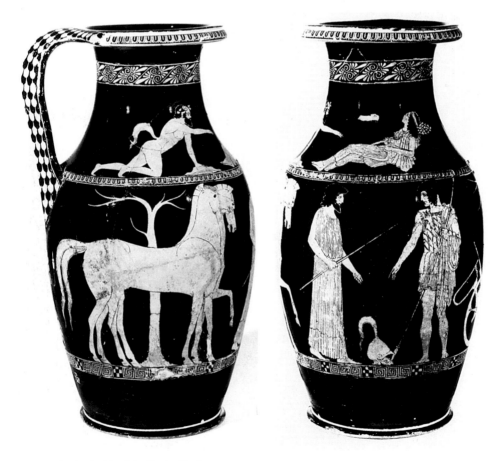

219 Oinochoe by the Mannheim Painter H. 30

220 (above and left) Oinochoe by the Mannheim Painter. Persian king. H. 19.4

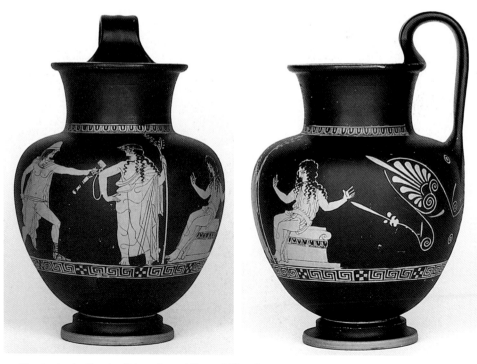

221 Oinochoe by the Shuvalov Painter. Ion and Kreousa? H. 21.8

222 Oinochoe by the Shuvalov Painter. Amazons. H. 21.5

223 Oinochoe by the Shuvalov Painter. H. 23

224 (above, left and right) Oinochoe by the Shuvalov
Painter. H. 19.5

225 (above and below) Kantharos of the Alexandre
Group. Greeks and Amazons: Phorbas and Alexandre,
Theseus and Andromache

226 (below) Oinochoe. H. 18

227 Squat lekythos. H. 10.3

228 Oinochoe, Group of the Perseus Dance (name vase).
Actor as Perseus on stage

229 Squat lekythos by the Eretria Painter. Dionysos and companions

230 (above and below left) Squat lekythos by the Eretria Painter. Amazonomachy with Theseus. H. 22.7

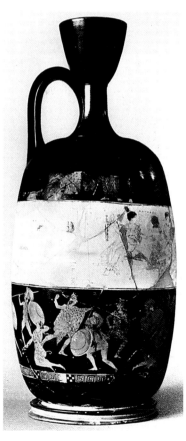

231.1 (right) Lekythos (top restored) by the Eretria Painter. In the white ground zone Nereids bring armour to Achilles mourning dead Patroklos. Below, Amazonomachy. Restored H. 49.5

231.2 Detail of 231.1

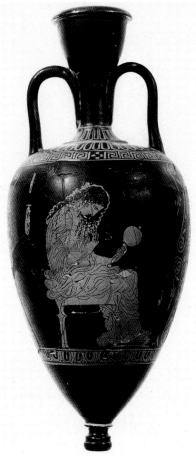

232 (right) Amphoriskos by the Eretria Painter. H. 18.3

233 (below) Oinochoe by the Eretria Painter. Women prepare Dionysos' mask in a liknon (winnowing fan)

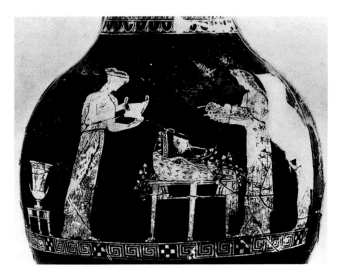

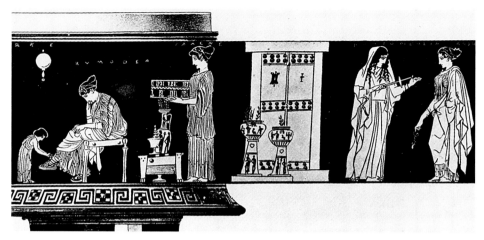

234 *Pyxis by the Eretria Painter. Preparation for wedding*

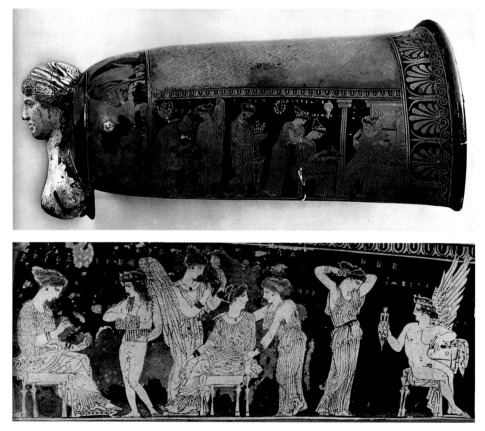

235 *Onos (epinetron) by the Eretria Painter. Preparation for weddings, Alkestis, Harmonia*

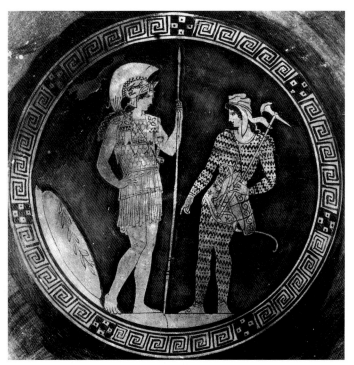

236 *Cup by the Eretria Painter.*
Amazons

237 *Cup by the Eretria Painter.*
Linos and Mousaios

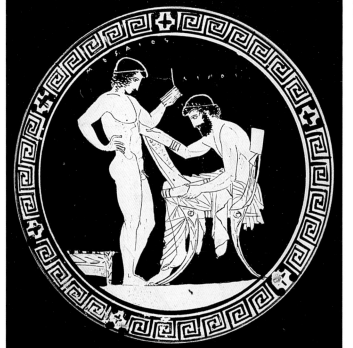

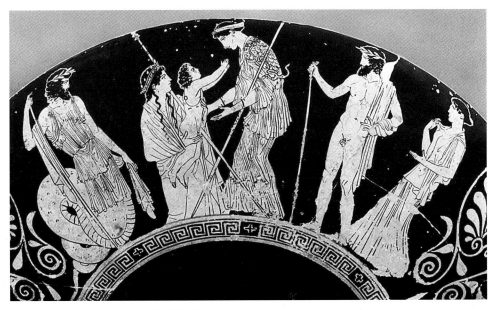

238 Cup by the Codrus Painter. Birth of Erichthonios

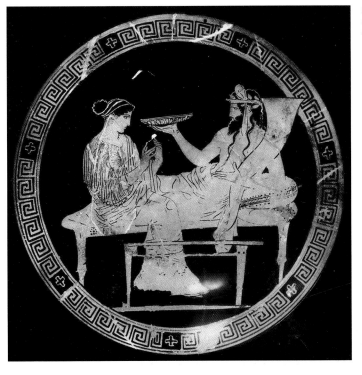

239 Cup by the Codrus
Painter. Plouton and
Persephone

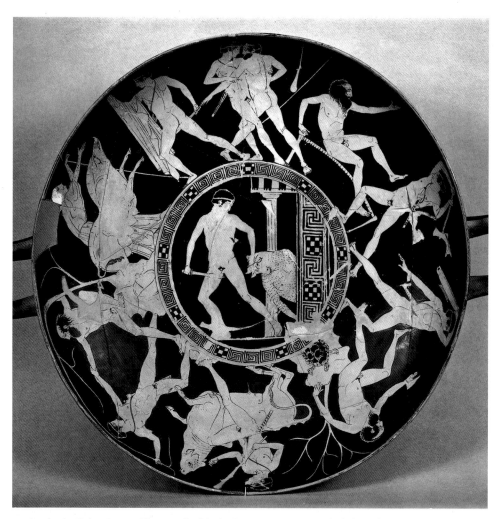

240 Cup by the Codrus Painter. *Theseus cycle of deeds: Centre, Minotaur; around, clockwise from top, Kerkyon, Prokrustes, Skiron, bull, Sinis, sow. Diam. 32.5*

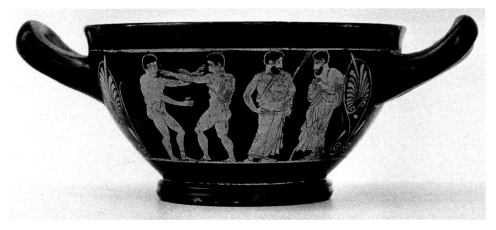

241 *Cup by the Codrus Painter. H. 8.2*

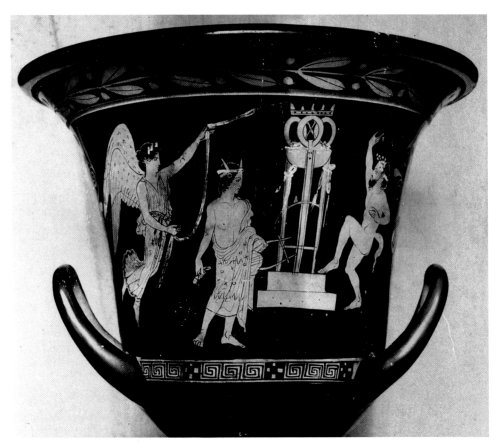

242 *Calyx crater by the Marlay Painter*

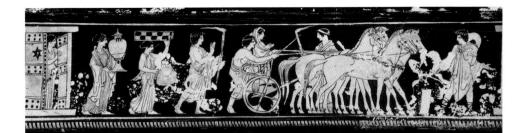

243 (above and left) Pyxis by the Marlay Painter, wedding; lid by the Lid Painter, Helios, Selene and Nyx. H. 17

244.1 Cup by the Painter of Berlin 2536

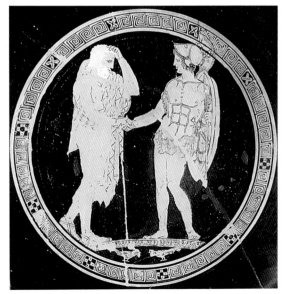

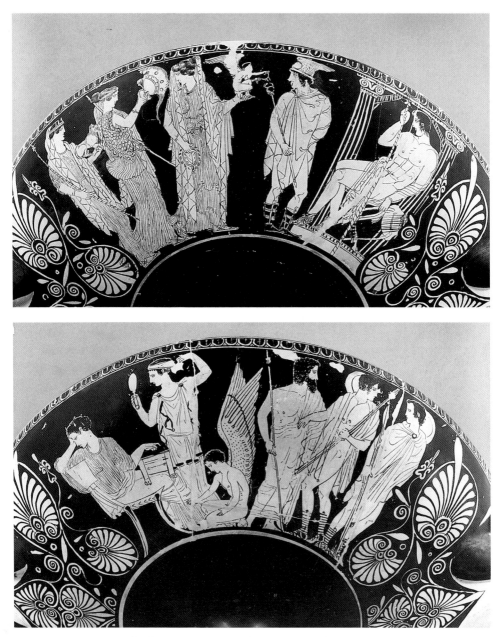

244.2, 3 Cup by the Painter of Berlin 2536. A, Judgement of Paris. B, Paris and Helen

245 *Cup by the Painter of London E 105. In, Herakles and the lion. A, Herakles and the bull*

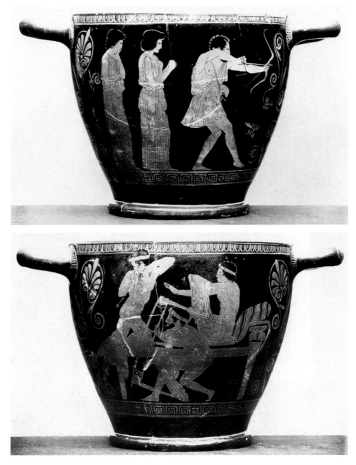

246 *Skyphos by the Penelope Painter. Odysseus slays the suitors. H. 29.5*

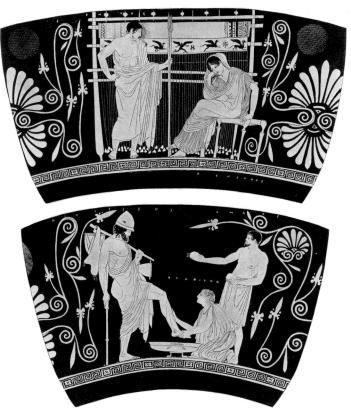

247 Skyphos by the Penelope Painter. A, Penelope and Telemachos.
B, Odysseus and his nurse, Eurykleia

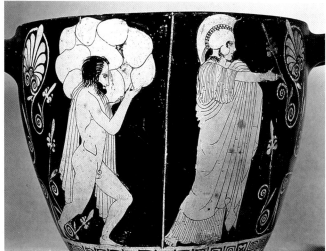

248 Skyphos by the Penelope
Painter. Athena and a giant

249 Skyphos by
the Penelope Painter.

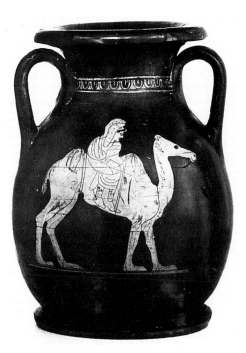

250 Pelike by the Erichthonios Painter. Athena and
Erichthonios. H. 26.5

251 Pelike by the Painter of the Würzburg Camel (name
vase). H. 15.8

Chapter Four

WHITE GROUND AND LEKYTHOI

Neither all white ground vases nor all lekythoi of the post-Archaic period are discussed in this chapter, but there is good reason for the title. In the Early Classical period the white ground technique and lekythos shape were especially associated, although there were other shapes still being decorated in white ground, notably cup interiors, and later came the big calyx craters by the Phiale Painter [*125, 126*]; see Chapter Two and the work of the Villa Giulia, Pistoxenos, and Tarquinia painters and Sotades. And in the Early Classical period most large lekythoi are still red figure, but there is already a move to make white ground lekythoi especially for burials and to decorate them appropriately. Most earlier lekythoi come from burials, of course, but we cannot be sure that they were all *made* for burials and their decoration is as that for other shapes. This is true in the Early Classical period for the work of several artists who used white ground quite freely, such as the Bowdoin, Aischines and Carlsruhe painters (Chapter Two). From the Classical period on to the end of the fifth century the technique is virtually monopolized by the shape, and after the time of the Achilles Painter, the leading Classical practitioner, the subject matter is nearly always funerary or intelligible in terms of funerary iconography, which we see also on gravestone reliefs. But the gravestones are commemorative markers, while the lekythoi record ritual at the graveside, or preparation for ritual, or the mythology of death. Virtually all examples of the funerary lekythoi come from Athens and Attica, or from Eretria in Euboea, where many Athenians had settled in the mid-fifth century. As a 'ritual' type it was not for general export and few reached other parts of Greece or Italy; we may usually suspect when they did that there was some strong and personal Athenian interest. A few places did, however, copy them.

Archaic use of white ground, for black or red figure, has been discussed elsewhere (notably *ABFH* pp. 105–6, 113–4, 147–50, 190 for the false interiors in many lekythoi, making their real capacity far less than their apparent capacity; and *ARFH* I pp. 17–18, 52–3, 61, 114, 132–3, 139, 195). Used for alabastra, the white ground imitates the stone vessels that the shape copies; on other shapes the inspiration may be different. It resembles the ground used for painted wooden panels (there are early examples of white ground clay plaques, *ARFH* I *figs.* 52–3) and in fifth-century vase-painting we perhaps come closest to the appearance of the work of muralists and panel-painters on these white vases, especially in

their use of colour, which was generally abjured in this period for the essentially bichrome red figure.

The first white ground lekythoi are decorated in silhouette black figure but later some are painted in 'semi-outline' (*ABFH fig.* 269) and a wholly outline technique soon appears too (*ARFH I fig.* 210). By this time colour washes are being added (ibid., *fig.* 107) and these remain a feature of all later work except the most pedestrian. The colours, though usually fired on (see Chapter Eleven), have often disappeared leaving a not unattractive transparent effect on drapery; this was certainly a deliberate intention on some vases, to judge by the anatomical detail beneath the colour. The lines are in the familiar gloss or 'glaze' paint of red figure but often thinned, giving a pleasing honey colour. By the Classical period the gloss paint is being replaced by matt colours for the lines, fired on but more fugitive. The greater range of other colours (some put on after firing, and many heavier, like tempera) have also proved vulnerable to time and burial (and over-enthusiastic cleaning), as has the white ground, which tends to lose its fine gloss and is often very powdery – perhaps a better base for colour. Since these vases seem to have been destined for burial or dedication after burial at the graveside they were not intended to be enjoyed by mortal eyes for long, and impermanent techniques would not have seemed objectionable.

The shape is cylindrical (so it is possible to take rolled-out photographs of the scenes, some of which are used here). It was developed by the end of the sixth century, and there are some trivial variants with tapering lower walls or plumper bodies. The 'squat lekythoi', with few exceptions, do not attract the white ground or the funerary decoration. Shoulder decoration is as that on earlier lekythoi (notably the latest black-figure) but the Early Classical period introduces a new palmette type with sparse, spindly leaves, some outlined or wash-filled, and soon to be rendered in matt colours. Some of those artists in whose work we see beginning the change from gloss to matt outlines for figures are the ones who also introduce the funerary subject matter, but the older-fashioned keep to the gloss paint outlines and use 'second white', as do the better Classical painters, to distinguish women's flesh from the background white (some black figure artists working on white ground answered the same problem in the same way). The Beldam Painter practised black- and red-figure and had introduced the false interiors to lekythoi (*ABFH* pp. 149–50, 190); the TIMOKRATES PAINTER [252] has red-figure palmettes on shoulders and uses a 'second white', as does the PAINTER OF ATHENS 1826 [253]. The SABOUROFF PAINTER [254–256] was observed in Chapter Two for his plentiful red-figure work [51, 52], mainly on cups, but most of his lekythoi are white ground (and cf. the cup [53]) and with funerary subjects, some three-quarters of them with matt outlines. Other Early Classical painters worth a mention are the INSCRIPTION PAINTER [257], who puts dot inscriptions on some of his gravestones; and the TYMBOS PAINTER [258–260], a prolific craftsman who moves from a yellowish gloss paint to a matt red generally without other colour. He is not a careful

draughtsman but shows some variety and imagination in display of tomb monuments and their decoration. His workshop is still busy through the Classical period.

This is the point at which to speak of the subject matter of the white lekythoi. When not funerary, as is still the case quite often before the mid century, subjects are repetitive, women and youths, rarely more. The funerary subjects, which are seen to the end of the century, include a few with appropriate mythical content such as Sleep and Death (Hypnos and Thanatos) removing a body [271, 275], or the ferryman of the dead, a shaggy, rustic Charon with his pole and punt [259, 268, 278, 282], receiving the dead, sometimes from Hermes (as *psychopompos*, leader of souls [255]), here in a swarm of midge-like winged souls (*eidola*, cf. [259]); the last have perhaps been denied passage over the Styx – they appear on other occasions [274] and some make mourning gestures. On [260] Hermes conjures souls into and out of a pithos. Of ordinary funeral scenes the laying-out (*prothesis*; ABFH pp. 13–14, ARFH I fig. 141) sometimes appears [256] (cf. [231] where the *prothesis* of Patroklos appears on white ground) but commonly the centrepiece is a tomb monument shown in a great variety of forms – generally a pillar (*stele*), sometimes more like an altar, or a grave-mound. This is occasionally decorated with sculpture [273] or topped by an appropriate object (cup [257], lyre [254], loutrophoros [267], etc.), and is often tied around with fillets and with offering vases standing (or broken) on its steps. Marble grave monuments only appear again in Attic cemeteries from about 430 on (GSCP p. 183) but those shown on earlier lekythoi are real enough and many must represent wooden monuments. Later stelai have acanthus ornament [276, 277, 284]. One, two or more figures stand by the grave and since at least one of them is regularly shown carrying an offering (a box or fillet) we may take this to be a visit to the tomb on one of the prescribed occasions after burial. Some figures, seated or standing, seem indifferent to the proceedings and it is natural to assume that these may represent the dead but it is suspicious that there is no uniform iconography to identify them. Many of the vases themselves were put into tombs at the time of burial, the oil having perhaps been used in the ritual; we know this because they have been found in tombs. But they must also have served as post-burial offerings, such as are depicted upon them (both the act and the objects).

More puzzling are the scenes with a tomb as background to other figures – an active warrior [277] or battle (cf. [325]), horsemen [279], hare-hunt [272]; some must allude to live behaviour (but not necessarily that of the person buried, since there are great mixtures of scenes on lekythoi from single burials; see below). Apart from a few ritual gestures of farewell or mourning there are very few really emotional scenes on the lekythoi [267]; they carry sober statements of what happened at the tomb, or what was thought to have happened. Thus, even Charon may put to shore beside a gravestone [282]. Several late scenes look very moody to us but are no more so than many contemporary stone grave reliefs.

The rather restrained, idealized, Classical Athenian style, shown on early gravestones or the Achilles Painter's vases, seems to lend an appropriate dignity to such scenes; a little later, the more florid styles probably look more charged with emotion to us than they did in antiquity.

We return to the painters, the middle of the century and the inception of the full Classical style. The ACHILLES PAINTER [261–265] is the paragon – we have seen his red-figure in Chapter Three [109–118]. Most of his white lekythoi have the old gloss paint outlines, using a 'second white', and the majority do not have funerary subjects, but quietly domestic groups, mistress and maid, a departing warrior [264, 265], even mythical such as the Muses on Helikon [262]. All but the last have subjects which seem appropriate to the tomb, and virtually all were found in tombs, but some are from Italy or elsewhere in the Greek world, and many carry *kalos* inscriptions which seem somehow inappropriate to a solemn offering, so we may harbour reservations about the funerary intent of *all* white lekythoi from the mid-century on. His pupil, the PHILALE PAINTER [266, 267], decorated white ground craters [125, 126] and a few white lekythoi, with rather more expressive figures than his master's. Many other specialists in white lekythoi of the Classical period have been identified. The PAINTER OF MUNICH 2335 [268] also worked in red-figure [215]; more dedicated to the shape and technique are the BOSANQUET PAINTER [269, 270] and the THANATOS PAINTER [271, 272], both competent artists still using mainly gloss paint outlines, and the more modest (in competence and generally in size of vessel decorated) QUADRATE PAINTER [275] and BIRD PAINTER [274], working mainly with matt paint outlines. The latter provided most of the eleven lekythoi found in a single sarcophagus at Anavysos in Attica; the variety of subjects in the group seem to reflect on the lack of deliberate choice for deposition: they include scenes at a tomb with women, or a youth and a woman, or a warrior and a woman, or Charon and a woman – indicating clearly neither a warrior's grave nor a woman's grave (the sex of the actual occupant has not been revealed).

In the later years of the century the finer lekythoi are large, all decorated in matt outlines and rich in colour. The artists betray the same new interests in drawing as their red figure contemporaries, such as (we shall see) the Meidias Painter, but their different rendering of forms, both anatomical and dress, suggest a different schooling, perhaps more directly influenced by styles on walls and panels, and with a positively sculptural air to many of them. The WOMAN PAINTER [276, 277] offers heavy, handsome figures (he is named for the beauty of his women). The REED PAINTER [278, 279] paints smaller, poorer vases, some with the reedy setting of the Styx to give him his name, but is one in a larger GROUP R(eed) which includes finer large vases, highly expressive in figure, pose and features [280–283]. Anatomical rendering anticipates the more impressionistic drawing of some fourth-century vases. Finally, there are surviving five HUGE lekythoi [284], up to a metre high, with detachable lips, painted all white and decorated in a wholly 'painterly' style of colour masses that must copy the panel-

painting of the day, with its experiments in chiaroscuro and shading, or, more directly, the painting on large marble lekythoi which have begun to appear as tomb markers in Athens' cemeteries and which the clay vases clearly copy. It is the stone vases, probably, that Aristophanes refers to in his play, *Ecclesiazusae*, of the late 390s, writing of 'the best of painters . . . the one who paints lekythoi for the dead' (lines 994–6). We do not know why the white funerary lekythoi were no longer made after about 400, but there were other clay oil-vases which could take their place as offerings, though none expressed their purpose so unambiguously in their decoration as did their white ground predecessors.

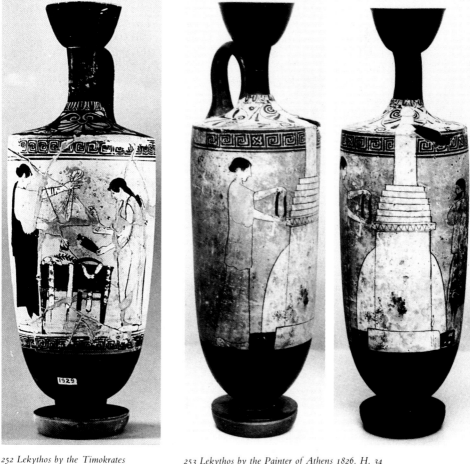

252 *Lekythos by the Timokrates Painter. H. 32*

253 *Lekythos by the Painter of Athens 1826. H. 34*

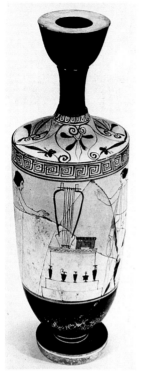

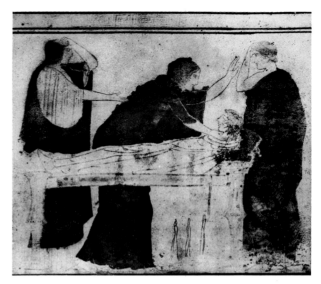

256 *Lekythos by the Sabouroff Painter. Prothesis*

254 *Lekythos by the*
Sabouroff Painter. H. 29

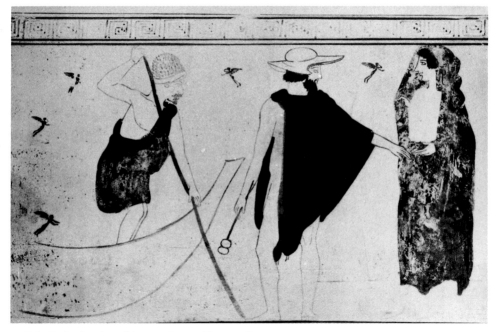

255 *Lekythos by the Sabouroff Painter. Hermes, Charon, souls*

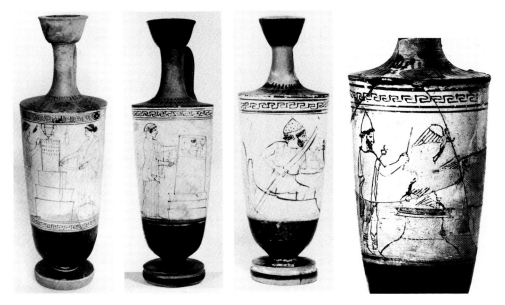

257 *Lekythos by the Inscription Painter. H. 35*

258 *Lekythos of the Tymbos Group. H. 22.2*

259 *Lekythos of the Tymbos Group. Charon and soul. H. 20.8*

260 *Lekythos of the Tymbos Group. Hermes and souls*

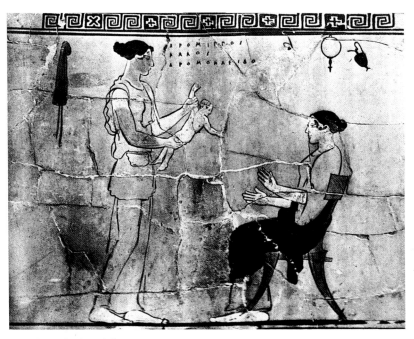

261 *Lekythos by the Achilles Painter*

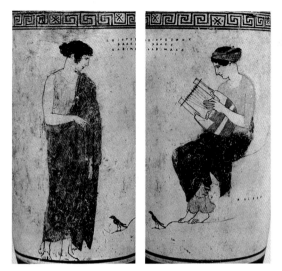

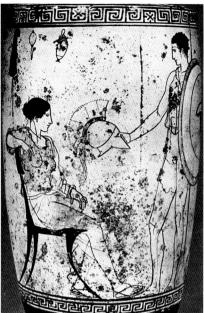

262 *Lekythos by the Achilles Painter. Muses on Helicon*

264 *Lekythos by the Achilles Painter*

263 *Lekythos by the Achilles Painter*

265 Lekythos by the Achilles Painter

266 Lekythos by the Phiale Painter. Hermes and woman

267 *Lekythos by the Phiale Painter* 268 *Lekythos by the Painter of Munich 2335. Charon*

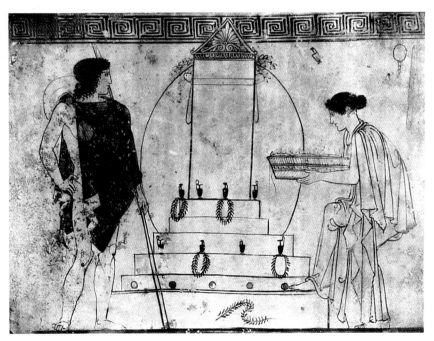

269 *Lekythos by the Bosanquet Painter*

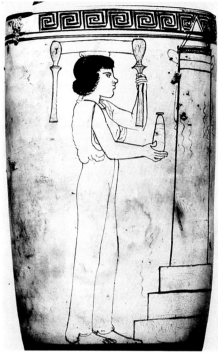

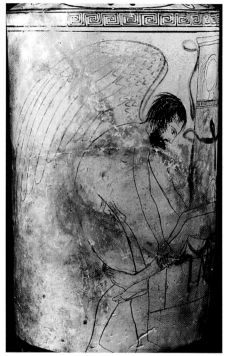

270 *Lekythos by the Bosanquet Painter*

271 *Lekythos by the Thanatos Painter. Sleep and Death*

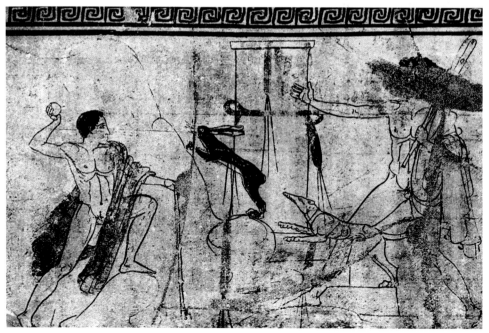

272 *Lekythos by the Thanatos Painter*

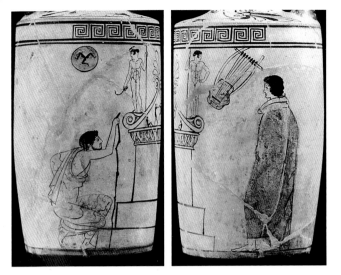

273 Lekythos near the Thanatos Painter

274 Lekythos by the Bird Painter

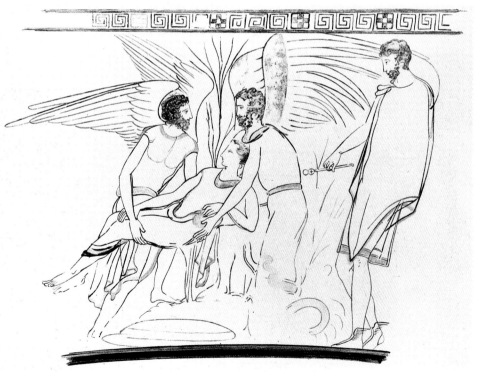

275 Lekythos by the Quadrate Painter. Sleep and Death

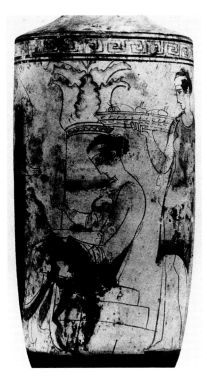

276 Lekythos by the Woman Painter

277 Lekythos in the manner of the Woman Painter

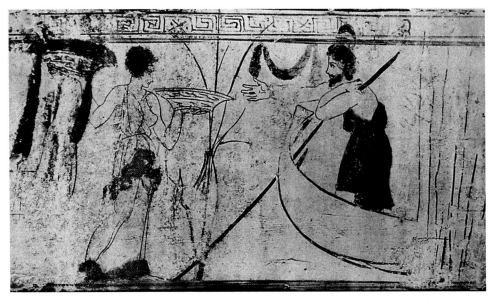

278 Lekythos by the Reed Painter. Charon

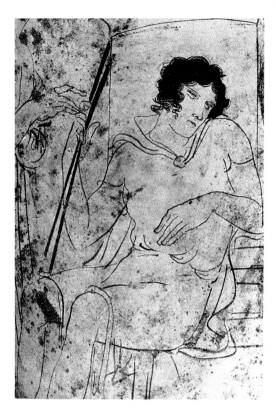

279 Lekythos by the Reed Painter

280 (right) Lekythos of Group R

281 (below) Lekythos of Group R

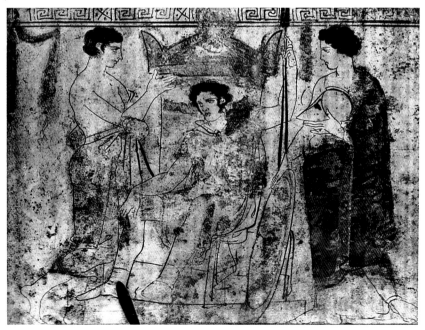

282 Lekythos of Group R. Charon

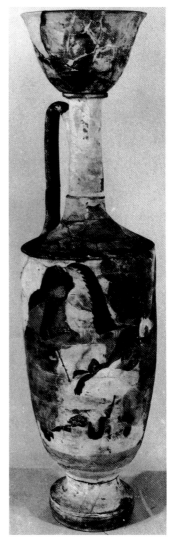

284 Huge Lekythos. H. 95

283 Lekythos fr. of Group R

Chapter Five

LATER CLASSICAL I

'Here also there's beauty: the gleam of gold, loves and ladies with soft limbs, in soft raiment, and all that is shining, easeful and luxurious: perfume, honey and roses, till the heart longs for what is fresh, pungent, and hard' (Beazley). Even the aesthete can find the mood of the Meidias Painter's vases too cloying and effete, but the 'rich' or 'ornate' style of the later fifth century has much to tell of the society which it served and which created it. The style on pottery relates easily to works in other, major media, and heralds the last phase of Attic red figure, when the craft abdicated any claims it once had to being a major art and became workmanlike, sometimes flashy, but no less informative and engaging than it had been in earlier days.

This chapter carries the story through the last quarter of the fifth century and on into the 370s. Midway, in 404, Athens acknowledged defeat in the Peloponnesian War, and thereafter relied for its reputation and standing in Greece more on memory of its imperial past than on its real power to influence affairs. The ornate style in vase-painting flourished in the years preceding Athens' defeat, a period in which the city was beleaguered by both enemies and plague. Life had never in living memory (which is what counted) been so squalid and hopeless, but on the stage the comic poets unerringly satirized the city's politicians and counsels, and some artists at least found it the time to draw the teeth from the savagery of both life and their traditional myth-inspired subject matter, to find peace and promise even in tales of slaughter, to dwell on a life style never quite known or enjoyed on earth, but surely earnestly dreamed of in a city whose gleaming new marble temples were simply a reminder of a glory which had so soon passed. After defeat, the chastened Athens and the declining craft of vase-painting dictated a more sober and less ambitious approach by the painters to their work, though some were capable still of producing master-pieces, and after the 380s an ornate style lingers and even flourishes again for a spell to lighten the last days of figure-drawing on Athenian vases (our next chapter). Here, we have first to characterize the ornate style of the later fifth century, then look at the work of the Meidias Painter and his circle, at some artists who in the same period keep to sturdier, older styles, then at the succession into the fourth century.

The up/down compositions of the Classical muralists grace the finer vases, the

144

figures usually disposed in registers although there are a few distinguished examples of more flowing and well-knit compositions than we have seen hitherto [287, 294]. It is unlikely that this manner was still favoured by major painters and, to judge from descriptions of their work, they were now concerned with more unified panel compositions on which they deployed new skills in shading, chiaroscuro and perspective. Here the vase-painter could not easily follow, but the Polygnotan murals were there still to be admired and the vase-painters had evolved their own tradition of dealing with scenes in a comparable manner.

In individual figures the Archaic and Classical pattern of linear contrast created by the use of intense relief lines beside paler detail lines is largely lost in the simpler line drawing which is never as emphatic, and which is varied mainly by a new interest in pattern on dress and bolder use of added colour and gilding. Anatomy is sketched rather than sharply defined. The lines are often short and seem hurried, yet they succeed in imparting a new sense of rotundity, and the manner of drawing comes very close to the effect achieved by relief sculpture of the day. Depiction of pose, relaxed or active, is accomplished and convincing, even in the hands of the poorer artists, and limbs are realistically foreshortened; three-quarter and frontal features remain exceptional but posing no real problems of delineation. This is a manner of drawing in which the strictly profile view for figures is bound still to be preferred. Hair is now shown in separate strands, washed over, and not as a black mass except on the poorest works or on the lay figures that decorate the backs of many vases. On dress, close-set lines are placed to emphasize the contours of the forms beneath; the lines may not be realistic but the sweeping arcs across a thigh or arm very well convey form in the manner that we recognize readily in sculpture, notably in the pediments of the Parthenon (of the 430s; GSCP figs. 79, 80), and the 'transparent' effect of this technique is echoed too on later relief sculpture, such as the balustrade to the Nike Temple on the Acropolis (of the 410s; ibid., fig. 130). Pattern on dress is largely a matter of broad hems of rays or hooks, sometimes spreading over the whole garment with stars and flowers; this is most often seen on post-Meidian works, into the fourth century. Stripes of wash on the folds may hint at shadow, but are rare. Gilt relief detail becomes increasingly common on the more elaborate vases, for items of furniture, wreaths, wings, jewellery. The Classical period had begun to use white on figures of women or Eros and the practice grows, embracing horses and furniture, lending the scenes a rather garish, pseudo-polychrome appearance, probably the nearest the painter could get to the variety and colour of the panel-painters. The Meidian vases are, however, modest in their use of these embellishments. Later, even more colour can be admitted, notably yellow, or yellow streaked over with brown, blue and pink. White ground vases (last chapter) enjoy an even broader palette until the end of the century. Of shapes, the bell crater comes to gain ascendancy over other forms of crater, but all classes continue to be made, the variety dwindling in the

fourth century. The hydria now becomes a carrier of major free-field compositions. The squat lekythos and stemless cup begin to take over from the tall lekythos and the footed cup (kylix) and there is a proliferation of minor pelikai, pyxides, oinochoai and dishes. Inscriptions appear often on Meidian vases, far less in later years until they become exceptional.

The MEIDIAS PAINTER is named for the potter whose signature appears on his most famous vase [287]. He uses the hydria for all-over compositions, usually mitigated by having a body frieze, but barely a score of vases altogether are attributed to him. This is likely to be a severe underestimate of what has survived and many others from his hand must lurk among those recognized to be in his manner. There is a ballet-like posturing to many of his figures but they are gracefully composed and he avoids the impression of offering a paste-up of disparate figures and groups, which is given by most multi-figure scenes on red figure vases. The manner of drawing had been heralded by the Eretria Painter

[229–237], and was itself an echo of sculptural forms, as we have seen, but the mood is new and it is foreign to both the vigour and the composure of the Classical models. Where there is bustle and excitement, as on [287], it is controlled and rather stagy. The initial impression of his work is unappealing to modern eyes, but familiarity with it wins respect for qualities barely matched by his contemporaries or successors. Notice the parade-ground precision of his pattern work in frieze dividers; this remains the hallmark of the best painting for another generation.

The work of two other artists, whose true names are known, has been claimed (by different scholars, of course) for the master himself. ARISTOPHANES, namesake and contemporary of the comic poet, signs two cups made for him by Erginos [289, 290] and another vase with no potter-signature. One of the cups reached Tarquinia with a near-replica from his hand, unsigned [291]: it is interesting to observe how like and unlike such rare 'replicas' can be. Another near-replica of the cup's interior (omitting Herakles) seems probably by the Meidias Painter, and on them all the style of drawing is certainly close to the master. The mood, however, is quite different, in vigorous and committed scenes of battle, more truly monumental than the Meidian and in a way backward-looking. But this can hardly be the young Meidias Painter, whose style and subject interest stems from a different tradition. This style, it seems, can

serve a variety of moods, but probably not all expressed by the same artist. AISON [*292, 293*] too has been taken for the young, Classical, Meidias Painter. He signs a cup devoted to the Theseus cycle [*292*], an old subject and treated in a more thoroughly Classical manner than the Meidian. The groups on his squat lekythos [*293*] come as close to those on the Parthenos shield (*GSCP fig.* 110) as any on vase-painting, but are still relatively distant and do not reproduce the most distinctive and innovative of the relief groups on the shield. The drawing might easily be seen as incipient Meidian, but the artist, as defined by Beazley, runs off into a dejected series of small pelikai with athletes which are incompatible with such a distinguished identity. If either of these artists was the young master, he suffered a dramatic change of heart in his early career.

Within the Meidian circle various individual artists can be recognized, and the range of subject offered in the distinctive style often wanders into themes with more monumental and old-fashioned associations than those of the master. 'Laboured copies' is Beazley's rather unkind view of the PAINTER OF THE CARLSRUHE PARIS [*294*] whose name vase presents the old theme in new dress, with an orientalized Paris, a statuesque Athena, Helios rising right in a group reminiscent of a recurrent theme on the Parthenon (*GSCP fig.* 78 a–c), and an assortment of personifications, some of immediate relevance to the story such as Eris (Strife), the Bad Fairy who provoked the contest between the goddesses, and some of less relevance such as Eutychia (Good Luck). Zeus, bearing the ultimate responsibility for events, also attends, top left. Other large vases, as the name vase of the PAINTER OF THE ATHENS WEDDING [*295*], are pedestrian in their two-register use of the field, but his big, lugged bell crater [*296*] of an unusual swelling shape, is grander and gives us another Sunrise over a Judgement of Paris. There are many graceful small vases, like the little acorn lekythos [*297*] made by a potter who calls himself Phintias the Athenian (recalling, to us at least, that Archaic Phintias who made cockleshell vases; *ARFH* I p. 35), or pyxides and squat lekythoi, which seem well suited to the delicacy of the style and attract the boudoir subjects which it expresses so well. We observe now the growing interest in added detail of gilt relief or white, and a certain floridity in background ornament, although the basic framing patterns, the maeanders and squares and palmette bands, are unaltered in all but execution from what had proved acceptable on such shapes for nearly a century. This is still a period for surprises in subject matter if not style: many personifications [*301, 304, 305*], a gory view of Oedipus and the Sphinx [*303*], baby Asklepios, a new god for Athens [*305*].

The alternative mood in late fifth-century vase-painting stems from the Polygnotan Group and its master, via the Kleophon and Dinos Painters [*171–182*]: more robust, virile, monumental in aspiration, but not destined for a comparably distinguished following. The spirit is expressed in the somewhat inappropriate Meidian style of drawing by Aristophanes and Aison, as we have seen.

285 (above and below) Hydria by the Meidias Painter. Aphrodite with Adonis

286 Hydria by the Meidias Painter. Aphrodite's chariot

287 (right and below) Hydria by the Meidias Painter. Rape
of the Leucippids. Below, Herakles and Hesperides. H. 52.1

288 Oinochoe by the Meidias Painter. Women air clothes

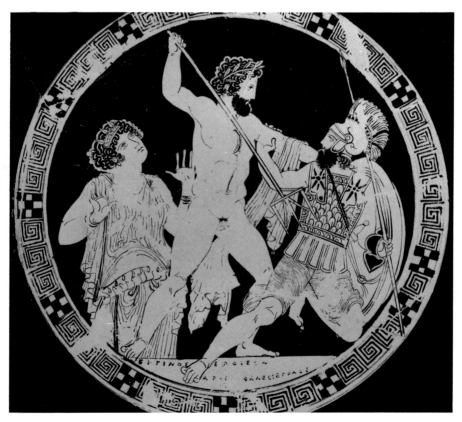

289.1 Cup by Aristophanes. Gigantomachy. In, Poseidon, giant and mother of giants, Ge

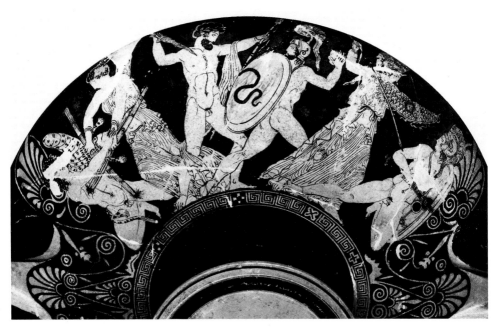

289.2 Exterior of 289.1. Artemis, Zeus and Athena attack giants

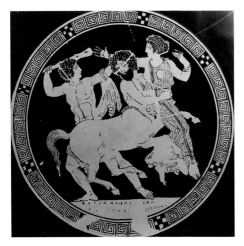

290 Cup by Aristophanes. Herakles and Nessos

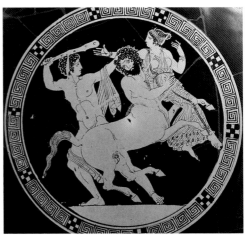

291.1 Cup by Aristophanes. Herakles and Nessos

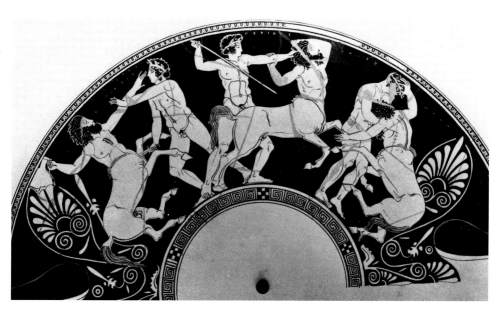

291.2 Exterior of 291.1. Centauromachy

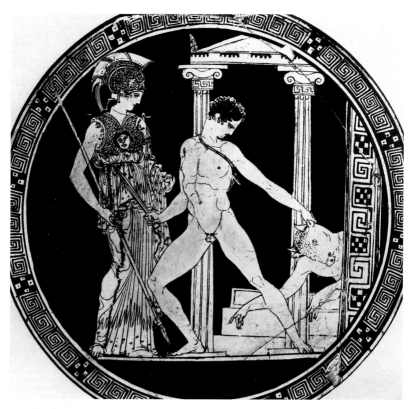

292.1 Cup by Aison. Theseus and Minotaur

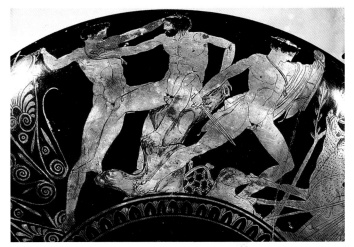

292.2 Exterior of 292.1.
Theseus and Skiron

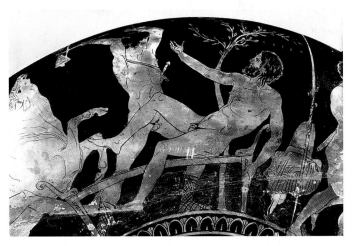

292.3 Theseus and Prokrustes

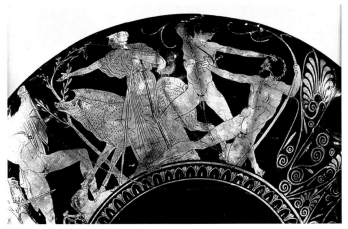

292.4 Theseus and sow, Sinis

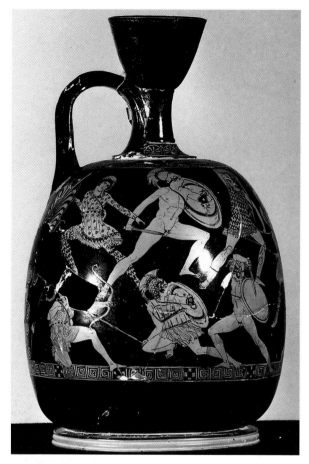

293 (left and below)
Squat lekythos by Aison.
Amazonomachy. H. 18.5

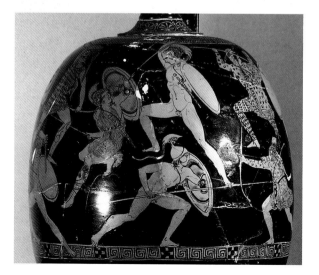

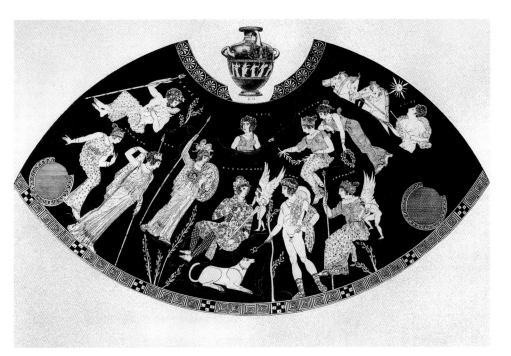

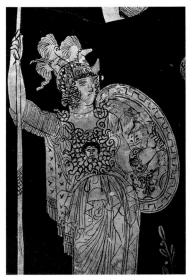

294 Hydria by the Painter of the Carlsruhe Paris.
Judgement of Paris

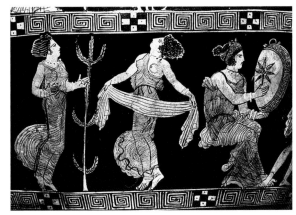

295 Calyx crater by the Painter of the Athens Wedding (name vase)

297 Acorn lekythos by the Painter of the Frankfurt Lekythos (name vase). H. 22.5

296 Bell crater near the Painter of the Athens Wedding. Judgement of Paris

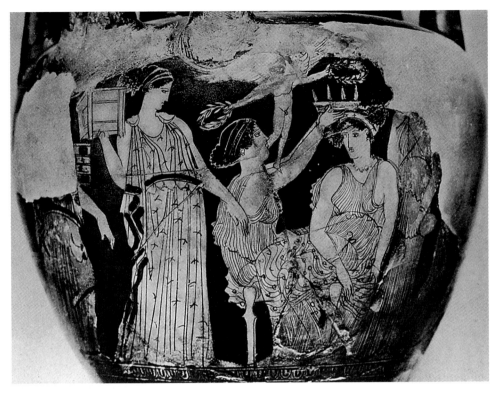

298 Lebes gamikos by the Painter of Athens 1454 (name vase)

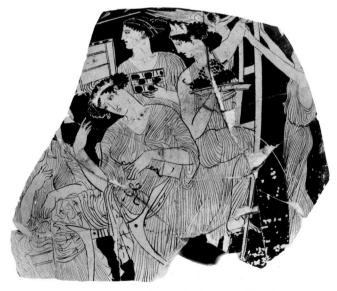

299 Lebes gamikos fr. by the Painter of Athens 1454. Wine festival?

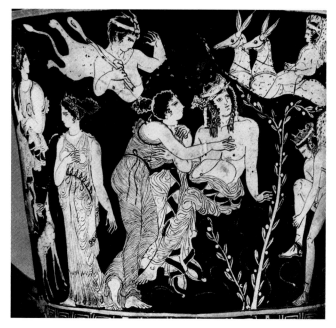

300 Calyx crater in the manner of the Meidias
Painter. Aphrodite and Phaon

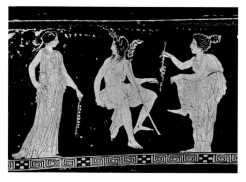

301 Oinochoe in the manner of the Meidias Painter.
Apollo, Eukleia, Eunomia

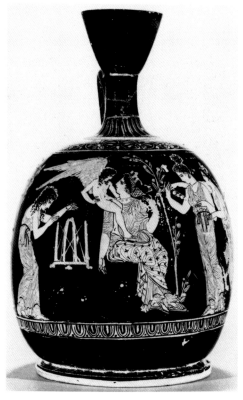

302 Squat lekythos in the manner of the
Meidias Painter. H. 19.5

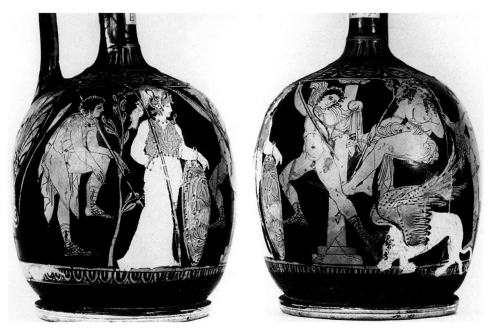

303 *Squat lekythos in the manner of the Meidias Painter. Oidipus kills the sphinx*

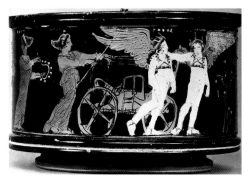

304 *Pyxis in the manner of the Meidias Painter.*
Aphrodite's chariot drawn by Pothos and Hedylogos
(Desire and Sweet-talk). H. 8.5

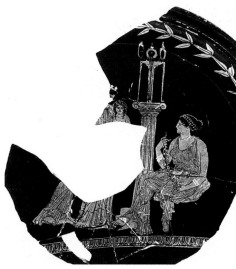

305 *Plate in the manner of the Meidias Painter. Infant*
Asklepios held by Epidauros, Eudaimonia. Diam. 20.8

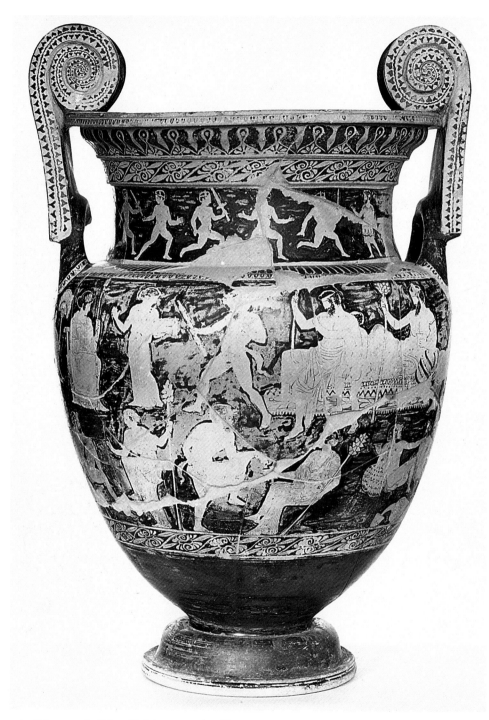

306.1 Volute crater by Polion. Hephaistos returned to Olympus

306.2 Detail of 306.1. Hera

307 Oinochoe by Polion

308 Amphoriskos by the Heimarmene Painter.
Helen (on Aphrodite's lap) and Paris

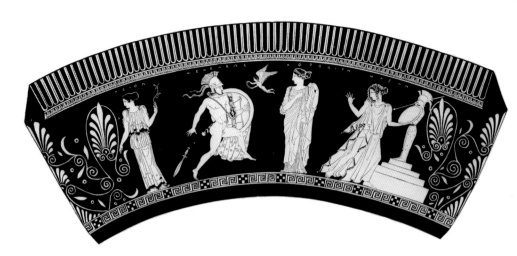

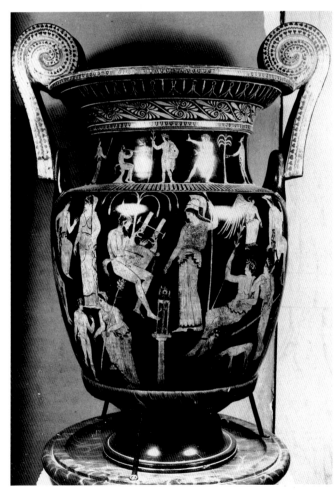

309 (above) Oinochoe connected with
the Heimarmene Painter. Menelaos
threatens Helen, with Aphrodite,
Eros, Peitho (left)

310 Volute crater by the Kadmos
Painter. Apollo and Marsyas (neck
and body of vase). H. 59.8

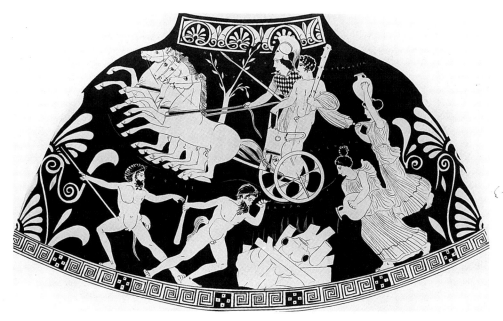

311 Pelike by the Kadmos Painter. Herakles rises from his funeral pyre

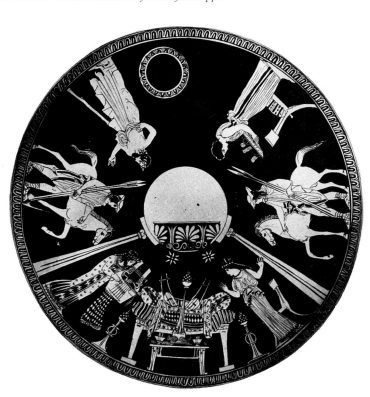

312 Hydria by the Kadmos Painter. Theoxenia for Dioskouroi

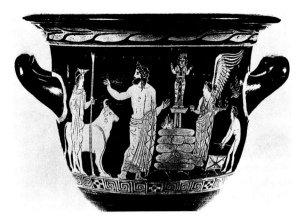

313 Bell crater by an imitator of the Kadmos Painter. Herakles sacrifices to Chryse

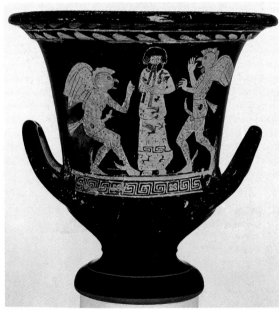

314 Calyx crater. Cocks chorus

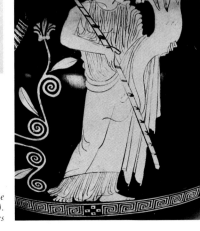

315 (right, above and below) Hydria by the Painter of London E 183 (name vase). Triptolemos and Hades

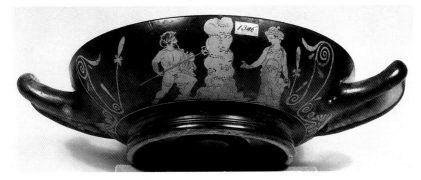

316 Cup by the Painter of Ruvo 1346. Poseidon and Amymone

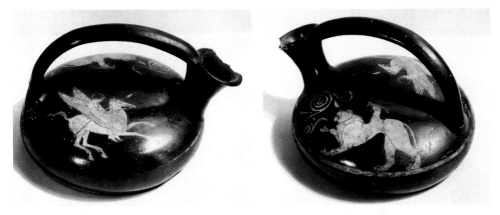

317 Askos. Bellerophon and the chimaera

318 Skyphos. Themis and Bendis. H. 17.5

319 Bell crater by the Nikias Painter. End of a torch race

320 Calyx crater by the Nikias Painter

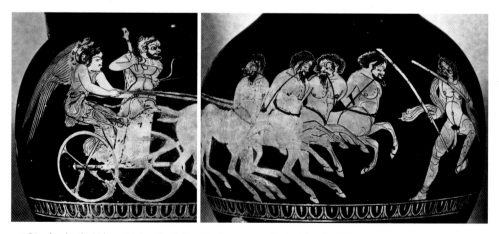

321 Oinochoe by the Nikias Painter. Comic Herakles in a centaur chariot driven by Nike

The Dinos Painter himself probably worked well into the last quarter of the century. POLION is an artist capable of both narrative imagination [306] and grace [307], Classical, yet advanced in his drawing style. He offers a new view of Hephaistos' return to Olympus, the drunken god dragging himself from his drinking with Dionysos towards Hera, imprisoned on her magic throne, fanned by a siren [306]. There is much of the pure Classical still in the work of these painters. The HEIMARMENE PAINTER ([308] and perhaps [309]) dwells on the Helen story, and the figure of Peitho rejected, on the left of [309], is a nice if naive way of saying that in the reconciliation of Helen and Menelaos it is Aphrodite, the sex-goddess, not Peitho (Persuasion) that is decisive. The KADMOS PAINTER [310–312] offers a good range of myth scenes on large vases, including hydriai, some composed up and down the field. But his figures are relatively stiff and second-rate. He shows a remarkable interest in the Marsyas story [310]. The inscriptions, presumably from his own hand, betray several doricisms, which may tell something about the painter's upbringing if not his style of drawing. The extraordinary vase which inevitably evokes Aristophanes' *Birds* (produced in 414) belongs near the end of the century, it seems, though the drawing is old-fashioned [314], perhaps provincial.

It is on vases of this tradition that we see more cult and specifically Athenian, patriotic themes. They contribute much to the subject matter of vases from painters whose careers run on into the fourth century, but whose style owes rather more to the Meidian. Their works lack the subtlety of composition and execution apparent in the Meidias Painter but they offer much of absorbing interest for the student of Greek myth, cult and the theatre, and some scenes have a grandeur which overcomes the rather casual manner in which the figures are drawn and ornamented. It may well be that the more run-of-the-mill panel paintings of the day resemble their works, but they are far from the achievements of those major painters, Parrhasios or Zeuxis, who were creating a new tradition which was to determine the course of their art for centuries to come.

The NIKIAS PAINTER [319–322] is named for the potter who signs himself Nikias, son of Hermokles, citizen of Anaphlystos (an Attic district) and this home-pride is answered by many of the painter's scenes, sacrifices, local cult and myth, executed in a competent, fairly non-fussy style, and with a touch of what we, and probably the fifth-century Athenian, would regard as humour [321]. The PRONOMOS and TALOS PAINTERS [323–325] are more ambitious artists. The name-vase of the former [323] sets an Athenian theatrical scene, with actors and satyr-players, the Boeotian guest-piper Pronomos, and Dionysos with Ariadne in the audience: an impressive display both for its antiquarian detail and for the way it seems to display a playbill of the type to become more familiar from South Italian (Apulian) vases of the fourth century (*RFSIS* p. 12, Chapter 4). It is composed in two registers and the dress of the figures displays in a rather exaggerated form the new interest in pattern; there is lavish use of added white

and colour in the picture, as also on the faces of the handles, while the palmettes and leaf-and-dart pattern on the neck show how far away are the flowing floral bands of a century before. The Talos Painter's name vase ([324], and he repeats the theme) uses the variable ground-line and, with its wealth of narrative detail and furniture, must come close to some major treatment of this strange episode on the Argonauts' expedition (a theme itself for a mural of the Polygnotan period, by Mikon). The women's dress is Meidian, the additional pattern as that of the Pronomos vase, and the white and brown on Talos' body a good attempt to match the fuller palette of the muralist in depicting the expiring, brazen giant. We may easily imagine such a figure as the centrepiece of a panel painting, whether or not the scene was further developed in a frieze.

Earlier major up/down compositions on vases had avoided the subject of Gigantomachy, but there is a new interest in it now, perhaps encouraged by a major work. The painting within the shield of the Athena Parthenos is often cited in this context, and the composition of the scene on a fragment in Naples [327], by a painter close to those just mentioned (if not one of them), might seem to justify the suggestion, though it is hard to see how such a composition could have been deployed within a shield mainly occupied by a coiled snake (GSCP fig. 106, cf. 108). Giants in the lower segment storm an Olympian heaven, with Helios rising in his chariot. A fine up/down composition for this subject appears on a pelike by the Pronomos Painter, but the best is seen on a large neck-amphora [329] by the SUESSULA PAINTER, of which free replicas appear on fragments of a volute [330] and calyx crater by other, more careful artists. The new freedom of posture and details of shading suggest a later source of inspiration than the murals which are thought to lie behind the earlier Amazonomachies and Centauromachies. Or is it that vase-painters are now given more to close imitation of each other's work? If so, there was a master-designer behind these vases. The neck-amphora is an unexpected shape for such a frieze, and others by the Suessula Painter are more modestly composed.

The MIKION PAINTER (his name may be EUEMPOROS) offers a free version of a Parthenon subject, Athena fighting Poseidon, on a vase dedicated on the Acropolis [331]. (That it does not copy the pediment group – GSCP fig. 77 – says something about painters' ability or readiness to copy from major sculpture.) The berserk Lycurgus [332] is in a related style. The SEMELE PAINTER's name vase [333] has Hermes bearing the premature baby Dionysos from his mother Semele, blitzed by Zeus (the thunderbolt is overhead). The KEKROPS PAINTER is a trivial follower of the Kadmos Painter, with some Attic scenes [334].

We turn now to painters whose style and subjects clearly derive from those just discussed, and whose work belongs wholly within the first third of the fourth century. At their head is the MELEAGER PAINTER [335–338], who decorates a wider range of shapes than most, including cups and stemlesses (dumpy cups that derive from the deeper skyphoi of the fifth century rather than the more graceful 'kylikes'). He takes his name from a number of vases with quiet groups

of hunters which include a woman, Atalanta, therefore with her lover Meleager [336]. His column and bell craters are mainly devoted to Dionysiac scenes and he shares a fondness for figures in oriental dress with several of his contemporaries. His cup interiors, in common with the best of other painters in these years, have their figure-decorated tondi bordered by a painted wreath. A common subject for his and his successors' tondi is single-figure studies of gods or divine groups. Outside his cups, and on the backs of vases, the figures are generally very poor and his best work is barely more than competent. Far better was the less prolific PAINTER OF THE NEW YORK CENTAUROMACHY who has left fragments of two monumental volute craters with some claim to narrative energy [339], and the XENOPHANTOS PAINTER, whose potter (Xenophantos) signs himself 'Athenian' on a large squat lekythos, with oriental and other subjects rendered mainly in low relief [340]. Relief figures like these have been met intermittently before (e.g., ARFH I figs. 100, 103); whole scenes must be inspired by relief metalwork and these become slightly commoner hereafter although painting will remain the dominant technique of decoration for another half century.

The work of other painters of craters in these years ranges from the slovenly to the abysmal with a few individuals of note more for their subjects than their style: the TELOS PAINTER [341], with Dionysiac and symposion scenes on bell craters, now admitting white even for adult males; the PAINTER OF THE OXFORD GRYPOMACHY [342] introducing what is to be a popular fourth-century subject with a fashionable 'oriental' twist – the griffin-fights of the frozen north; the RETORTED PAINTER [343] with the inside-out eyes of some of his plain figures, and the BLACK THYRSUS PAINTER [344], explained by his name. The IPHIGENEIA and OINOMAOS PAINTERS are memorable for their name vases [350, 351] and there is a mass of plain work mainly on bell craters. 'Court' scenes of a god or hero, Dionysos on [344, 347], Herakles on [346, 353], with attendants or other deities and heroes, satyrs and maenads, placed up and down around them, begin to be very popular now and might be inspired by painted votive panels. They present single-focus up/down compositions, unlike the free-ranging battle friezes of earlier years.

The JENA PAINTER [358–362] is the dominant decorator of cups in the early fourth century. Most of his work is known from a single find of fragments in what must have been a shop in or near the Athenian potters' quarter (modern Hermes St.). His tondi are often painted within ivy wreaths but a feature of the period is the decoration of black cup interiors with stamped patterns of ovules, palmettes and the like, in imitation of metalwork (this mainly on stemlesses, not ordinary cups). The outsides of his cups are very poorly decorated, not always certainly by the same hand, and it is clear that he was the mainstay of a large workshop producing generally low-quality vessels. The painter himself, however, could draw well and offers interesting subjects and figures to offset the dreary hordes of youths, women, satyrs and maenads that people most of the cups. A companion, perhaps the same artist, is the DIOMED PAINTER [363]; and the

Q PAINTER [366–368] is the only other distinguishable cup-painter of note in these years.

Throughout the long period surveyed in this chapter there was a brisk production of more trivial figure-decorated vases. Nolan amphorae and a variety of oinochoe shapes do not maintain the standard of decoration of their predecessors. An odd phenomenon of the end of the century is the class of 'Panathenaic oinochoai', their bodies like slim neck-amphorae, with Athena's chariot on the body and sometimes with the goddess on the neck too. There is also an entertaining crop of small oinochoai (*choes*) at the end of the fifth century, largely devoted to scenes of children at play or acting adult ritual [369, 370]. These may have been an unusual concession to the market for children's toys, but they were probably at the same time gifts for children to commemorate the Anthesteria spring festival and its drinking matches. The festival (though not the boozing) was one in which even three-year-olds could take part. The choes found in the graves of the very young (surely the first victims of the recurrent plagues that swept Athens) may recall their early participation in the festivities. These are mainly for the local market, but some of the lesser shapes were popular overseas. Squat lekythoi proliferate, decorated with heads or whole figures of women, and these persist into the fourth century, more often with animal subjects. A batch sent to Al Mina gives a name to one of their painters. Spina, in the north Adriatic, collected many of the poorer oinochoai and seems almost to monopolize our knowledge of stemmed plates, with heads, busts or an occasional full figure within a maeander or floral border. A comparatively new shape, the fish-plate [371], has a more prolific and colourful record as a decorated vessel in South Italy (*RFSIS* pp. 162, 169, *figs.* 207, 394). It is commoner in plain black but, when decorated, fish are the almost invariable subject and this must give some indication of its use (dried fish and a 'dip'?). The last of the red-figure cylindrical lekythoi carry women or Nikai, and some even have stele scenes like their white-ground kin. The poorer cups magnify the daubed tondo borders, or make do with impressed decoration, while exteriors carry dull lay figures, if anything.

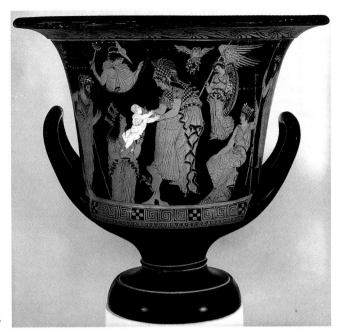

322 Calyx crater.
Birth of Erichthonios.
H. 37.7

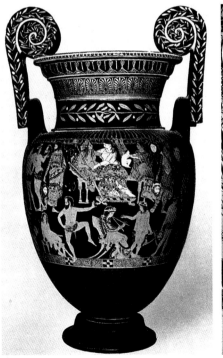

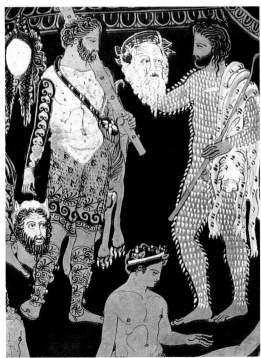

323 Volute crater by the Pronomos Painter (name vase). Dionysos attends a gathering of satyr players and actors, including a Herakles and the Theban piper, Pronomos. H. 75

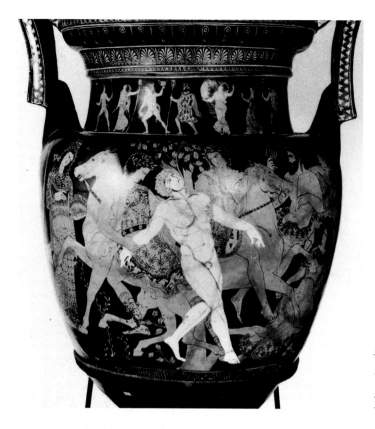

324.1 Volute crater by the
Talos Painter (name vase).
Death of Talos

324.2, 3 (below) Details of
324.1 Medea; Talos

325 Loutrophoros by the Talos Painter. Fight before tombs

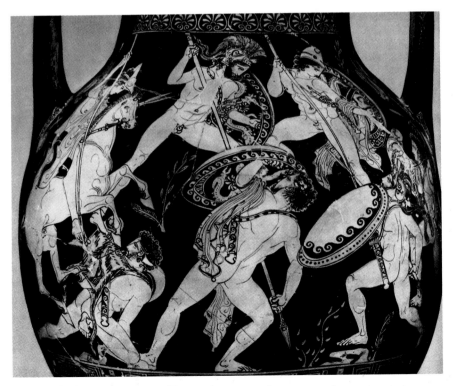

326 Pelike near the Pronomos Painter. Gigantomachy

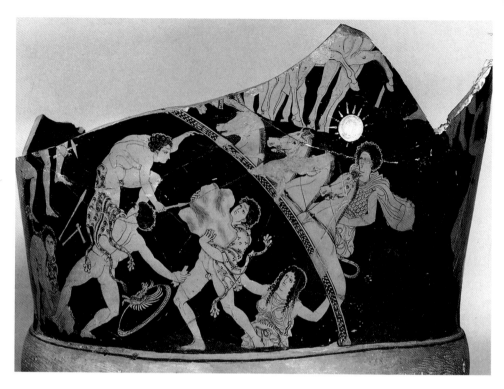

327 (above) Calyx crater fr. near the Pronomos Painter. Gigantomachy

328 Plate fr. near the Pronomos Painter

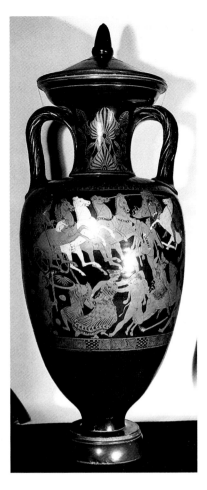

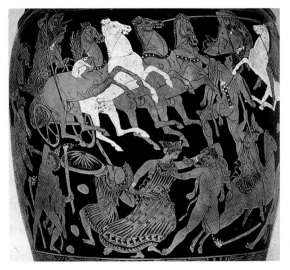

329.1, 2, 3 Neck amphora by the Suessula Painter.
Gigantomachy

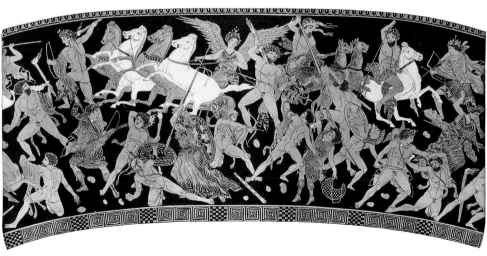

330 Volute crater fr. Gigantomachy

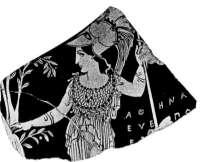

*331 Lekanis fr. by
the Mikion Painter.
Athena (and Poseidon)*

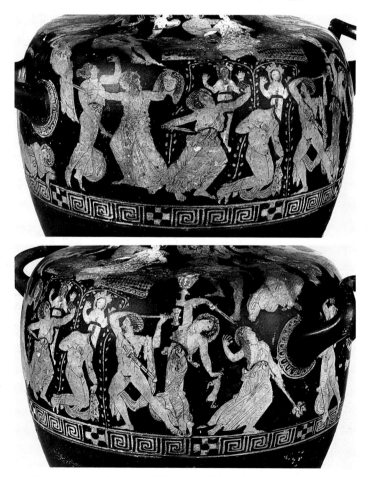

*332 Hydria. Madness of Lycurgus (killing his family) watched by Dionysos and
Ariadne (above)*

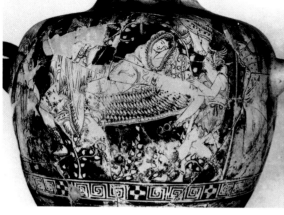

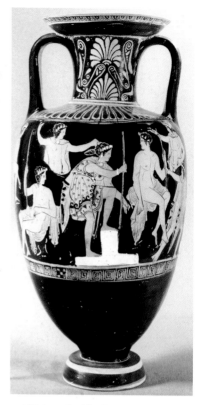

333 Hydria by the Semele Painter (name vase). Semele and the birth of Dionysos (carried off by Hermes, left)

336 Neck amphora by the Meleager Painter. Atalanta and Meleager. H. 61.9

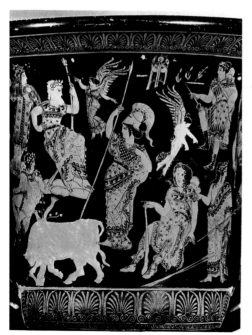

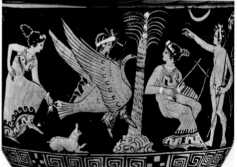

335 Bell crater by the Meleager Painter. Apollo

334 Calyx crater by the Kekrops Painter (name vase). Kekrops, Theseus and the bull, Athena

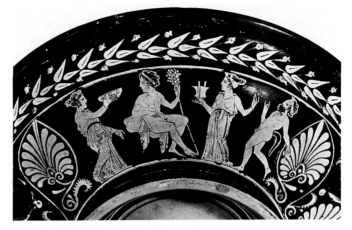

337.1 Cup by the Meleager Painter. Diam. 24.8

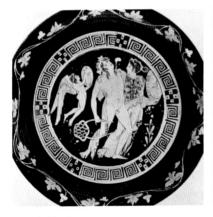

337.2 Inside of 337.1

338 Cup by the Meleager Painter. Theseus and Minotaur

339 Volute crater fr. by the Painter of the New York Centauromachy

340 (above and below left) Relief squat lekythos by the Xenophantos Painter. Persians; a hunt

341 Bell crater by the Telos Painter. Apollo in concert. H.41.5

342 Bell crater by the Painter of the Oxford Grypomachy
(name vase)

344 Bell crater by the Black-Thyrsus Painter

343 Bell crater by the Retorted Painter

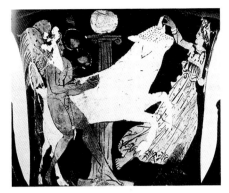

345 *Calyx crater. Eros leads a bull to sacrifice, with Phyle*

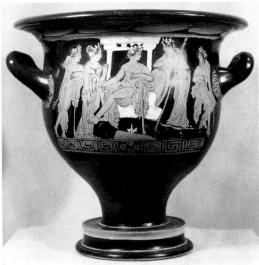

346 *Bell crater by the Painter of Louvre G 508. Herakles*

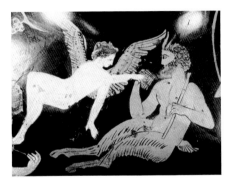

347 *(left and below) Hydria. Dionysos*

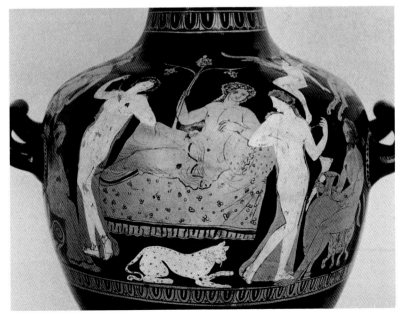

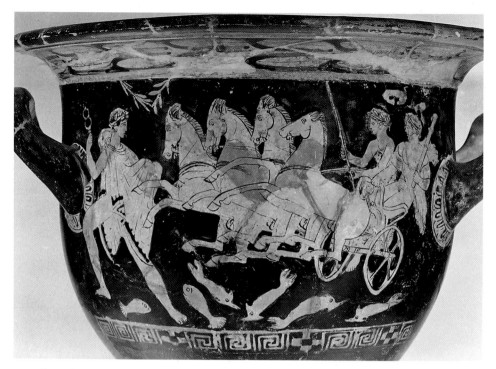

348 Bell crater by the Upsala Painter. Herakles' chariot

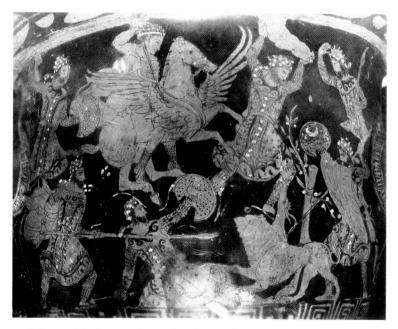

349 Bell crater of the Budapest Group. Bellerophon and the chimaera

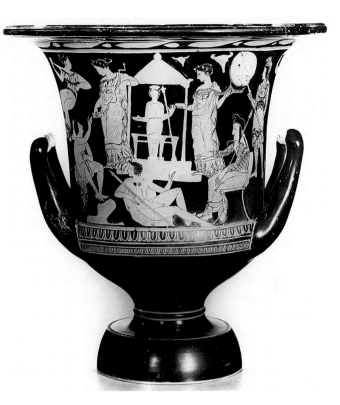

350 Calyx crater by the Iphigeneia Painter (name vase). Iphigeneia in Tauris with Pylades, Orestes, King Aietes. H. 42

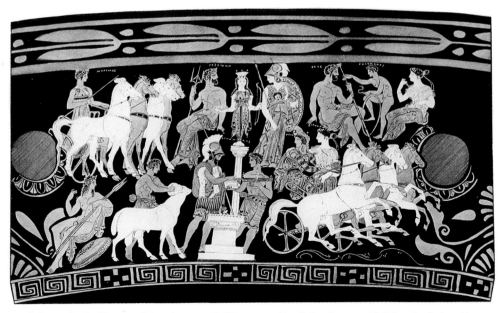

351 Bell crater by the Oinomaos Painter (name vase). Oinomaos sacrifices before the race, with Pelops (in chariot with Hippodameia, at right)

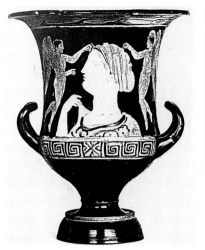

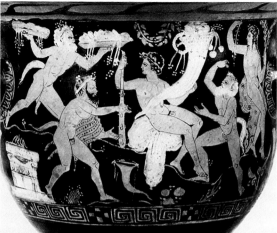

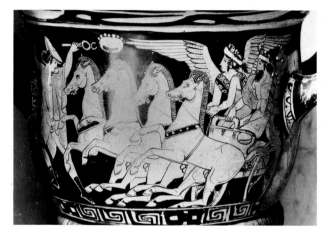

352 (above left) Calyx crater by the
Painter of Rodin 1060

353 (above right) Bell crater by the
Erbach Painter. Herakles and Apollo

354 (left) Bell crater by the Painter of
London F 64. Nike drives Herakles to
Olympus

355 (below) Bell crater by the Painter
of London F 64. Reconciliation of
Herakles and Apollo

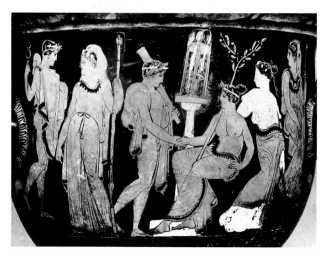

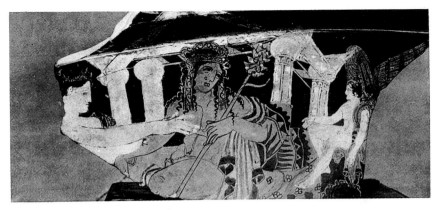

356 Calyx crater fr. Dionysos in a temple

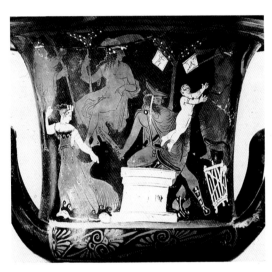

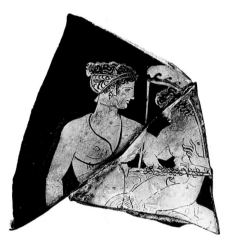

357 Calyx crater. Telephos takes the child Orestes hostage

358 (above right) Cup fr. by the Jena Painter

359 (right) Cup fr. by the Jena Painter

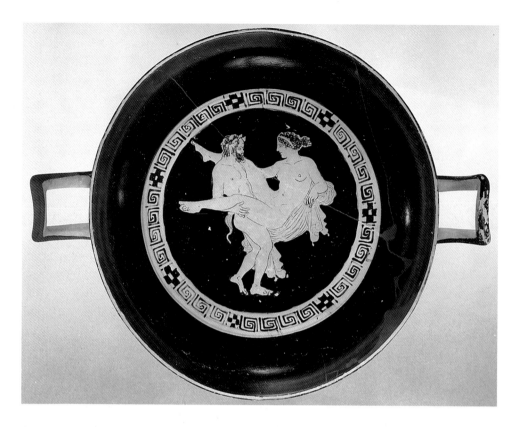

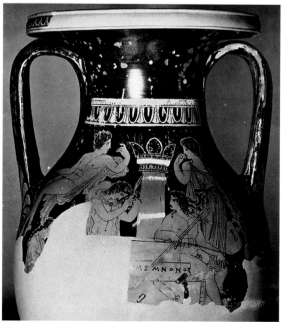

*360 (above) Cup by the Jena Painter.
Diam. 23.4*

*361 (left) Pelike by the Jena Painter. Orestes
(cutting hair) and Elektra at the tomb of
Agamemnon*

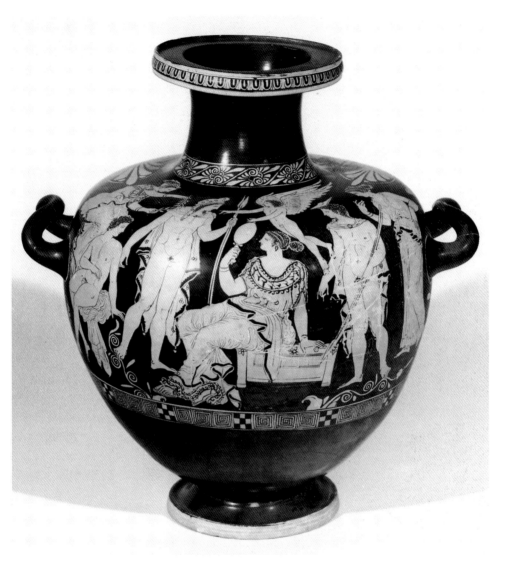

362 Hydria by the Jena Painter. Paris and Helen. H. 43

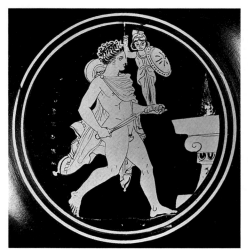

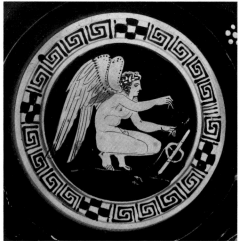

363 Cup by the Diomed Painter (name vase). Diomedes with the palladion

364 Cup by the Diomed Painter. Eros with a trap. Diam. 16.7

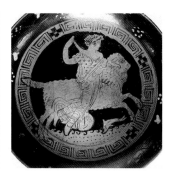

365 Cup near the Diomed Painter. Sparte

366 Cup by the Q Painter. Nereid

367.1 Cup by the Q Painter. Helle on the ram

368 Stemless cup by the Q Painter

367.2 Exterior of 367.1

369 Chous. Children at play.
H. 5.7

370 Chous. Children make a Dionysiac procession with Maypole and cart

371 Fish plate: bream, red mullet, lettered perch, scorpion fish. Diam. 34

Chapter Six

LATER CLASSICAL II

This chapter brings us to the end of red figure in Athens. It is largely concerned with what is called the Kerch Style, named from the site in the eastern Crimea (ancient Panticapaeum) where a considerable number of late red figure vases was found (mostly now in the Hermitage Museum in Leningrad). A general characteristic of the finer vases is a return to and further elaboration of the styles of the later fifth century accompanied by close attention to detail and ornament, an increase in the use of colour, relief and gilding, and occasionally some very fine draughtsmanship. Definition of date within the series is not easy, but the earlier vases can be seen to develop naturally from the work of the hydria and crater painters of earlier in the century; and it may be doubted whether there was any real break in production of vessels of quality after the finer styles of around 400, rather than simply a temporary decline in the number of artists of quality attempting it. The finest work follows, centring on the vases of the Marsyas Painter, roughly of the mid century or little earlier; followed by fairly prolific production of third-rate work as well as some terminal experiments with technique and colour which are more pretentious. It could well be that no red figure painting of any consequence was being attempted much after 320, but the trivial decoration may have lingered. Throughout the period vase shapes tend to slim, profiles are more curvaceous, lips flare and overhang their bodies, handles curl. There is not the ornateness of the major South Italian schools, and the only really satisfying work is executed in the traditional technique with a fine linear style, little recourse to white paint, and only modest concessions to relief or gilt detail.

Connoisseurship of artists presents something of a problem. In the 1930's Karl Schefold published important monographs on the Kerch style and defined some painters and groups. Beazley covered the same ground only in his second edition of *ARV*, accepting several of Schefold's artists, but ignoring some groups entirely, including several of the very finest vases, which he felt unable to associate with individual hands.

Of the earlier painters the POURTALÈS PAINTER [*372, 373*] and the poorer TOYA PAINTER [*374*] decorate bell craters (a shape that begins to go out of fashion in this period) and calyx craters, already becoming slimmer and taller, and presenting bold simple patterns in their handle zones. The former's name vase [*372*] has an elaborate Eleusinian scene of initiation (for heroes) and his Berlin crater [*373*] has

a myth scene relating to what appears to be a recently favoured Attic cult. There will be a few more vases displaying this local interest but most are devoted to genre or to stock types of Dionysiac or other mythical but non-narrative themes.

The pelike is one of the more important Kerch shapes and the earlier ones are still buxom vases offering a fine swelling field for multi-figure scenes. The HERAKLES [376, 377] and PASITHEA [378, 379] PAINTERS (the latter named for a Hesperid on [378]) continue the tradition of the bell crater painters of the previous generation, on the different shape. [380] has a spirited version of the popular Arimasp-griffin fights. Hydriai and craters attributed to a HELENA PAINTER [381–383] by Schefold (the works are not assigned by Beazley) are slightly more ambitious in drawing though not subject matter. The veiled dancer [382] is a familiar sculptural type. The Botkin pelike [384] offers an up/down composition in the fifth-century manner, cut-off figures and all, but in the new Kerch technique: a lively Calydonian boarhunt. Other hydria painters, as in the GROUP OF LONDON E 230 [386], echo some of the finer figure-drawing of artists yet to be discussed.

The MARSYAS PAINTER's work [388–391] 'includes most of the masterpieces of Attic fourth-century vase-painting' in Beazley's view, but we start with a vase bearing a Marsyas scene not attributed to the painter by Beazley, but which he called 'the finest, I think, of all late Attic vases'. It is a fragmentary and large calyx crater in Oxford, from Al Mina [387]. The composition is heavy and formal on the monumental shape (61 cm high) but the drawing of individual figures is exquisite, the best line drawing in any surviving medium of the period, but with lines too fine to be caught readily by the camera.

The Marsyas Painter's masterpiece is a lebes gamikos from Kerch with a bridal scene [388]. White is restricted to furniture, Erotes and the flesh of the principal Aphrodite-like figure, whose dress was painted over in a matt colour in contrast to the ordinary red figure of the other women. Details of furniture are gilt but what on other vases seems meretricious ornament here enhances the general appearance and focuses attention on the main figure without appearing flamboyant. The figures are statuesque, easy, relaxed and assured in their poses; lines are bold and not as densely set as on the Al Mina vase, nor are they as fine – this is an exceptional feature of the crater recalling fine etching or silverpoint rather than the emphatic linearity of most red figure (and especially the early relief line).

The big pelike with Peleus and Thetis [390] also uses colour with restraint and for narrative emphasis; and it includes two nude studies of women of an accomplishment unmatched on earlier vases. Three-quarter views of bodies and faces are achieved freely now and although the technique still militates against compositions in depth the fullness and rotundity of individual figures is perfectly expressed despite the black ground. The quality of this drawing might lead one to think that the painter(s) were practised in other, major media, moonlighting

in the potters quarter, but the vases display a pride in potting too which suggests that this is a genuine if shortlived revival of interest in the craft and technique which lifts it for a while from the pedestrianism of most fourth-century vase-painting. This is shown by the care devoted to ornament (always a feature of the better painting on Attic vases) and the distinctive broad band of maeander and chequer squares used for ground-lines on several of the vases, much in the manner of the best Meidian, but tighter, fussier.

The ELEUSINIAN PAINTER [392, 393] may have seemed to Beazley 'laboured and weak' beside the Marsyas Painter, and his figures are indeed somewhat weaker and more crowded, but he too recalls the Meidian, has another elaborate Eleusinian scene on a large pelike and an unexpected view of Zeus with Themis plotting the Trojan War [393]. His work on black figure Panathenaics places his floruit before the mid century.

Other vases of the quality of those just named include the work of Schefold's POMPE PAINTER: a chous [394] with a relaxed Dionysos observing Pompe, personification of the procession, and a skyphos (a shape rarely graced with decent drawing in this period) with women and satyrs, surely not by the same hand [395]. The Pompe is a good example of a figure with transparent dress, such as appears on several Kerch vases (and see [347]); an effect achieved not by simple line, as often hitherto on vases, but by a combination of white for the figure, ordinary red figure and matt paint. The bunch of dress caught between her knees is another popular motif of the period, for men or women (cf. [422]). Some of the vases attributed by Schefold to his PAINTER OF THE WEDDING PROCESSION [396] might deserve a place here for the quality of figure drawing though the style is generally crowded and slapdash if detailed.

It is easy, perhaps too easy, to see in the figures and dress on these 'ripe' Kerch vases, reflections of the sculptural styles of the day. In Athens, this is the period of Praxiteles' nude Aphrodites and of the heavy and complicated drapery for women anticipating the Hellenistic. The dress at least can be matched on the vases where it generally appears lighter and clinging, following earlier styles in vase-painting, while the few nudes seem decidedly non-Praxitelean. Panel painting, as in the fifth century, is more likely to have been a model, since although colour and chiaroscuro were beyond the vase-painter's capacity for imitation, there was a continuing tradition in a more linear, contoured treatment in major painting, though we have to judge it more from description than from extant work which never hints at the display of linear detail seen on the vases. An occasional relief metal vase, such as the later Derveni crater, approaches the style of the vase scenes, but most are less detailed (as are the incised figures on gilt silver vases). Closest, perhaps, are the incised figures on bronze mirror covers. On the vases too this is still essentially a draughtsman's style, not a pseudo-sculptural one, for all the facile imitation of trivial relief ornament and figures that certainly ape metalwork and will eventually preoccupy the potter.

A shape barely mentioned so far, but bearing some of the most characteristic Kerch decoration, is the lekanis, the flat round bowl with decorated lid, normally devoted to scenes of women and weddings. The subjects recall those of the later fifth century, and the Erotes and occasional toplessness of the principal figure may sometimes leave us wondering whether we have a mortal or Aphrodite (probably a deliberate ambiguity or compliment on the part of the artist). The drawing is rather slack and dry though elaborate; both shape and decoration have much of the 'chocolate box' about them. These are of Beazley's OTCHET GROUP [397, 398]. Most of the scenes on the lekanides of the main group have four components: seated woman with Eros; seated woman and maid; seated woman; running maid. Other examples are more explicitly nuptial in subject [398] with wedding vases shown. The later examples reduce the decoration to four figures and others economize with simple heads or admit the occasional oriental subject [400–403].

The remaining vases of the Kerch style are numerous but rarely ambitious, some are much given to colour and ornament, others are grossly repetitious. The APOLLONIA GROUP [404, 405] offers scenes of Athens' Adonis festival on a hydria and squat lekythoi, a shape not forgotten for the occasional major scene. On pelikai the AMAZON PAINTER [406, 407] leads us into the familiar late Kerch world of Amazons, griffins, heads and busts, but can offer some fights of crude vigour. He takes some trouble with, but crowds the ornament, plugging the area between scenes under the pelike handles with big blunt palmettes. The pelikai of GROUP G(riffin) [408, 414] are also largely devoted to this peripheral arena, with mounted Arimasps fighting griffins, fights with Amazons and other orientals, the later pelikai becoming quite thin-necked and crudely figured. To the same group Beazley assigned a series of bell craters, with similar scenes, or symposia, rather old-fashioned; and a few bell craters of special form ('Falaieff Type') with high flaring lips [414]. Bell craters by the FILOTTRANO PAINTER [416, 417] add to the oriental and symposion repertory more old-fashioned scenes of Dionysos and the komos.

Calyx craters of the L.C. GROUP (for Late Craters) become tall and emaciated [418–422], decorated with few but sometimes well-drawn, tall figures, especially in the work of the EROTOSTASIA PAINTER [418, 419]. The poorest are satisfied with merely one or two figures on the front and summary mantle figures behind.

On minor shapes the decoration is even more dispiriting. The F.B. GROUP (for Fat Boy) of oinochoai (and a few poor skyphoi) is devoted to appalling youths and athletes [423, 424]. These are the figures too of the exteriors of cups in the YZ GROUP ('the end of the red-figured cup') but adding some women, Erotes and Nikai [425]. The interiors recall the figures on cups earlier in the century, but crudely drawn with gross borders, or sometimes none at all beyond one or two reserved hoops, occasionally with a degenerate version of the vine wreath around the tondo and reducing the figure to a single head. Askoi have oriental

subjects and heads [426]; pyxides and small lebetes gamikoi have degenerate versions of the wedding scenes [427].

For how long these vases were being painted is hard to tell. Though there are many of them, and well-distributed round the Mediterranean (though few now into the Black Sea, which may have been a matter of taste and demand rather than date), the period of production may have been short if lively.

The last vase we consider is rather better, one of the latest to attempt quality, and from the new city in which much of the future of Greek and western art was to be forged – Alexandria. A slim-necked hydria, with a Judgement of Paris [428]. The red-figured work for the attendant figures is summary, but for the central figures there is much gilt relief and thick matt paint. It seems to represent the exhaustion of a style and technique which, but a few years before, had seen some revival of pride in draughtsmanship and restraint in decoration. The craft was, however, bound to succumb to the taste of a new age in which, it seems, shoddy hand-painted vases of clay were (understandably) judged inferior to the plain painted, and in which the mass market was to become more readily satisfied from the mould than by the brush.

372 Bell crater by the Pourtales Painter. Initiates at Eleusis; Herakles and Dioskouroi (stars), Triptolemos

373 Bell crater by the Pourtales Painter.
Herakles carries Palaimon

374 Bell crater by the Toya Painter.
Herakles, Athena, Eros

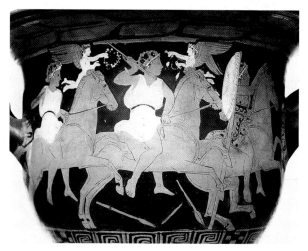

375 Bell crater. Riders and javelin-target.
H. 40.5

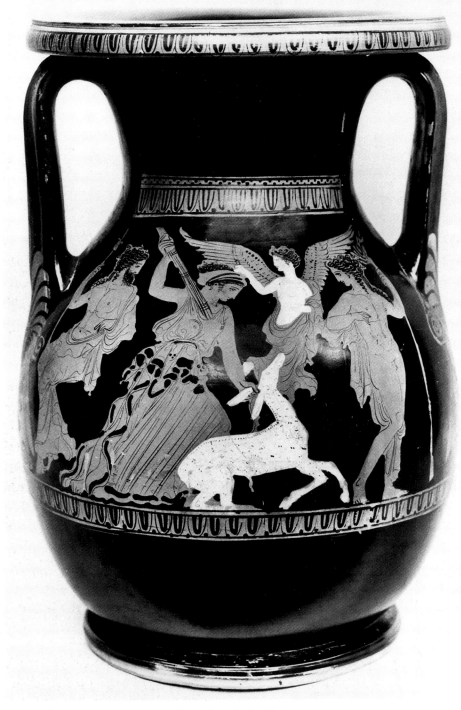

376 Pelike by the Herakles Painter. Artemis hunts; Zeus, Apollo. H. 28.5

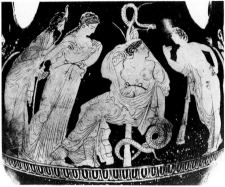

377 Hydria by the Herakles Painter. Anodos of Aphrodite. H. 31

378 Pelike by the Pasithea Painter. Pan, Herakles and the Hesperides

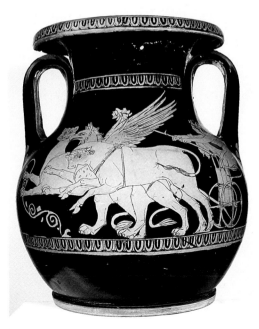

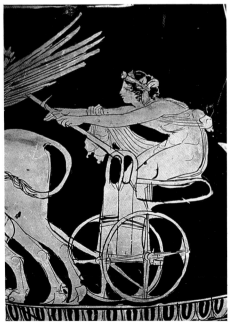

379 Pelike by the Pasithea Painter. Dionysos' chariot. H. 24.5

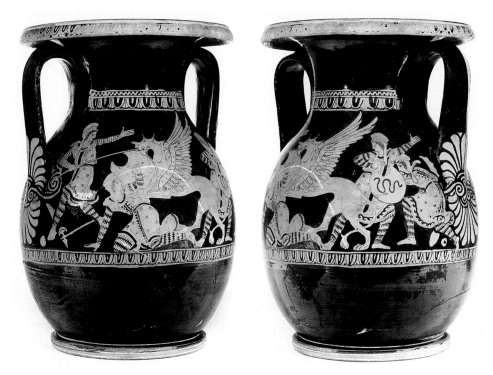

380 Pelike by the Painter of Munich 2365. Grypomachy. H. 28.2

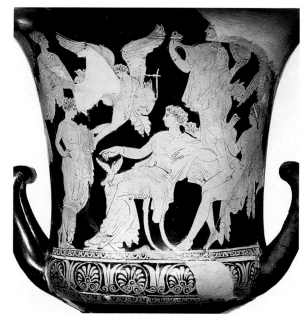

381 Calyx crater. Paris and Helen?

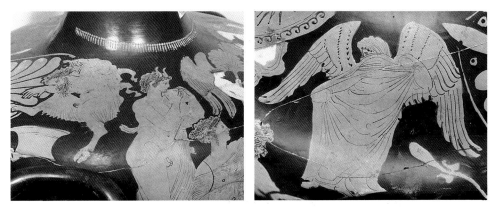

382 Hydria. Details, satyr and Pan; dancing Nike

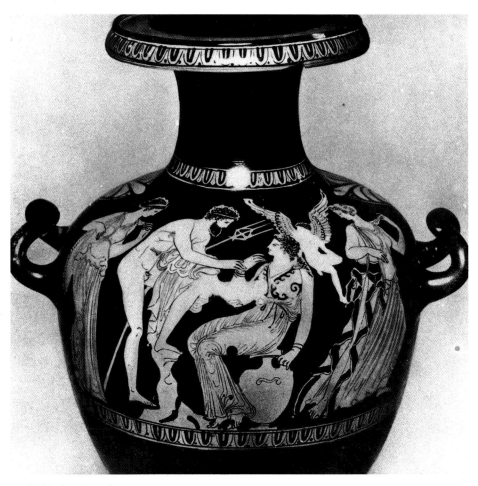

383 Hydria. Poseidon and Amymone

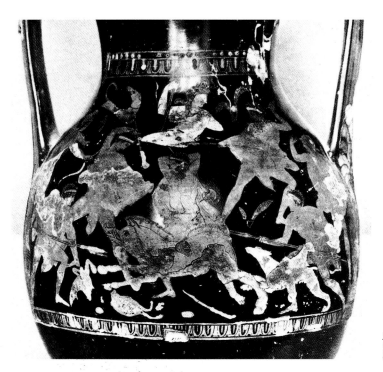

384 Pelike.
Calydonian
boar hunt

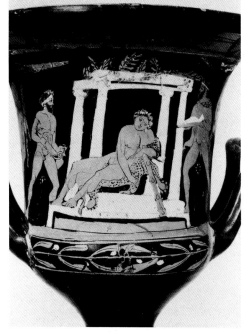

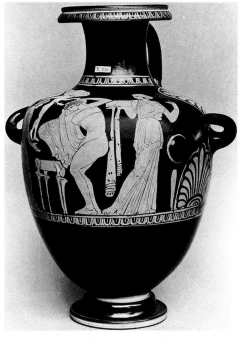

385 Calyx crater. Herakles at ease in a shrine

386 Hydria of the Group of London E 230. H. 31.7

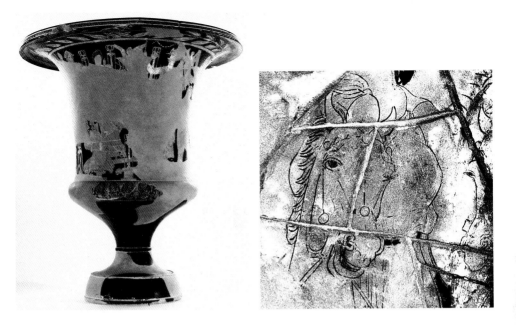

387 (above and below) Calyx crater. Apollo and Marsyas; detail, Marsyas. H. 61

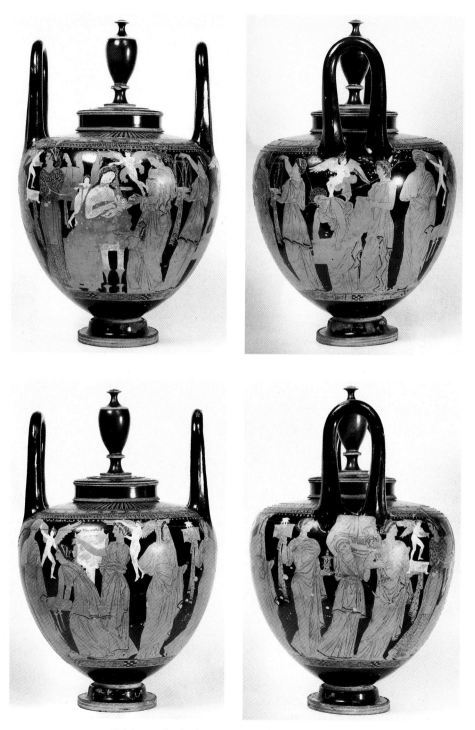

388 Lebes gamikos by the Marsyas Painter. Wedding preparations

389 Pelike by the Marsyas Painter. Apollo (and Marsyas)

390 (above and right) Pelike by the Marsyas Painter. Peleus and Thetis. H. 42.5

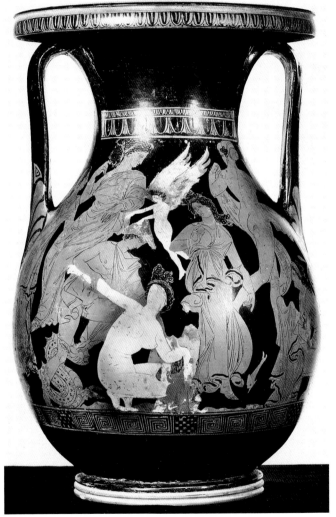

391 (right) Lekanis lid by the Marsyas Painter

392 (below) Pelike by the Eleusinian Painter.
Triptolemos, Dionysos and the initiate Herakles at
Eleusis

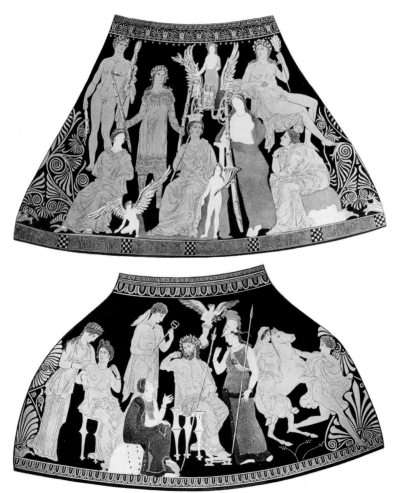

393 Pelike by the Eleusinian Painter. Zeus, Themis and Athena

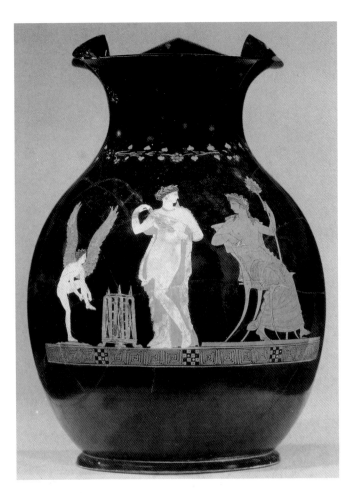

394 Chous. Pompe and Dionysos.
H. 23.5

395 (below) Skyphos. H. 17.5

396 Hydria fr. Zeus and Hera

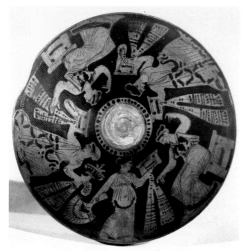

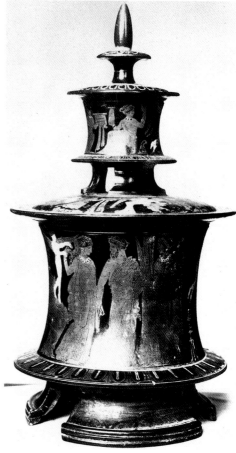

397 (above) Lekanis lid of the Otchet Group. Diam. 21.6

398 (below) Lekanis lid of the Otchet Group. Diam. 24.8

399 (right) Pyxis

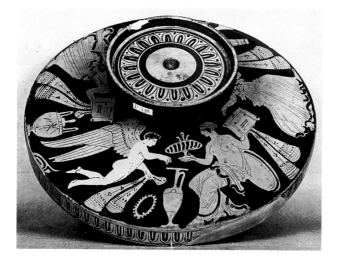

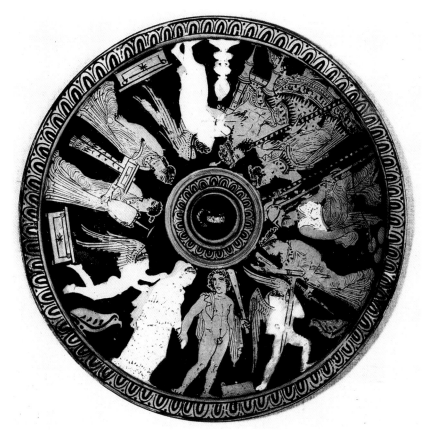

400 Pyxis lid. Herakles and Hebe marry in Olympus. Diam. 21

401 Lekanis lid by the Painter of the Reading Lekanis. Diam. 13.2

402 Lekanis lid of the Group of the Vienna Lekanis. Diam. 19.2

403 *Lebes gamikos. H. 21*

404 *(below) Hydria of the Apollonia Group.*
Adonis festival

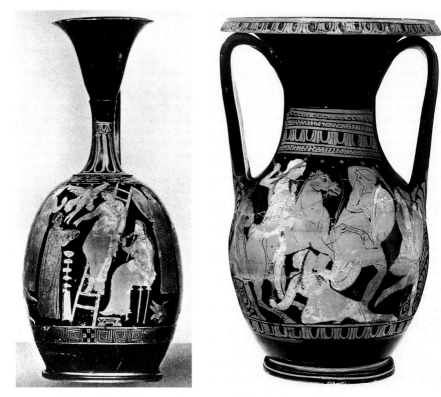

405 Squat lekythos of the Apollonia Group. Adonis festival

406 Pelike by the Amazon Painter

407 Pelike by the Amazon Painter

408 Pelike of Group G. Arimasp and griffin

409 Pelike of Group G. Fight with orientals

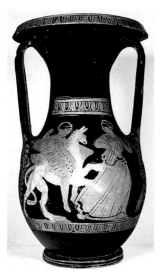

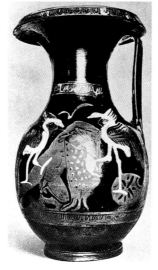

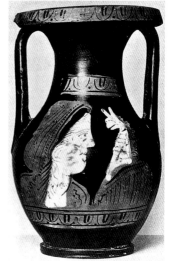

410 Pelike of Group G

411 Pelike of Group G. Pygmy and cranes

412 Pelike of Group G

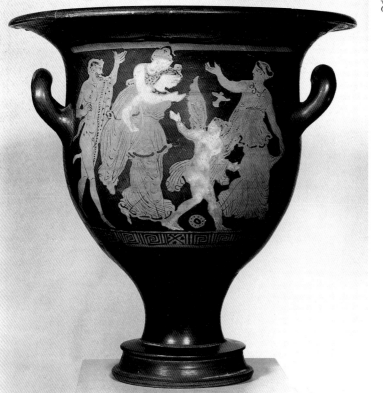

413 Bell crater of Group G

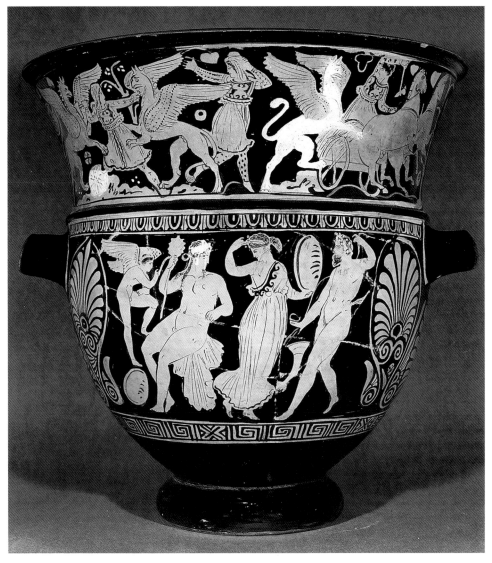

414 *Falaieff bell crater of Group G. Grypomachy; Dionysos. H. 43*

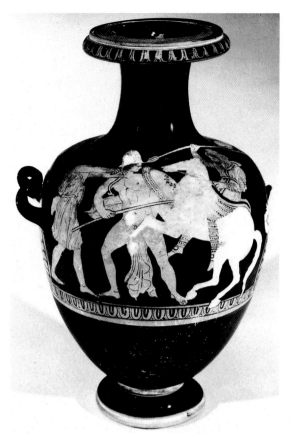

415 *Hydria near Group G. Fight with Persian.*
H. 29.2

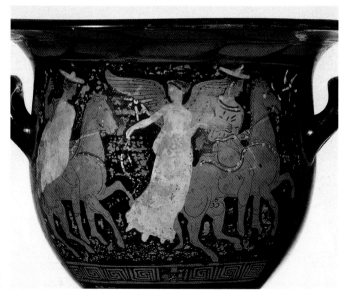

416 *Bell crater by the Filottrano*
Painter. Dioskouroi and Nike

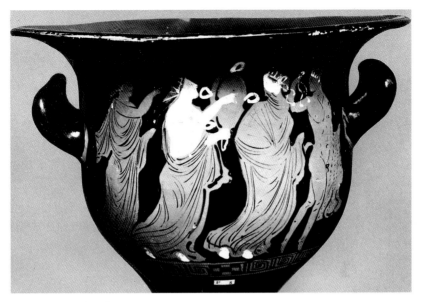

417 Bell crater by the Filottrano Painter

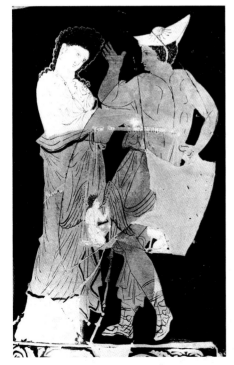

418 Calyx crater of the L.C. Group. Erotostasia

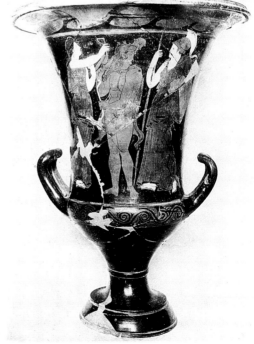

419 Calyx crater of the L.C. Group. Herakles and Athena

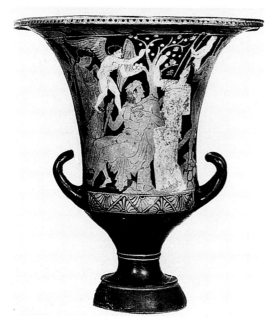

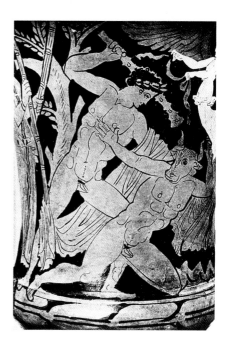

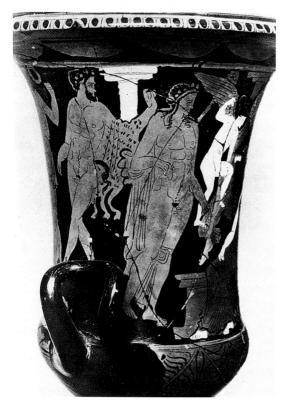

420 (above left) Calyx crater of the L.C. Group.
Herakles and Hesperides. H. 45

421 (above) Calyx crater of the L.C. Group.
Theseus and Minotaur

422 (left) Calyx crater of the L.C. Group.
Dionysos

423 (below) Oinochoe of the F.B. Group. H. 17.4

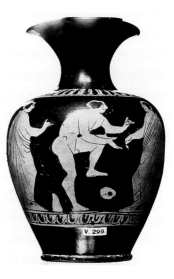

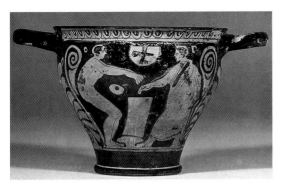

424 Skyphos of the F.B. Group. H. 13.3

426 Askos of the Group of the Cambridge Askos (name vase)

425 (above and right) Cup of Group YZ. Apollo

427 (above and right) Pyxis of the Chalki Group

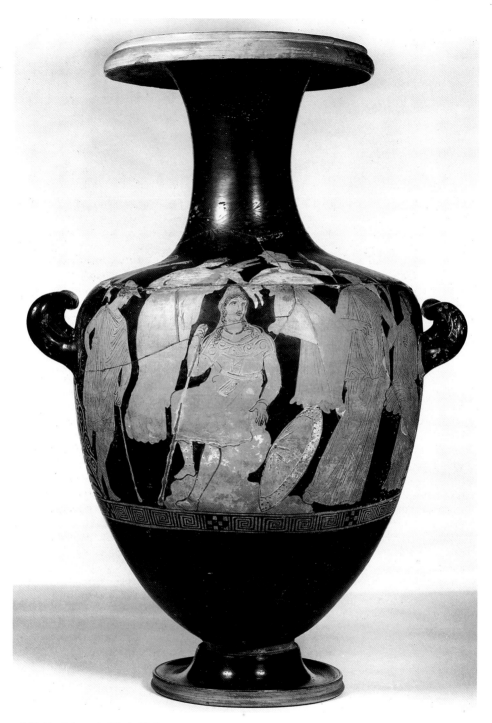

428 Hydria. Judgement of Paris. H. 61.5

Chapter Seven

THE SCENES

In Classical and later red figure there are rather fewer main lines of subject interest displayed by the vase-painters, accompanied by greater diversification of lesser themes. This is particularly apparent in the myth scenes, the sources for which we shall have to consider. The changes of emphasis, in scenes either of reality or myth, are gradual, although single events must sometimes have provided the stimulus for a new interest. They should be able to tell us something about the changes in fortunes and preoccupations of the Athenians for whom the vases were decorated, and to a modest degree they seem to, though rather indirectly and there are no really explicit references to Athens' loss of empire and defeat, though there are several to Athens' pride. On the whole we must judge that the view we are given of Athenian life on these later red figure vases is far less rich than it had been in the Archaic period except in what they show us of the life of women.

The means of communication through the pictures were as they had always been: a syntax of stock figures and groups, identified by attribute, posture or sometimes inscription, but chiefly reliant upon a knowledge and expectation on the part of the customer that we may not always be able to share. Purpose must often have determined subject, and matters considered in Chapter Nine must be borne in mind. Ingenious suggestions that all the decorated clay vases were intended for the tomb (since many, but not all, and most not in Greece at all, were found there) or that they are dedicatory (for tomb or temple) substitutes for metal vases (gainsaid by the fact that many show signs of regular use and repair and that many are found in houses) need occupy us no longer than this sentence, but they have been found to suit some of the quainter currents of modern scholarship.

Animals had already ceased to be subjects in their own right (the Athenian owl is the main exception [96, 97]) and there is only the occasional old-fashioned animal frieze in the traditional position on column crater lips; and note [48]. Ornament observes long familiar patterns for handle palmettes or bands of maeander and squares. The laurel wreath wins bell crater lips, and cups may sport a colourful ivy wreath round tondi or a simpler laurel. By the fourth century painters who take trouble over their ornament are exceptional. A few vases are simply patterned [99] and the impressed patterns which become common on the plain black vases are to be found on the interiors of some groups of cups.

The vases are still an important source of information about contemporary life and conduct, although we are sometimes baffled by an action or object and the motivation for some of the scenes is open to varying interpretations. By 'scenes of reality' I mean, of course, scenes with figures which are not identifiably mythical or divine. The 'real' scenes no less than the 'mythical' are subject to formulae and conventions, and their messages may be no less subtle for the apparent ordinariness of their settings. Moreover, we shall sometimes find the mortal associated with the divine. There are other limitations too; painters and their customers were not interested in pictures of the official civic life of Athens. Most of the scenes are private. Those that are 'public', like sport and fighting, are generalized, or are concerned with public enactment of cult – we are shown no Mysteries or the actual rites of initiation and even the *rites de passage* which marked a young Athenian's growing-up are barely hinted at, for all the enthusiasm with which they are pursued and hopefully identified by some scholars. This reminds us of the level and expectations of the society for which the vases were made, and it was for the same market that the many scenes of myth were created. They too must be thought to have had, potentially, some common message, and the ready mingling of divine and mortal for some mainly domestic subjects is a further indication of their common appeal which is different from that of 'major' or state- and cult-sponsored art, on temples and stoai. We are dealing with pictures designed to appeal to the people, and though state and cult propaganda may well intrude (more in the past than now, at least on vases) it must be at the level at which it was generally accepted and understood. This gives these scenes a documentary interest which is different from that offered by literary texts.

In the rest of this chapter, I follow approximately the order of Chapters Seven and Eight of *ARFH* I, to which the reader should turn for fuller accounts of subjects of continuing importance.

SCENES OF REALITY

Everyday life

There are no significant changes in the depiction of dress although patterning over the whole garment or for wider hems becomes more elaborate. Male dress is the most conservative. Travellers and youths wear only chlamys-cloak, petasos sunhat, and boots with puttees; they usually carry two spears. There are still a few hunting scenes, for deer or boar [*90, 216*], but the aristocratic palaestra scenes of courting and conversation are no more, and the scenes of groups of youths and athletes are generally just convenient space-fillers. There are a few quiet scenes of Persians, apparently kings or satraps in Greek Asia Minor [*220*];

they were not always the foe in our period, and by presenting them sometimes in a domestic situation the painter is offering scenes unfamiliar to the Court styles of the Persian Empire, and only otherwise apparent within the Empire in areas more than a little hellenized (southern Asia Minor).

In subject matter, the main change comes with more detailed interest in the life of women. The reasons for this are not obvious but, since the vases seem to have been made and marketed by men, it must reflect on the status of women in society, though not always in the way suggested by some scholars' use of this evidence. In earlier red figure the courtesan's life is of far more interest than the housewife's, but now the women's parlour becomes a common setting, especially for decoration of vessels which we may suppose to be for women's use – pyxides and hydriae. The wool basket (kalathos [91]) and spindle [209] are common furniture. That men visit can give rise to speculation that we are observing a Madame in a domestic moment, and purses are sometimes in evidence; this is possibly true for some scenes but unlikely for most. The ladies may be musical, or playful, with children or each other. Apart from domestic activity there are more and more scenes of women dressing, with finery and jewellery, not for the bordello, it seems, but for marriage. This is shown by the presence of marriage vases (loutrophoros and lebes gamikos) [40, 234, 235, 243, 398]. Heroic compliments are paid by the admission of Eros and sometimes by supernatural identifications. Where the lady is part naked we may suspect that Aphrodite's own toilet is offered as the paradigm. The wedding on [235] becomes supernatural only through the addition of the names of Alkestis as bride and several goddesses and nymphs; and notice Herakles' marriage on [41, 400]. Details of jewellery and elaborate hair styles for the women in the boudoir scenes are features of Meidian vases and of the wedding scenes on Kerch vases of the mid fourth century. Ritual occasions, such as the procession to get water for the bridal bath, or the leading of the bride by the groom to her new home 'hand on wrist', or the presentation of gifts at the Epaulia, all appear. The maenads who dance for Dionysos' image are Athenian devotees and the women's cult of Adonis is show (see below).

Dances range from the stately [21, 105], juvenile [128, 138], to the more ecstatic, with the muffled figure [382, 417] becoming a feature of the later Classical scenes. Young girls are taught to dance a version of the warrior's 'pyrrhic', or around swords, or the oriental oklasma like a Cossack dance, but these are to be displays for a male audience [153, 320].

Children at play, with go-carts and animals, appear on the late-fifth-century choes [369]. There is an occasional dwarf [120] but there are generally fewer ethnic studies, except of Persians, with their soft hats, sleeves and trousers, and loose jackets. Thracian and Thessalian dress had become fashionable for the cavalier class [66]. Architectural detail is no more common than hitherto and usually less informative except as a signifier for a temple or palace, but there are detailed studies of domestic furniture, thrones, chairs and stools.

Fighting

There is a general tendency for less armour to be worn, often none at all except for a helmet in the action scenes. These are usually heroic in content but the lack of armour perhaps only slightly exaggerates contemporary practice. The all-metal corselet is completely replaced by one of linen or leather and the only elaborate type is the modelled body-corselet. The Corinthian helmet is becoming old-fashioned and the commonest types are the Thracian, with peak and cheekpieces, and the Attic, with open face and hinged cheekpieces. The pointed pilos and wide, wavy-brimmed petasos may be seen on fighting men. These types are essentially of leather or woven material but metal versions have been found. There are the usual greaves but no other leg armour. The hoplite's thrusting spear is used more often than the sword (jabbing or cutlass *machaira*); chariots are exceptional, and appear only in traditional myth scenes, but there is more cavalry. Scythian dress for archers (and Amazons) is eventually abandoned.

Fighting scenes follow traditional schemes and there is still no explicit demonstration of a hoplite rank rather than individual duels. Fights with Persians [29] show the opponent in the expected dress but sometimes including pieces of Greek armour, and we may wonder whether all are meant for real Persians or for Greeks serving new masters. The arming scenes of early red figure appear less often. The scene of a warrior leaving home is especially favoured in the fifth century; wife, mother and father can often be identified; a libation is poured or ready and a column may designate the home porch [3, 7, 115, 172, 175, cf. 140]. These are quiet, static scenes of notable dignity – poignant too, no doubt, in a city almost continuously at war and in which the war dead were being singled out for especial honour and heroisation at state graves and in annual funeral orations.

Work and play, public and private

The symposion and komos remain popular themes for a while, generally in the traditional schemes and without innovation or even as much detail as hitherto. Does this indicate a somewhat lower social level in the expected market for clay vessels designed for feasts? Probably it does, and at the same time accounts for the virtual disappearance of palaestra and other athletic scenes, except for oddities like the innovative contest for javelin-throwing at targets from horseback [375] (cf. *ABFH fig.* 304.2), and the torch races which may be associated with the reorganisation of the Hephaisteia festival in 421/0 [319]. But if the general rarity of such scenes does indicate a shift down market in choice it is perhaps surprising that scenes of trade and commerce should also virtually disappear. The joys of sex are seldom now celebrated, as they had been in the Archaic period.

Religion

This is a far richer field, especially in scenes related to Athenian festivals, with other stock scenes of sacrifice [*42, 60, 183*] and some devoted to mythical occasions (as [*313*]), and we find lesser divinities so engaged: Nike or Eros [*84, 141, 345*]. Moreover, in the new range of festival scenes Athena herself seems to be ignored and the greatest of the Athenian festivals, the Panathenaea, can hardly be recognized. The closest we get to such an Olympian occasion is in the fine procession to Apollo in his temple on [*171*]. There is a small number of scenes of the Adonis festival for Aphrodite [*404, 405*], at which Athenian women attend their short-lived Adonis-gardens, potted and set on house roofs, symbols of burial and resurrection (compare too the phallus garden of [*213*]). This is a foreign, exotic cult and there are others, as for Bendis, a Thracian Artemis (perhaps seen on [*318*]), and the eastern Dionysos, Sabazios (perhaps seen on [*157*]).

Dionysos is better served. The mask-idol remains the centre piece for rituals involving maenad-dances by women and wine-tasting, usually associated with the Lenaia festival [*24, 177*]. The mask alone is seen in a winnowing fan on [*233*]. In the spring festival Anthesteria the god, impersonated by the archon, is ritually married to his consort Basilinna; cf. [*163, 249*]. The same festival involved a drinking contest in the day called after it Choes. The chous shape of jug often carries Dionysiac scenes but the most interesting are the series of miniatures of the late fifth century and for a while thereafter, with their scenes of children at play or imitating adult rites [*369, 370*]. The Maypole on [*174*, cf. *370*] is for another spring festival, with its elderly chorus.

Classical Athens was much concerned with new religions or with the more exotic fringes of the Olympian. The promise of immortality achieved through initiation at Eleusis and participation in the Mysteries acquires special significance, and there are several scenes devoted to the deities of the site, and to groups including initiates, but heroic figures, Herakles or the Dioskouroi, rather than mortals. These are commonest in the fourth century [*372, 392*].

A few vases show special occasions such as the Theoxenia [*312*], preparation of a communion feast with the divine; and the 'court' scenes, with Apollo, Dionysos or Herakles at the centre, imply at least some communion with worshipping mortals although they are often peopled with other immortal figures.

For the dead, the laying-out (*prothesis* [*38*, cf. *231*]) and lament are confined to vases of shapes specific to the event (loutrophoroi: the hydria type for women, the amphora type for men). The grave lekythoi demonstrate acts of piety at the tomb after the burial rather than the funeral rites themselves. Their reflective character is in keeping with the comparably low-key rendering of, for instance, warriors leaving home, or the scenes on gravestones. For the scenes on the lekythoi see Chapter Four.

The vase-painter's sources for his scenes of myth in this period are not easily defined. Much clearly depended on what was already in the repertory, but the stock Archaic scenes are gradually abandoned and those that replace them are not repeated with the obsessive regularity observable before. Other artistic media seemed not to have been a major source in the Archaic period, or rather, their idiom was not so different from that of the vase-painter, nor was his craft necessarily so inferior or his range of activity limited to work on clay. In the Classical period the vase-painter is more of a specialist, and often for a mass market. We have seen how he was open to influence from the composition and appearance of the mural paintings of Early Classical Athens but, apart from the obvious Amazonomachies and the like, we cannot say that their subject matter dictated his stock of scenes and it clear that he did not merely copy; if there had truly been a market for replicas or souvenirs of major works of art in humbler media we would have found ample evidence for it and there is virtually none beyond the vaguest echoes.

The painter is no more likely to have turned to the written word for inspiration than hitherto. Even if his society was somewhat more literate (and this can be much exaggerated), the stock of stories carried by oral tradition was no less influential, and he would inevitably be influenced by vogues stimulated by new hymns or odes, and especially by stage productions. We are well provided with titles of fifth-century Athenian plays but have very few texts. It has not proved difficult, therefore, for dedicated scholars to find the stage behind many or most of the new myth scenes in the repertory. To some degree this certainly happened, but the painter does not present 'on stage' scenes, masks and costumes are generally ignored, even for the satyr-players (see *ARFH* I p. 234), and so certainly is the number of actors (only three in 'real' tragedy). By the end of the century some scenes are presented with what seem to be stage 'props', such as the arch-cave which is the setting for the bound figure of a Prometheus or Andromeda. The otherwise inexplicable presence of a tripod might be thought an indication that a stage production of the story depicted won a prize. Sometimes the *dramatis personae* seem to repeat those of a known production, but they are just as likely to include other appropriate figures, and, as time passes, deities thought to have an interest, far beyond those who might have been produced on stage *ex machina*. Scrutinising new stories on vases or renewed popularity for stories, and comparing the dates of known productions, there are found to be very few instances in which the scenes appear within a significant lapse of time. We expect them immediately, but often they lag by twenty or more years and then there could be other explanations for their appearance (not, generally, repeats of the stage production, which were very rare in this period).

Satyr-plays are the most readily recognized, since satyrs had virtually no function in myth-narrative off-stage (see *ARFH* I p. 234). The Pronomos vase

[323] is the best demonstration of their dress and masks, but also about the latest, and it is by no means clear what production, if any, it celebrated. We focus on the figure of the guest artist, the piper Pronomos, in the foreground, but if he had not been named and known from other sources, the scene would have been taken for a detailed study of Dionysos and consort attended by the cast of a play, which is basically all it is. The satyr-plays of Aeschylus earlier in the century found several echoes on vases. Those of his successors, Sophocles and Euripides, are less readily identified, and in our period some vases seem to depict Aeschylean satyr-play subjects, either with a satyr 'chorus' such as Prometheus the fire-giver [181], or without, such as the recovery of Danae in her floating chest by fishermen or Poseidon's pursuit of Amymone [316]. Sophocles wrote a *Pandora* or *Hammerers*, which may inspire the scenes of an emergent goddess attended by satyrs with mallets [160, 377]. And it is always possible that the analogy of satyr-play was enough to give a painter the licence to introduce satyrs in appropriate myth settings, whether staged or not. I shall indicate below where scenes might be thought to relate to a known or suspected satyr-play, tragedy, comedy or dithyramb.

Stage dress may possibly have had an influence on the painters independent of specific productions. It might explain the heavy, patterned costumes, often with boots, from the end of the century on, and the growing tendency to depict Trojan figures in oriental or Persian dress. Specific allusions to the stage seem to die out completely in the fourth century and the subjects of Middle and New Comedy have no appeal for the painter. This is an area in which the vases of South Italy satisfy our desire for stage illustrations; but see [124, 228]. It is perhaps surprising that Old Comedy in particular did not inspire vase scenes. There is an unusual small class of polychrome (not red figure) jugs of late in the century [429] which might allude to some form of comic performance, and the apparently Aristophanic [314] is exceptional. Not all the parody or burlesque elements in some scenes can be attributed to the influence of satyr-plays, perhaps; for instance, the satyr confronting a tree full of jugs like Herakles before the tree of the Hesperides with its snake [33], or the comic Herakles driven by Nike in a chariot drawn by bound centaurs, led by what looks like a comic actor [321].

The use of myth as a parable for the fortunes of the state (or its leaders) and to provide justifications (*aitia*) for new cults was well apparent in the Archaic period. As Athenian hero *par excellence*, Theseus had taken over from Herakles by the early fifth century but cannot be said to dominate the iconography of democratic and imperial Athens. The cult of the individual survived longer in politics, even in a democracy, than in myth, and the important stories related to Athens' fortunes which are most familiar from the architectural sculpture of Periclean Athens (*GSCP* Chapter Twelve) have a more generalized focus, and the honours are distributed more widely among the early kings and heroes of Attic history whose names accordingly appear the more frequently in appropriate vase scenes, notably the Amazonomachies.

223

In the sections that follow the reader will do well to bear in mind what was said in *ARFH* I Chapter Eight, where many of the figures and stories were introduced. It may be remarked that inscriptions identifying figures become progressively less common, although the Meidian vases are quite informative, and they are most welcome where a figure personification appears which would otherwise be quite anonymous. Not all examples illustrated are cited here; see the Index.

The Gods

The signal honour paid to the Olympian family as such in Athenian architectural sculpture is not echoed on the vases. Libation scenes between deities, which began in the early fifth century, continue for a while [25, 92], even sometimes in an apparently terrestrial setting of a blazing altar. They seem to place the relationships of the gods on the same footing as that of mortals, however incongruent the act. Perhaps all such scenes were thought to show the gods visiting earth though not mixing with mortals. This was an activity reserved for heroes (in myth, not art), the outsider Dionysos, for Athena visiting her folk (*ARFH* I *fig.* 101), and for Eros in the boudoir. On votive reliefs (and the Parthenon frieze) where mortals occupy the same field as gods, the mortals are diminished in size, a feature not matched on vases where the honoured deity may attend 'in the flesh' but essentially as an incarnation of his cult statue.

From the 480s to the 420s pursuit scenes of gods or goddesses with boys or girls seem to acquire a special status; not, so far as we can judge, from any literary or stage inspiration. They serve to illustrate the intercourse of divine and hero/mortal, though this is not likely to have been their only or prime function. Bringing the gods 'down to earth' might be thought a function of much in Classical Greek culture.

Accommodation of an Olympian presence in multi-figure scenes of myth is easier, and they can be used to reflect either their special interest in what takes place, or the mood of the event, although sometimes the reasons for their presence are obscure. Their position in the wings of many later Classical multi-figure scenes may become simply conventional.

ZEUS remains an infatigable pursuer of *Ganymede* [77, 82] and of a woman, sometimes identified as *Aigina* [49], into the Classical period. In libation scenes he is with Nike (or is it Iris?), Athena or Hera. A Late Mannerist reverts to the old scheme of the *Birth of Athena* with the diminutive goddess emerging from his head [199]. *Europa* on the Zeus bull is still seen [123], a subject in her own right with Zeus implicit in the story rather than explicit. Otherwise Zeus is mainly an onlooker of appropriate scenes and his council with *Themis* [393] planning the Trojan war, is exceptional.

APOLLO becomes increasingly popular. We have met him receiving worshippers [171]. He is an occasional pursuer of women and joins his sister in libation

[25] or the chastisement of *Niobids* [4] or of *Tityos* [35], where the woman who seems protected from his arrows by a clod of earth may be Ge, Tityos' mother, rather than Leto, Apollo's mother, who had been attacked by Tityos. His role with the *Muses* becomes more prominent now [23, 206, cf. 144, 262]. Later, there are 'court' scenes of him with appropriate attendants, probably including Muses, and often his sister Artemis and mother Leto, the Delian triad probably acquiring some cult importance in these years (Delos was 'purified' again by Athens in 425). This may account for the Later Classical scenes of him riding a swan or a griffin [335, 425], the latter perhaps through his association with the Hyperboreans and the northerly home of the griffins. His contest with *Marsyas* is prominent from the mid-fifth century into the fourth [310, 387, 389]. The piper-satyr had challenged the lyrist-god and is, of course, defeated, but vases often show him playing the lyre himself, and it seems that his conversion to the instrument may have been the theme of Melanippides' play on the subject, which served to introduce the instrument to the dithyramb, an event which may have been celebrated in sculpture too (cf. *GSCP figs.* 61–4, the last a red figure vase). On [310] both the stages in the story are shown, contest and conversion. Mousaios and Linos are musician-heroes [144, 237].

HERMES pursues women [39] and has still to deal with *Argos* for Zeus [76]. As leader of souls (*psychopompos*) and intermediary between the worlds he appears on funeral vases. Otherwise he is attendant and bystander, or carrier of divine infants [22, 126]. His 'herm' is turned to a 'live' Priapus on [155].

DIONYSOS remains a dominant figure and his cult is that most commonly shown on vases. His birth from the unfortunate *Semele*, blasted by Zeus, is shown [333], as well as his second birth from Zeus' thigh [46] and delivery by Hermes to the nymphs and Silenos for education [22, 126]. After the Classical period (perhaps first on the Parthenon; *GSCP fig.* 80.1) he appears as a young, rather effeminate god, but retains his seniority for some drunken scenes or the traditional processions returning Hephaistos to Olympus [162]. His consort *Ariadne* appears with him most often in the Later Classical period [323, 337], especially in the common 'court' scenes where the god is attended by satyrs and maenads [178, 180, 229]. The older symposion setting, sometimes with Herakles, is not neglected [204]. The Later Classical also shows him in more exotic behaviour, riding an animal-chariot or on a panther [379].

HEPHAISTOS is relatively unimportant, despite his cult in Athens, except for his return to Olympus and role at the birth of Athena. POSEIDON molests Amymone still [316, 383] and sometimes confronts Athena, as on the Parthenon [331]. ARES is still merely an extra. The cult of ASKLEPIOS was introduced to Athens in 420 and the infant god is seen on [305] in the arms of his nurse Epidauros (home of his original cult in Greece), attended by Eudaimonia (Good Fortune) and another personification.

ATHENA is somewhat less prominent than we might have expected. Her birth may have dominated the front pediment of the Parthenon but no longer much

interested vase-painters [199]. Her civic role, accepting young *Erichthonios* from Ge, is more important [238, 250, 322], and there are other peculiarly Athenian scenes (as with the giant, building the Acropolis [248]) attending Attic heroes or kings [106, 334]. She still stands by Herakles, and he by her on Olympian occasions.

ARTEMIS shares something of her brother's popularity and her harsh treatment of *Aktaion* remains a popular Classical theme [13]; his translation into animal form begins to be shown [152]. Her huntress role becomes more prominent [376] and she may ride a fawn, griffin or deer, but the old winged Mistress of Animals is not forgotten [215].

DEMETER and PERSEPHONE are important from the mid fifth century through the fourth and there are several Classical scenes of the young goddess rising from her sojourn in Hades to earth (the *anodos*; [121, 160?]). *Triptolemos* on his winged throne bringing agriculture to mankind may appear with the goddesses or on his own [10, 315, 372]. Eleusinian initiation is a subject for fourth-century vases, as we have seen. For Persephone in the underworld see [184, 239].

With the new interest in the life of women APHRODITE, commonly with her child EROS, achieves a new status and importance, especially in the Later Classical period. Scenes of her birth, arising from the ground [86, 377] or, less commonly, emerging from the sea in a shell, now appear. She, and especially Eros or a plurality of Erotes, attends scenes of bridal preparations; her own love life is depicted in scenes with the luckless *Adonis* [285], who was to be killed by a boar, but whose eastern-inspired cult was of more moment in Athens (see above), or rejuvenated *Phaon* [161, 300], the handsome boatman of Lesbos. She may ride a goose [67] or, as Epitragia, a goat; her chariot is drawn by Pothos and Hedylogos (Desire and Sweet-talk; [304, cf. 286]). Weighing Erotes in a balance (*erotostasia*) is puzzling; neither quite moralizing nor mercenary [418]. Eros remains adolescent, often alone with mortal women but with a boyish life of his own, hunting [364], with animals or at play [307], or in a more serious role at sacrifice [345] or admitted to the Dionysiac troupe. He pursues boys and, in the Classical period, girls [203].

The principal Olympians are not so often now seen together in council but their fight against the giants, very popular in earlier days, remains an important theme, and its prominence in major art suggests that it conveyed a message about the rule of law or dominance of the Greek pantheon. Some giants are still dressed as hoplites, but they become wilder creatures, naked or with animal-skins and throwing stones. Fewer individual duels are shown; they are more often set side by side in a frieze [6, 9, 10, 158, 289] or spread in the fine up/down compositions of the late fifth century [326, 327, 329, 330]. Zeus, with bolt and chariot, sometimes driven by Nike, with Athena and bowman Herakles, remains the focus; goddesses wield spears, the Eleusinians their torches, Apollo and Artemis their bows, Dionysos (sometimes backed by satyrs [32]) his entangling vine and animal familiars, Hephaistos throws coals, Poseidon uses

an island missile. A greater range of lesser deities are allowed to join the mêlée.

Several minor deities and upgraded heroes are given Olympian status in our period. The DIOSKOUROI, sons of Zeus but mortal Laconian heroes who may still be seen raping the daughters of Leukippos [167, 287], are found in an Olympian setting, or in Eleusinian initiation scenes. They are dressed as travellers, often wearing the pointed *pilos* hat and on horseback, sometimes over sea [130, 416], and at a *theoxenia* on [312]. PAN, who had acquired a mainly human physique (*ARFH* I *fig.* 335.1) settles for a human upper part with a goatish horned head and goat legs and tail [347, and cf. 5, 86]. He joins the Dionysiac *thiasos* and may attend various mythical events, especially those set in the outdoors. IRIS is seldom identifiable after the mid-fifth century but her lookalike NIKE, is everywhere, attending victors [202, 226, 242, cf. 149], driving chariots [192], erecting a trophy [54], offering libations (where confusion with Iris becomes possible), sacrificing [84, 141]. HEBE's role is with Herakles, his bride on Olympus. The dressing of PANDORA by the gods and her emergence upon earth is the subject for some Classical vases ([5, 170, cf. 73]; and for the base of Pheidias' Athena Parthenos – *GSCP* pp. 110, 174).

Big fights

AMAZONOMACHIES take on a new significance after the Archaic period, when they were mainly centred on Herakles. Theseus becomes the central figure, though not always readily identifiable, once the battle becomes that for Athens itself and not an overseas expedition; in this it is patently used as a parable for the Persian invasions of Attica and repulse, first at Marathon, then from Greek soil after the sacks of Athens, victories in which Athens took especial pride. The Greeks are often identified as Attic tribal or local heroes. The Amazons may still be dressed as Greek hoplites or archers, but come to be given Persian dress, making the point of their role the clearer. Most of the scenes are Classical, declining in the fourth century. Amazons were respected foes and can be shown arming or at ease [132, 222, 236].

CENTAUROMACHIES also involved Theseus, helping his comrade Peirithoos against the beasts who had disturbed his wedding. This story too seems to have held a message for the Athenians, though more obscure, perhaps reflecting on the barbaric behaviour of northern Greeks during the Persian troubles. We see the fight at the feast [50, 185, 339] and the subsequent battle (including the battering of *Kaineus* [37]), and conflations of the two. They decline in numbers in the fourth century.

A new fight, exclusive to the fourth century, is the GRYPOMACHY [342, 380, 408, 414]. *Arimasps*, shown as orientals, fought the griffins who guarded gold. The fights are shown, and foreparts of the belligerents. GIGANTOMACHIES have been considered with the Gods.

227

Herakles

The most active and popular of the Archaic heroes cuts a very different figure in the Classical period. Very few of his basic Labours and other exploits are shown, and then seldom, with the notable exception of the Hesperides Labour, which changes character in a significant manner [287, 378, 420]. Instead of the fight with the snake guarding the tree, or the hero supporting the world for Atlas, he sits or stands quietly observing the maidens gathering the apples for him. The apples guarantee immortality and he is often shown already rejuvenated, in a garden Elysium. The alternative story of his apotheosis, his self-immolation on a pyre, tortured by the poisoned robe sent (not handed to him as on [212]) by Deianeira, and ascent thence by chariot to Olympus, seems to have been a comparatively late invention. The pyre is seen in the 460s, then with the rising chariot, driven by Athena or Nike, added, leaving behind only his mortal husk, indicated by a body-corselet [311]; then, into the fourth century, the chariot drive alone [348, 354]. On [11] he is introduced to Zeus by Athena, on foot, in the Archaic scheme, and on [400] married to Hebe at an Olympian reception.

More attention is paid to his early life: wrestling the snakes in his cradle [196], going to school [68], marrying [41], with wife and child. There are some groups of special scenes. His intervention with *Prometheus* in the late fifth century may be stage-inspired. About the same time begin scenes with him carrying or attending an old man with a cornucopia [373], perhaps relating to a new or revived cult shared with the shadowy figure of *Palaimon*. His sacrifice at the rock altar of *Chryse*, on his journey to Troy, is another novelty, perhaps inspired by new Athenian interest in Lemnos [313]. Some of the older, familiar subjects recur, and new is his rescue of Theseus (or Peirithoos) from Hades ([47], cf. [184, 214]).

He is usually shown naked now, but for the lionskin, and his weapon is invariably the club; a new occasional attribute is a cornucopia [353]. He is more often beardless, especially at the end of his career, with the Hesperides or on the way to Olympus, and he sometimes retains his Archaic rolling eye. His cult in Attica was important and there are scenes (on votive reliefs too) of him seated at a small columnar shrine [346, 385]. There are many early fourth-century scenes of his 'court', with the hero seated centrally and being honoured or served by various deities (Athena and Nike are prominent) or satyrs and maenads [346, 353, 374, cf. 131]. He is often with Dionysos.

Theseus

The new cycle of deeds created at the end of the sixth century is presented as a cycle still until late in the fifth century [81, 181, 240]. Of individual scenes only the encounter with the bull of Marathon survives the Classical period at all strongly [334], and the Minotaur is also singled out [292.1, 338], often in an interesting architectural setting suggesting the Labyrinth. In the Classical period, dressed as a traveller, he pursues women. He had attacked his mother

Aithra on an Archaic vase (by Makron) but this is not likely to be her. Later, where the woman drops a cup or jug, she is *Medea*, intent on poisoning him until his recognition by his father *Aigeus*, sometimes also present (cf. [*164*]). His role in Amazonomachy and Centauromachy has been noted above.

The Trojan Cycle

The story of Troy is quite well served, if with a somewhat different range of scenes. Of the preliminaries, *Peleus* pursuing *Thetis* [*390*] and wedding her are still shown [*89, 137, 142*], the *Judgement of Paris* (the goddesses still dressed and Paris often an oriental) [*34, 244, 294, 296, 428*], and there are domestic scenes of Paris with *Helen* [*244, 308, 362, 381*]. In camp, *Achilles* is an important figure, arming, or being rearmed by Thetis and her attendant Nereid sisters, on foot [*18, 31*] or waterborne [*231, 366*]. His muffled figure on the former recalls the earlier 'silent' Achilles (*ARFHI figs.* 166, 270, 304.1, 332). Most of his, and other Trojan fighting scenes disappear, but there is an odd treatment of his death from the arrow deflected by Apollo to his heel [*8*]. There is a general dearth of action scenes but for some of *Diomedes* (and *Odysseus*) stealing the Palladion from Troy [*363*]. The Sack of Troy is no longer shown as a cycle after the mid-century, but individual scenes survive, notably the rescue of *Aithra*, rape of *Cassandra* [*1*], and *Menelaos* recovering *Helen* [*119, 309*]. After the 420s the Troy story virtually ceases to interest the vase-painter. The story of *Iphigeneia in Tauris* [*350*] is surely inspired by a play, as is *Orestes'* attendance at his father's tomb [*361*] and subsequent problems at Delphi with the Furies [*198*]. His killing of Aigisthos [*36*] is an older theme. *Telephos* seizing the infant Orestes as hostage [*357*] must also be stage-inspired.

The ODYSSEY fares no better, with scenes concentrating on Odysseus' private adventures or life: with *Nausicaa* [*194*], his visit to the underworld [*150*], his homecoming to Penelope [*246, 247*].

Other heroes and cycles

There are few scenes from the THEBAN CYCLE: *Polyneikes* bribing *Eriphyle* to send Amphiaraos to Thebes [*28*], Athena withdrawing immortality (Athanasia) from the cannibal *Tydeus* [*218*], the mêlée at Thebes [*15*]. *Kadmos'* encounter with the serpent is another Theban story, seen on Classical vases [*19*, cf. *103*], as is *Oidipus* confronting and killing the Theban Sphinx [*111, 303*], and as an infant [*110*]. The ARGONAUTS are slightly more popular than hitherto. There is *Jason* with the fleece [*43*], the episodes with the brazen giant *Talos* in Crete, bewitched by Medea [*324*], and with the Boreads driving away the robber Harpies from *Phineus'* table.

Atalanta fights Peleus (misnamed Hippomenes on [*143*]) at the games for Pelias (and cf. [*88*]) and in a unique scene prepares for the famous footrace [*179*], where she will be distracted by the golden apples, here being given by Aphrodite

to the future victor, via Eros. In about 400 she is seen with hunter companions, including Meleager [*336*], perhaps inspired by Euripides' treatment of their love-match, and the *Calydonian Boarhunt* is revived in a fine fourth-century composition [*384*] – she appears top left as an oriental, with her bow. Notice also the huntress on [*216*].

Boreas pursues *Oreithyia* still in the Classical period [*30*], as does *Eos* the hunter *Kephalos* or schoolboy *Tithonos* [*61, 93, 112*]. On [*351*] the preliminaries for the fatal race between Pelops and Oinomaos recall the great east pediment at Olympia (*GSCP fig.* 18) in subject only. *Andromeda*, the subject of plays by both Sophocles and Euripides, is staked out for the monster to trees or a rock on fifth-century vases, but Perseus is not often seen with her [*125, 166, 169*]. He is, however, found still as an infant with his mother, castaways in a chest [*127*], and dealing with a comparatively humanized *Medusa* [*136, 197*] and a petrified Polydektes [*217*], who had sent him on what should have been the fatal mission. *Helle* and *Phrixos* attempt to escape on their sea-going rams from their jealous stepmother Ino [*367*] – a new story for vases.

The death of *Orpheus* is still shown in the Classical period [*64, 122,* cf. *189*], and to the end of the century, the blinding of the bard *Thamyras* by jealous Muses [*165*]. *Bellerophon* is a rarity [*317, 349*] – there was a sculpture group of him with the chimaera on the Acropolis (*GSCP* p. 170). *Lykourgos* [*332*], like Pentheus on earlier vases, was driven mad by Dionysos.

Other figures

Personifications of abstractions, normally by figures of women and only identifiable by inscription, are a feature of Classical and later vases. Usually they suit the mood of a scene or help positively if clumsily to interpret it (as Athanasia on [*218*] and Peitho on [*309*]). The heavenly bodies too enjoy corporeality: Helios [*296*] and Selene had long been shown with chariots, or the latter on horseback, and they are joined by various stars [*145*] and planets. There are also some less obvious personifications of place (Phyle [*345*]; Sparte [*365*]) and Games [*149*]. *Thanatos* and *Hypnos* (Sleep and Death) remove the dead from the battlefield, or to a grave, and *Charon*, dressed in a skin cap and coarse tunic, ferries the dead on funeral vases. [*184*] is devoted wholly to underworld figures.

Pygmies, sometimes carefully characterized as dwarfs, fight the Cranes [*107, 148, 411*], as they had on much earlier vases. *Satyrs* have changed little in their way of life and attitude to maenads [*65, 168, 360*] since the Archaic, but in the fourth century there is a tendency for their form to become more goatish than equine, sometimes with shorter goat tails, and even tiny horns, perhaps influenced by their new companion, Pan. Of their unlucky Anatolian cousins Marsyas had problems with Apollo (see above) and Silenos faces Midas [*139*] who sports the donkey ears which were either inflicted on him by Apollo or are an indicator of his own satyric character.

Chapter Eight

TECHNIQUES, PRODUCTION AND MARKETING

In a tradition of pottery-decoration in which figure scenes played a vital role it is not surprising that the overall appearance of the vases should differ markedly from those of other cultures whose pottery we prize (the glazed wares of China and Japan, for example) and that techniques should have been devised to abet the aims of the decorator. Colour becomes of less importance than clear definition of decoration, and this was much enhanced by the ability to produce a very fine, and intense black paint which is also glossy but without such a highly reflecting surface that detail and contrast are obscured. The techniques were developed in the Greek Bronze Age, but perfected in the sixth and fifth centuries BC in the service of the best figure-drawing.

There was good potters' clay in many parts of Greece, and notably in Attica, which is our prime concern here. The sedimentary beds produced a clay rich in iron which gives the characteristic ruddiness of the fired clay and also assists the production of the black gloss. Primary clays which are white (kaolin) and used elsewhere for porcelain were available but not used for the body of vases, only for special effects or slips.

The throwing of a vase on the wheel is a process familiar to most of us and practised in ancient Athens with no especial tricks that we can detect. Some vase representations show that the wheel was turned by an assistant squatting beside it or by the potter himself for work at which he could spare a hand. Major parts of the vase would be thrown separately – the necks of amphorae and hydriai, the feet of stemmed cups – and it is likely that the potter made several individual parts in one batch, and then fitted necks, feet and lids to bodies. A good potter requires no templates or mechanical aids to reproduce size and profile to a very high degree of consistency. The assembled vase, by now leather-hard but not brittle, was then returned to the wheel for the turning, in which clay was pared away, especially at foot and lip, to produce the fine definition of profile which we misleading call metallic. The technique is the carpenter's with his lathe, transferred to clay for this refinement of shape, as it was eventually (in the second half of the fifth century) to metal vases.

Attic clay required no substantial slip to provide a good surface for decoration, such as was needed in many other parts of Greece. On many of the finer Athenian vases, however, and especially in the Archaic period, the surface was coated with red ochre (ancient *miltos*) before the decoration was applied. This intensified the redness of the clay but is seldom preserved on the vases as we

see them today. Where it is, the darkness of the red is surprising since it considerably reduces that contrast of the clay ground with the black which, in modern photography, we increase towards an almost black and white effect.

The black gloss paint is in fact a slip, of the same basic composition as the clay body but more refined (levigated) and possibly otherwise treated so that the iron content gave full value to the desired black under controlled firing. A special 'intentional' or 'coral' red is met in the Archaic period, as a background to some black figure (*ABFH* pp. 57, 106, *figs.* 104.3, 170), exceptionally for red figure (*ARFH* I p. 18) but sometimes replacing the black round the interior tondo on red figure or white ground [*108*] cups or beneath the figure friezes outside them (ibid., pp. 30, 56, 132, *fig.* 26.1), once covering the whole of the body of a volute crater, and in occasional use for special vases down to the mid-fifth century. It is a glossy orange-red in tone, sometimes quite deep red, apparently again the result of careful levigation of the body clay to a degree slightly coarser than that required for the black gloss. White, produced by the use of a primary clay, could also be used in bands on cups, as with coral red, but more frequently as a background to black figure (*ABFH* pp. 35, 106, 147–50; *ARFH* I pp. 15, 18, 36), exceptionally for red figure (ibid., p. 17, *fig.* 4), and, in the fifth century, as background to outline drawing, as on the numerous white lekythoi, alabastra, and a few other shapes (*ARFH* I pp. 114, 132–3, 139, 180, 195; and above, Chapter Four). Of the colours employed over the white a range from brown to yellow could be achieved by varying the haematite content of the usual but thinned mix for black gloss, blue is from powdered glass frit, green from a copper compound. The white and purple-red on black figure is from primary clay and red ochre respectively, most freely used in the incising 'Six technique' (*ABFH* p. 178, *figs.* 309–14; *ARFH* I pp. 18, 36, 60). Gilding is seen occasionally in the Archaic period (*ARFH* I p. 56) and again from the end of the fifth century. Relief and figure vases are made from moulds, retouched by hand, with thrown feet or lips added, and moulded reliefs can be applied to thrown vases.

The paints, or slips, were applied by bristle brushes, broad areas being painted with the vase turning slowly on the wheel, and figure work with the vase in the hand. The relief line has been discussed already (*ARFH* I pp. 12, 89), probably applied with a thin bristle, although a syringe has been suggested, or a hair, dipped in the paint and laid on the vase – neither technique seems probable; both are cumbersome and do not adequately answer what we see on the vases. In black figure the painter could make a guiding sketch by brush or light incision; in red figure by light incision, or rather by gently bruising the surface of the vase. The lines are readily seen, especially where the ochre wash has gone, and they betray changes of composition by the painter before he picked up the brush.

The black/red effect, produced by basically the same clay for body and slip, depended on careful firing. In a clean, oxidizing atmosphere, both turned red. A smoky, reducing atmosphere was then introduced in the kiln which turned both black. The reintroduction of an oxidizing atmosphere returned the body of the

vase to red before it affected the black paint slip, though overfiring could turn it back to red also, a mistake sometimes to be observed on vases, which also may display some unevenness in coloration through draughts or bad circulation of the gases in the kiln. Another kiln mishap, through allowing vases to touch, is the appearance of 'ghosts', which are partial transfers of the decoration of one vase on to its neighbour. When vases, usually open shapes like cups, are stacked within each other in the kiln to save space, areas within a vessel covered by the foot of another will not always fire properly and stay an oxidized red.

The principal characteristic of Athenian vase-making in the sixth and fifth centuries is the clear evidence for the potter's readiness to take infinite pains over preparation of clay, slips and pigments and his attention to careful firing. It has taken modern science long to discover the essential simplicity of these techniques, meticulously applied, rather than of any obscure formulae, mystery compounds or multiple processes. It is remarkable that these techniques were applied to what became a minor craft, but we must recall that they were first developed for the work of artists whose draughtsmanship on pottery must have rivalled that on any other medium of the day for its finesse.

A word should be added here about restorations and forgeries. Very many of the vases we see in public collections outside Greece were collected early in the last century and subjected to extensive restoration and repainting, sometimes with the addition of colours and inscriptions, and the painting of whole new figures or parts of figures on missing, plastered areas. Not all such restorations have been removed and some can still mislead us although sufficient experience in looking at the real thing is usually adequate safeguard. Photographs, however, can easily deceive. Like the vases in the early collections, most new acquisitions by collectors and galleries are also from Italian tombs, and a large proportion have probably been illicitly exported, although the remarkable wealth of old private collections still stocks many a sale room. Modern methods of restoration range from the utterly honest, which shows plaster as plaster and repaints no more than the occasional crack, to a total counterfeit (as is common with oil paintings) of what was thought to have been on the vase originally. These are not so easy to detect. Moreover, these new acquisitions naturally have no stated provenance and among them there can easily be forgeries. Early forgeries are usually easy to identify, with experience; techniques are inadequate for the firing and the drawing inept. Modern forgeries, however, are often technically perfect and the scenes upon them are carefully researched. Various different factors may arouse suspicion and support one's instinctive reaction against too good a 'new' vase. Replicas, as we have seen, are most uncommon in Athenian red figure, but the forger is readily tempted to copy or to combine copied models. Sometimes he is too clever with his iconography, or fails to maintain consistency of treatment and detail in a single scene. We can say this of those that we dismiss; others may pass the tests and still be wrong. I would not be surprised if at least one of the vases I have illustrated in these handbooks is

modern, though most that I have chosen have been long known. Thermolumin-escence tests can indicate the approximate date at which clay has been fired; but if an ancient vase has been refired in recent times, to restore its colour, it will be declared modern. And ancient vases might be repainted and fired to below the crucial temperature so that their bodies pass the tests as ancient; nor, in such a very lucrative market, should we underestimate the ingenuity of the forger in irradiating his product so as to confuse the test. The more sophisticated tests are more secure but expensive.

Having considered how the vases were made and decorated we may consider *where* they were made. The Athenian potters' quarter, the Kerameikos, lay north and west of the Classical Agora (market place), within the walls near the Dipylon Gate and had once occupied the Agora area itself. It gave its name to the district (deme) Kerameis, which extended outside the walls. The workshops of our period have not been excavated (the 'Kerameikos excavations' are of the cemetery outside the gate), but a hoard of Jena Painter vases was found in the area (modern Hermes St.) and was perhaps from a shop. Classical kilns have also been found outside Athens' north gate (the Acharnian), so the area occupied by the industry may have been greater, or less concentrated, than we imagine. The clay came from any of the rich beds outside Athens; those at Amarousi (on the road to Mt. Pentelikon) are still used, and there was finer clay at Cape Kolias, near Phaleron. The kilns and shops lay mainly within the city, it seems. The roughest of calculations suggests that there could have been at least a hundred vase-painters at work at any one time in the hey-day of production, down to the Classical period (declining considerably thereafter). But many must have been potter/painters, and all need not have spent all their time painting pots rather than walls, or wooden panels, or, the better of them, being engaged in some other craft. We identify the specialists by their plentiful extant production, perhaps barely one per cent of their total output, at best three per cent. Vase-scenes showing potters' studios have them quite populous, but we need not take them literally. There must have been small family establishments, and some prestigious workshops employing (not perhaps always at the same time) several different artists, as well as mass-production units like the Penthesilean workshop. In the period dealt with in this volume there are fewer signatures of potters or painters and the names seem less informative than they were in the Archaic period (*ARFH* I pp. 9–10); we have observed the piracy of the name of the famous muralist Polygnotos by three painters. The few potter/painter signatures which indicate Athenian birth might, I imagine, imply some element of non-Athenian competition in the potter's quarter or in the trade.

Production must have been primarily for the local market and the potters must have displayed their wares, but there was a brisk export market too, considered below. 'Sets' of vases were no doubt provided. A 'dinner service' might have been decorated with related themes, but this is no more than a plausible guess and the 'services' seem not to have survived for us to recognize in

Etruscan tombs, our principal source for complete vases. 'Wedding sets' of lebetes gamikoi, pyxides and lekanides may also have been provided, for home and for export to the Black Sea; on these there was normally congruity of theme at any rate. Otherwise pairs of vases, or small sets (like the Sotadean [*100, 102, 103*]), can be identified, with complementary scenes. Replicas (and none of them line-for-line replicas) are exceptional [*290–91, 329–30*]; another reason for doubting the existence of anything like pattern-books used by painters.

It has been suggested that finer vases were bespoke for special occasions (symposia) and then exported, secondhand. This might be true of some; we cannot tell. It was certainly true of the Panathenaic prize vases (*ABFH* ch. 7). But there was also mass export of batches of the same shape and workshop, as we can judge from finds in shipwrecks or guess from the odd pattern of distribution in remoter places. Graffiti on vases (generally on the feet) seem to indicate batches, or give codes for individual traders, and sometimes indicate price. We may assume that a merchant would make up part of a cargo by purchase in the potters' quarter, and himself (or his agent) accompany it and other commodities to the intended market, in Greece or overseas. A 'hoard' of craters by a Classical painter found in the Piraeus may be a mislaid or damaged consignment. The merchants might not be Athenian, or even Greek, to judge from one or two pre-fired painted inscriptions in Etruscan (one indicating a gift) which seem to have been bespoke in Athens. The vases were packed in rubbish and shavings, probably in baskets, and many shapes could be stacked, as they had been in the kiln, or small vases packed within large ones, for security and economy of space.

The evidence about prices is skimpy. It seems likely that a smallish decorated vase – a lekythos or cup – might cost one drachma; a larger one – a hydria – two or three. The very large and elaborate vases must have been much more expensive; the small, mass-produced, probably dozens to a drachma (which was very roughly one day's wage). The determining factors were probably size (difficulty of throwing and firing) and number of figures (compare the payments per figure for sculpture on the Erechtheion, *GSCP* pp. 148–9). Calculations based on the weight of the vases and the volume of cargo space they would have occupied indicate that decorated pottery compared well in absolute value with any of the other staple commodities of trade – oil, wine, corn. The difficulties involved in the transport and packing suggest that the profits must have been well worth the trouble. This is at any rate clear from the numbers and distribution of the vases in and outside the Greek world. The raw materials involved in making the vases were inexpensive (clay and fire), and for most of this period Athens enjoyed a monopoly in the product. There were some feeble local wares, some imitating Athenian red figure, in other parts of Greece, and the South Italian and Sicilian market (a Greek colonial area) was lost once the local workshops were in full production in the second half of the fifth and the fourth century (see *RFSIS*).

After the Archaic period, Etruria remained a major importer of Athenian

vases but there was a marked decline in the third quarter of the fifth century followed by an almost complete halt except in the north where, at Spina, import was strong from the Early Classical period on to the end. These vases had travelled up the Adriatic and not through the straits of Messina. Etruria was making her own red figure vases, though not many, and the decline is the result of worsening relations and trade with Greeks in general, not Athenians in particular. The value of the vases to the Etruscans is indicated by the way that many of them were mended with lead clamps after accidents en route or at home – far more than we observe on vases which stayed in Athens. There is some decline in export to Spain and France after the mid fifth century, but a wreck off Mallorca was carrying a lot of poor fourth-century Athenian red figure and black vases. In the fourth century there is a surge of export to the Greek cities of the Black Sea coast and to Cyrenaica, a symptom of the new importance of these areas to bulk trade in foodstuffs. In homeland Greece the vases are well distributed, and the finds in the houses of the north Greek city of Olynthus show that they were not simply bought as grave goods, though even the tomb of Philip II of Macedon, Alexander's father, contained a simple Athenian red figure askos and black vases beside the gold and silver. Vase shapes of peculiarly Athenian significance generally did not travel, but the white funerary lekythoi and the small choes are found in quantity at Eretria, where Athenians had settled. Cups are the favourite export shape everywhere except in Sicily which seems to have been greedy for lekythoi. The export of Athenian pottery seems to have been only minimally affected by Athens being in a state of war, either with the Persian bloc or with other Greek states; a further indication that much of the trade and carrying was probably not in Athenian hands. It is clear, however, that there was an overall decline in production throughout this period, only partly offset by a rise in the production of plain black vases (mainly the smaller shapes).

The volume of trade suggests no mere disposal of surplus production, so if there was deliberate production to meet the demand we might ask whether the demand affected the product. This was true in the Archaic period, when Etruscan shapes were deliberately copied for the market (*ABFH* p. 64). In red figure there are rare copies of South Italian native (not Greek) shapes, and some sites seem to have favoured unusual (but Athenian) shapes, such as Spina and its reception of stemmed plates of the later fifth century. That subjects were chosen for decoration with the overseas customers in mind seems unlikely. The popularity of the obscure story of the Arimasps who fought the griffins might indeed have been inspired by the new Black Sea market, since the myth was placed in the distant north, but if so the vases decorated with this subject were not reserved for that market. The scenes simply joined the standard repertory and the vases so decorated travelled south to Africa as readily as they went north. Some exotic subjects may have been chosen or bespoken individually, by donors or dedicators, to take overseas, but that is another matter. It might explain, for instance, the Persian and his camel from Egypt [*101*].

Chapter Nine

SHAPES AND USES

The approach to Athenian vases in these volumes has been directed mainly to the demonstration of the work of individual craftsmen and the style and subject matter of the decoration. The vessels themselves have been treated as artefacts, sometimes even as 'works of art' (in the modern sense; the description is virtually meaningless in terms of Classical antiquity). The development of shapes was discussed in separate chapters in *ABFH* (ch. 9) and *ARFH* I (ch. 5). In the period dealt with in this volume no important new shapes are introduced and the changes in form are adequately described in earlier chapters and referred to briefly at the end of this one. It is perhaps more useful here to consider the range of uses to which they were put, to consider how these might have determined or affected their shapes, and to what extent these shapes were traditional or influenced by other media. An extreme recent view on the last topic has them mere slavish copies of vases in precious metal, so there is call for some quiet reflection on shapes and uses, and consideration of the role of these clay vases, the most varied and plentiful material testimonia that we have for Classical Athens.

Most clay shapes were traditional and their designs were developed to meet specific functions – storage, pouring, carriage, drinking, mixing. Most were dictated by their medium as well as their function, and the ready malleability of clay, together with the potter's-wheel technique which favoured the strictly circular in plan. Sawn wood favours the rectilinear, for chests, boxes, and decorative panels, but when wood was worked on a lathe, as it had been for centuries for both vessels and furniture, it produced forms very like those easily achieved in clay. Wood must lie behind many familiar vase shapes, especially plates and round boxes (whose name, *pyxides*, reveals their origin in boxwood), and perhaps even larger vessels such as the earliest bell craters with their lug handles – a wooden form – though the vessel's shape itself might derive from basketry. The turning of wood on a lathe is most closely related to the turning of vases, to refine mouldings and detail. The elaboration of the underside of clay plates derived from this technique which was, from the second half of the fifth century, also applied to metal vases, so that there was considerable similarity in treatment of this feature in clay and metal (and, we may be sure, wooden) vessels.

Dumpy and sagging shapes, the round *arballos*, *pelike* (as [*81*]) and *askos* [*317, 426*], probably derive from skin vessels; the *rhyton* takes the shape of a horn;

basketry suggested various round boxes and straight-sided *kalathoi*; the *alabastron*, in name and appearance, recalls its Egyptian stone prototype.

Metal vases were obviously far more valuable in antiquity, and therefore far rarer, and even yet rarer in the archaeological record since the material could be so readily re-used in a way that pottery cannot. One-piece hammered or cast vessels are the most efficient since the rivetting or soldering together of parts can be a source of weakness, as can sharp corners, but luxury material encouraged luxury treatment, and although much silver, for instance, was fairly summarily worked into convenient shapes (the *phiale*) virtually as bullion, table ware was elaborated with cast or hammered details applied – relief decoration, figure handles, and the like. The techniques of making the cast features were basically the same as those for making moulded details for clay vases, but in the Classical period the clay forms took their lead from the metal, sometimes, it seems, even using moulds taken from metal originals. Linear decoration on metal, by incision, is as the black figure technique on vases, clumsier and less subtle than what could be achieved by a brush and by varying mixes of paint and pigment. Decoration by impressing or punching was a very old technique in clay but, as we see it on some Classical vases, it seems to follow metal. The metal vases were as open to influence from other media as were the clay and there are hardly any basic clay vase forms which seem essentially metal-inspired (the lebes/dinos [*116, 178*] is an obvious exception), though in Greece some derive from foreign prototypes in metal (the phialai and some rhyta and figure-vases, shapes introduced from the east in early days but with fresh inspiration from fifth-century Persian booty).

This is the place to mention also the plain black vases ('black glaze') which were being made in increasing numbers through the fifth and fourth centuries, though the genre had been long familiar, and not only in Athens. Shapes are as for the decorated vases, except for some vessels which derive from metal – e.g., 'salt-cellars' and 'bolsals' (deep stemless cups, named after specimens in Bologna and Salonica). The punched patterns, probably of metallic inspiration, best suit the black vases and appear sometimes on the decorated (cup interiors). Many are finely potted, thin-walled, and quite close to metal shapes. They were of course cheaper than decorated vases. We admire their taut shapes and austere blackness but need not believe that fifth-century Athenians were similarly moved. Their shapes and their glossy blackness owe much to the model of metal (silver) vases, but the absurd deduction that silver vases were deliberately made or left black in Classical Athens is easily refuted, and the history of the black clay shapes and their decoration has to be understood in a broader context, as we have seen.

We turn now to uses. A high proportion of Athenian decorated vases was made for use at the feast, and not so much for eating as for drinking – the *symposion*. It is odd that Greeks should have continued to favour two-handled cups for drinking, given that, reclining on a couch for a symposion, only one hand is easily available for handling a cup. There are one-handled shapes, like

mugs, but these are never shown used for drinking, at least at the symposion, and are generally classed with oinochoai (pourers) though they do not have pouring lips. The cups provided frieze and circular fields for decoration and some are clearly more for show than use (e.g., the Penthesilea Painter's cups [80, 81], 43 and 72 cm across). Ordinary stemmed cups are generally little over 30 cm across but only four or five centimetres deep; there must have been a lot of spilling. There are some special forms, such as covered cups with strainer mouths. *Craters* are used for mixing the wine and water; in vase scenes they sometimes appear at the symposion, but the cup-boy is commonly shown leaving the party to fetch more wine, and it is likely that the mixing was usually done in the anteroom or courtyard. The special shape for cooling wine (the mushroom-shaped *psykter*, set in a crater) disappears in the Early Classical period. The *stamnos* is the only wine-mixing shape which may be lidded and its appearance in some ritual Dionysiac scenes [24, 177] suggests special use (possibly, at least on occasion, for unmixed wine). The pourer *oinochoai* explain themselves, and the variety of shapes (cf. *ARFH* I p. 209; [29, 76, 219–224]) suggests a variety of influences, notably metal, especially for those with beak-like spouts.

Some vessels are designed for special (i.e., not bulk) storage. The *amphora* is the obvious example. Many Archaic examples are very large and some imitate storage shapes (pointed [31] and Panathenaic) and so may have held wine or oil (cf. *ABFH fig.* 215). Smaller examples found through the rest of the fifth century (the shape virtually disappears in the fourth) might have held various wet or dry commodities. The neck-amphorae, notably the small Nolan amphorae, have grooves within the lip for a lid or stopper and it is quite probable that they were exported with contents – oil, olives, fine wine. The *pelike* was especially for oil, to judge from vase scenes (*ABFH fig.* 212) and its suggestive sagging shape. Portable oil-dispensers were probably generally of skin (part of an athlete's standard equipment) and the *squat lekythos* was for the table rather than for suspension from the wrist. The tall lekythos, which held less than appeared, is also for the dressing table, when not for the tomb (see below). There are also exotic versions: acorn lekythoi [297] and small figure vases. The *hydria* is essentially for carriage and pouring (water) but the larger ones are probably mainly for display and the very small ones for any liquid. The word *kalpis* is used to distinguish the one-piece Classical type from the angular Archaic hydria.

A feature of the decoration of vases from the Classical period on is the number devoted to scenes of the life of women. They appear on appropriate shapes, ritual (see below), or for the boudoir – little boxes (*pyxides* [89, 91, 399, 427]), *lekanides*, small hydriai, *epinetra* (knee covers for carding wool [235]). The potters had identified a new market, substantial if not as reliable as that for the symposion, and their recognition of it says something (different things to different scholars) about changing attitudes to women in the fifth century. The lekanides, lidded or not, are a new or revived shape, virtually ignored in the earlier fifth century.

The finds on the Athenian Acropolis show that any vase shape, symposiac, feminine, even sometimes funereal, might be used for dedication. We have fewer examples from this source in our period since the really rich finds are Archaic, generated by the dumping of material after the Persian sack in 480/79. Clay plaques, imitating wood or stone, are very rare. Oil was used in funeral rites, and oil flasks were buried with the dead, and placed at the tomb in post-burial ceremonies. We have seen in Chapter Four how the white lekythoi came to serve these purposes, and these only. The *loutrophoros* [*134, 191*] and *lebes gamikos* [*40, 388, 403*] serve marriage rites (the fetching and storage or heating of water for the bridal bath). This is apparent from their appearance in vase scenes and the decoration of the vases themselves (we must not think of bathing by immersion, but the pouring of water over hands, feet, perhaps head [*391*]). The loutrophoros is also a grave vase [*38*] and could serve as a grave monument [*267*]. This accounts for the funerary and battle scenes on some, which may be regarded as commemorative, or appropriate gifts for the tomb [*113,* cf. *176*]. The Huge Lekythoi [*284*] are exceptional as grave markers. We considered in the last chapter the modest extent to which shapes may have been influenced by the overseas trade in decorated pottery.

The development of individual shapes has been discussed in earlier chapters. The most notable change is the reduction in both numbers and varieties of shape decorated in the fourth century: neck-amphorae disappear, as do crater shapes except the bell (though this too declines) and calyx, and tall lekythoi; there is less variety too in oinochoe forms, and cups are more commonly stemless; only the lekanis finds new life. The general tendency to elongate forms, spread lips and bases, and inturn handles, is apparent on many shapes, and the overall floridity of form and decoration record a change of taste which we should not interpret as a sign of decadence simply because painted pottery is in decline, since it is as readily apparent in other, costlier media, which probably gave the lead.

429 Polychrome chous. Men carrying spit with obelias loaf-cake

ABBREVIATIONS

AA	Archäologischer Anzeiger
ABFH	J. Boardman, *Athenian Black Figure Vases, a Handbook* (1974)
ABV	J.D. Beazley, *Attic Black-figure Vase-painters* (1956)
ÀDelt	Archaiologikon Deltion
AGAI	Ancient Greek Art and Iconography (ed. W.G. Moon, 1983)
AJA	American Journal of Archaeology
AK	Antike Kunst
Amsterdam	Ancient Greek and Related Pottery (ed. H.A.G. Brijder, 1984)
ARFH I	J. Boardman, *Athenian Red Figure Vases, the Archaic Period, a Handbook* (1975)
ARV	J.D. Beazley, *Attic Red-figure Vase-painters* (ed. 2, 1963)
BABesch	Bulletin Antieke Beschaving
BCH	Bulletin de correspondance hellénique
Boston	L.D. Caskey and J.D. Beazley, *Attic Vase-paintings in the Museum of Fine Arts, Boston*
BSA	Annual of the British School at Athens
CVA	Corpus Vasorum Antiquorum
Eye of Greece	*The Eye of Greece* (edd. D.C. Kurtz and B.A. Sparkes, Studies Robertson, 1982)
FR	A. Furtwängler and K. Reichhold, *Griechische Vasenmalerei* (1904–32)
Getty Vases	*Greek Vases in the J. Paul Getty Museum*
GSAP	J. Boardman, *Greek Sculpture, the Archaic Period* (1978)
GSCP	J. Boardman, *Greek Sculpture, the Classical Period* (1985)

Hesp	Hesperia
JdI	Jahrbuch des deutschen archäologischen Instituts
JHS	Journal of Hellenic Studies
Kurtz, AWL	D.C. Kurtz, *Athenian White Lekythoi* (1975)
KV	K. Schefold, *Kertscher Vasen* (1930)
LIMC	Lexicon Iconographicum Mythologiae Classicae (1981–)
Murray/ Smith	A.S. Murray and A.H. Smith, *White Athenian Vases in the British Museum* (1896)
OJh	Jahreshefte des österreichischen archäologischen Instituts in Wien
OJA	Oxford Journal of Archaeology
Para	J.D. Beazley, *Paralipomena* (1971)
Pfuhl	E. Pfuhl, *Malerei und Zeichnung der Griechen* (1923)
Richter/ Hall	G.M.A. Richter and L.F. Hall, *Red-figured Athenian Vases in the Metropolitan Museum of Art* (1935)
Riezler	W. Riezler, *Weissgrundige attische Lekythen* (1914)
RFSIS	A.D. Trendall, *The Red Figure Vases of South Italy and Sicily* (1989)
Trendall/ Webster	A.D. Trendall and T.B.L. Webster, *Illustrations of Greek Drama* (1971)
UKV	K. Schefold, *Untersuchungen zu den Kertscher Vasen* (1934)
VAmer	J.D. Beazley, *Attic Red-figured Vases in American Museums* (1918)
Webster, PP	T.B.L. Webster, *Potter and Patron in Classical Athens* (1972)

NOTES AND BIBLIOGRAPHIES

ACKNOWLEDGEMENTS

I am indebted to Donna Kurtz for reading the text and suggesting several improvements; and to Antoine Lebel for discussion of fourth-century painters and dating. The lists below were 'closed' in March 1988.

GENERAL BOOKS

Beazley's *ARV* has full lists of painters, with indexes to provenience, myth, museums, *kalos* names. It is supplemented in his *Paralipomena* (1971) and additional references to vases listed in these books are given in *Beazley Addenda* (ed. 1 compiled by L. Burn and R. Glynn, 1982; ed. 2 compiled by T.H. Carpenter, 1989).

CVA remains the fullest sequence of volumes devoted to vase illustration and can best be used with T.H. Carpenter, *Summary Guide to CVA* (1984), listing contents and indexing main concentrations of shapes. At the Beazley Archive in Oxford (Ashmolean Museum) a computerized database recording brief descriptions and bibliographies of all published Athenian figure-decorated vases is nearing completion.

For fine illustrations with scholarly comment see P. Arias, M. Hirmer and B.B. Shefton, *History of Greek Vase Painting* (1962); and E. Simon and M. & A. Hirmer, *Die griechischen Vasen* (1976).

See also for general books and supplementary bibliography to all given below, *ARFH* I 236–41.

1. INTRODUCTION

Connoisseurship and Beazley: D.C. Kurtz, *Getty Vases* ii, 237ff.; *JHS* ciii, 68ff.; *The Berlin Painter* (1983).

Inscription: H. Immerwahr, *The Attic Script* (forthcoming).

DATING

UKV 62–71; W. Hahland, *Vasen um Meidias* (1930) 6f.; G.M.A. Richter, *Attic Red-figured Vases, a Survey* (1958) 141f., 156; C. Isler-Kerenyi, *AK* Beiheft ix, 23ff. (Parthenon period); A. Lezzi-

Hafter, *Der Eretria-Maler* (1989); B.A. Follmann, *Der Pan-Maler* (1968) 20–25.

Excavations at Kition iv, 71–3 (M. Robertson); D. Schilardi, *The Thespian Polyandrion* (1977); *Expl. Délos* xxi; *Himera* i, ii; *Olynthus* v, xiii; E. Vermeule, *JdI* lxxxv, 94ff. (Dexileos); *AA* 1937, 194 (Laconians' tomb); Panathenaics – *ABV* 413–7; N. Eschbasch, *Statuen auf panath. Preisamphoren* (1986).

NON-ATTIC RED FIGURE

References in B.R. MacDonald, *AJA* lxxxv, 159ff.; Eretrian (?) Bern Painter – K. Gex-Morgenthaler, *AK* xxix, 115ff.; cf. *OJA* v, 371ff. (white ground); North Greek – E. Giouri, in *Kernoi* (Fest. Bakalakis, 1972) 6ff. I. MacPhee proposes a monograph on non-Attic red figure.

2. EARLY CLASSICAL

Wall painting: M. Robertson, *History of Greek Art* (1975) 240ff.; J.P. Barron, *JHS* xcii, 20ff. Alkimachos P. – B. Schwarz, *AK* xvii, 36ff. Altamura P. – *VAmer* 143–5. Lewis P. – H.R.W. Smith, *Der Lewis-Maler* (1939); E. Simon, *AK* vi, 6ff. Niobid P. – *VAmer* 145–50 passim; T.B.L. Webster, *Der Niobidenmaler* (1935). Penthesilea P. – *VAmer* 129–32; H. Diepolder, *Der P.-Maler* (1936). Pistoxenos P.-Diepolder, *Der P.-Maler* (1954). Sotades – E. Buschor, *Das Krokodil des. S.* (1919). Sotades P. – H. Hoffmann, *Attic red-figured rhyta* (1962) ch. 2; on [*102, 103*] L. Burn, *AK* xxviii, 93ff., A. Griffiths, *JHS* cvi, 58ff. and A. Collinge, *AK* xxxi, 9ff. Villa Giulia P. – *VAmer* 153f.

Owl-skyphoi – F.P. Johnson in *Stud. Robinson* ii, 96ff.; *AJA* lix, 119ff. St Valentin vases – S. Howard and F.P. Johnson, *AJA* lviii, 191ff.; X. Gorbunova, *Trudi Ermitazh* xiii, 62ff.

3. CLASSICAL

Achilles P. – Beazley, *JHS* xxxiv, 179ff. Eretria P. – A. Lezzi-Hafter, *Der E.-Maler* (1988). Kleophon P. – *VAmer* 181–3; J.M. Hemelrijk, *BABesch* xlv, 50ff. Polygnotos – S.B. Matheson, *Getty Vases* iii, 101ff. Shuvalov P. – A. Lezzi-Hafter, *Der S.-Maler* (1976). Two-tier composition: J.H. Oakley, *Amsterdam* 119ff.

4. WHITE GROUND AND LEKYTHOI

Important sources for pictures are W. Riezler, *Weissgrundige att. Lekythen* (1914); A.S. Murray and A.H. Smith, *White Ath. Vases in the B.M.* (1896); A. Fairbanks, *Attic White Lekythoi* (1907, 1914); E. Buschor, *Att. Lekythen der Parthenonzeit* (1925) and *Grab eines att. Mädchen* (1939). Beazley, *Attic White Lekythoi* (1939) is an important essay, shortly to be reprinted. Kurtz *AWL* is a detailed study of shape, style and ornament, and for continuity of funerary decoration on Attic vases, *eadem* in *Amsterdam* 314ff. See also, I. Wehgartner, *Attisch weissgrundige Keramik* (1983). On funerary use, D.C. Kurtz and J. Boardman, *Greek Burial Customs* (1971).
Kalos inscriptions – H. Jucker, *Hefte Arch. Seminar Bern* i, 45ff.; H. Immerwahr, *Hesperia* Suppl. xxix, 59ff. and *AK* xxvii, 10ff.; K. Schauenburg in *Mon. Chiloniense* (Fest. Burck, 1975) 556f.; H.A. Shapiro, *Zeitschr. Pap. Epigr.* lxviii, 107ff.
Achilles P. – Beazley, *JHS* xxxiv, 179ff.; I. Wehgartner, *Ein Grabbild des A.-Malers* (1985). Reed P. – S. Karousou, *ADelt* viii, 117ff.

5/6 LATER CLASSICAL

Kerch style; the principal illustrated sources are *KV* and *UKV*. See also K. Schefold, *Getty Vases* ii, 199ff.; J.M. Boháč, *Kerčské Vázy* (1958). I. MacPhee proposes a monograph on Attic fourth-century vases.
Aristophanes – *Boston* iii, 83ff. Jena P. – W. Hahland, *Stud. zur att. Vasenmalerei* (1931) 58–68; Beazley, *JHS* xlviii, 127; A.D. Ure, *JHS* lxiv, 70–2. Meidias P. – W. Hahland, *Vasen um Meidias* (1930); U. Knigge, *Athenische Mitteilungen* c, 123ff. (= Aison?); L. Burn, *The Meidias Painter* (1987). Pronomos P. – B.B. Shefton, in *Eye of Greece* 156f. Suessula P. – A. von Salis, *JdI* lv, 126ff. (gigantomachy); B.R. MacDonald, *AJA* lxxxv, 162f. (to Corinth?). Oxford Marsyas vase [387] – Beazley, *JHS* lix, 35–44.
Choes – G. van Hoorn, *Choes and Anthesteria* (1951). 'Panathenaic oinochoai' – J.R. Green, *Hesp* xxxi, 82ff. Relief vases – G. Kopcke, *AA* 1969, 545ff. Fish-plates – I. MacPhee and A.D. Trendall, *Greek red-figured fish plates* (1987).

7. THE SCENES

Most of the bibliography in *ARFH* I 239–41 is relevant here, and I repeat little of it. *AGAI* 301ff. for a very full bibliography on iconography, broadly divided by subject.

SCENES OF REALITY

Webster, *PP* especially chs. 4–18 for a detailed analysis of subjects. *La Cité des Images* (1984), especially on cult, warfare, hunting, women. J. Bazant, *Les citoyens sur les vases athéniens* (1985). Armour – B.B. Shefton, *Greek Arms and Armour* (1978). Barbarians – W. Raeck, *Zum Barbarenbild in der Kunst Athens* (1981). Dionysos pillar – J.L. Durand and F. Frontisi-Ducroux, *RA* 1982, 81ff. Homosexuality – K. Dover, *Greek Homosexuality* (1978). Hunting – A. Schnapp, *RA* 1979, 195ff.; *idem* and P. Schmitt, *RA* 1982, 57ff. Maypole – K. Friis Johansen, *Eine Dithyrambos-Aufführung* (1959). Sacrifice – J.L. Durand, *Sacrifice et labour* (1987). Sport – J. Jüthner, *Die athletischen Leibesübungen* (1965/8). Symposium – J.-M. Dentzer, *Le motif du banquet couché* (1982). Women – E. Keuls, in *AGAI* 209ff. Children – H. Rühfel, *Kinderleben im klassischen Kunst* (1989).

SCENES OF MYTH

Webster, *PP* ch. 19; *LIMC* for comprehensive lists, commentary and illustration (vol. iv, 1988 reaches Herakles); K. Schefold, *Die Göttersage in der klassischen und hellenistischen Kunst* (1981) and *Die Urkönige, Perseus, Bellerophon, Herakles und Theseus* (1988). T.H. Carpenter, *Art and Myth in Ancient Greece* (1989). F. Brommer, *Vasenlisten* (ed. 3, 1973) for full lists.
THEATRICAL: Trendall/Webster; A. Pickard-Cambridge. *The Dramatic Festivals of Athens* (ed. 2, 1988). Satyr-plays – E. Simon in *Eye of Greece* 123ff.; F. Brommer, *Getty Vases* i, 115ff. Birds vase [314] – J.R. Green, *Getty Vases* ii, 95ff. Comic oinochoai [429] – M. Crosby, *Hesp* xxiv, 76ff.
GODS: Aphrodite – W. Atallah, *Adonis* (1966). Apollo – J.-M. Moret, *RA* 1982, 109ff. Asklepios – D. Cramers, *AA* 1978, 67ff. Dionysos – H. Metzger, *Recherches sur l'imagerie ath.* (1965). Eleusinian – Metzger, ibid.; E. Simon, *AK* ix, 72ff. Eros – A. Greifenhagen, *Griechischen Eroten* (1957). Helios – K. Schauenburg, *Helios* (1955); J. Marcadé, *Monuments Piot* 1, 11ff. Hephaistos – F. Brommer, *Hephaistos* (1978). Zeus – B.B. Shefton, in *Eye of Greece* 149ff.
Anodoi – C. Bérard, *Anodoi* (1974). Births – E.H. Loeb, *Die Geburt der Götter* (1979). Divine chariots – L. Lacroix, *Et. d'arch. numismatique* (1974) ch. 5. Pursuits – S. Kaempf-Dimitriadou, *Die Liebe der Götter* (1974). Underworld – W. Felten, *Unterweltsdarstellungen* (1975).
HEROES, TROY ETC.: Amazonomachy – J. Boardman in *Eye of Greece* 1ff. Andromeda – K.M. Phillips, *AJA* lxxii, 1ff. Atalanta – J. Boardman in *Art Inst. Chicago Centennial Lectures* (1983) 3ff. Dolon – F. Lissarrague, *RA* 1980, 3ff. Helen – P. Clement, *Hesp* xxvii, 48ff. Herakles – F. Brommer, *Herakles* i (1979), ii (1984); R. Vollkommer, *Herakles in Classical Art* (1988). Niobids – R.M. Cook, *Niobe and her Children* (1964). Odysseus – F. Brommer, *Odysseus* (1983). Oidipus – J.-M. Moret,

Oidipe (1984). Perseus – K. Schauenburg, *Perseus* (1960). Phrixos – *idem, Rheinisches Museum* ci, 41ff. Theseus – F. Brommer, *Theseus* (1982). Attic heroes/kings – F. Brommer in *Charites* (Fest. Langlotz, 1957) 152ff.; U. Kron, *Die zehn att. Phylenheroen* (1976). Personifications – H.A. Shapiro, *Personifications of Abstract Concepts* (1977).

8. TECHNIQUES, PRODUCTION AND MARKETING

TECHNIQUES

ARFH I 12–14; J.V. Noble, *The Techniques of Attic Painted Pottery* (1965); R.E. Jones, *Greek and Cypriot Pottery* (1986) ch. 9; I. Scheibler, *Gr. Topferkunst* (1983) part 2. Standard parts – H. Holzhausen and R.C.A. Rottländer, *Archaeometry* xii, 189ff.; F. Beltov, *Hephaistos* vii/viii, 125ff. Ability to reproduce shapes – O.R. Impey and M. Pollard, *OJA* iv, 157ff. Coral red volute crater – Malibu. Ghosts – K. Schauenburg, *AA* 1974, 156ff. Hair relief line – G. Seiterle, *Antike Welt* vii, 2ff. Preliminary sketch – P.E. Corbett, *JHS* lxxxv, 16ff.; in thinned paint, exceptional, *CVA* Austria i, pl. 23.1.

PRODUCTION

Personnel – Webster, *PP* ch. 1; R.M. Cook, *Greek Painted Pottery* (1972) ch. 12. Kerameikos – *Athenian Agora* xiv, 186. Sets of vases – Webster, *PP* ch. 2 (symposia); S.R. Roberts, *AJA* lxxvii, 435ff. (weddings); M.F. Jongkees-Vos, *Talanta* i, 9ff. (pairs).

MARKETING

Webster, *PP* ch. 20; Scheibler, op. cit. part 3; A.W. Johnston, *Trademarks on Greek Vases* (1979) – also for prices; J. Boardman, *Expedition* 1979, 33ff., distribution charts; *idem, OJA* vii, value in trade; Piraeus hoard – *CVA* Bonn i, 31–3, *ARV* 1180–2. G. Vallet and F. Villard in *Et. archéologiques* (ed. P.

Courbin, 1963) 205ff. Etruscan inscriptions – F. Giudice, *Cronache* xviii, 153ff. White ground export – Kurtz, *AWL* 137ff. Attic in near east – Perrault, *BCH* cx, 145ff. Eretria – J.R. Green and R.K. Sinclair, *Historia* xix, 515ff. Wartime trade – B.R. MacDonald, *JHS* cii, 113ff. *ARV* ch. 69 (stemmed plates to Spina), 1353ff. (poor oinochoai to Spina), 1366f. (squat lekythoi to Al Mina). South Italian shapes in Attic – M. Jentoft-Nilsen (forthcoming). Mallorca wreck – A. Arribas et al., *El barco de El Sec* (1987).

9. SHAPES AND USES

See bibliography in *ARFH* I 239 and T.H. Carpenter, *Summary Guide to CVA* (1984) for an index to shapes well represented in *CVA*. Scheibler, op. cit. part 1; M.G. Kanowski, *Containers of Classical Greece* (1984). For vase names – M.L. Lazzarini, *Archeologia Classica* xxv/xxvi, 341ff.; F. Brommer, *Hermes* cxv, 1ff.
Black vases – L. Talcott and B.A. Sparkes, *Athenian Agora* xii. Clay and metal vases – D.K. Hill, *AJA* li, 248ff.; M. Vickers. *JHS* cv, 108ff. ('silver is black'); J. Boardman, *RA* 1987, 279ff. (silver *is* white); D.W. Gill in *Pots and Pans* (ed. M. Vickers, 1987) 9–30 (shape comparisons).
Aryballoi – G. Schwarz, *OJh* liv, 27ff.; leather – H. Hommel, *Bocksbeutel und Aryballoi* (1978). Askos – H. Hoffmann, *Sexual and Asexual Pursuit* (1977), corrected by Boardman, *Classical Review* xxix, 118ff. Calyx crater – H. Hinkel, *Der Giessener Kelchkrater* (1967) 38ff. Choes – J.R. Green, *BSA* lxvi, 189ff. Columbus alabastron – B. Heldring, *Meded. Ned. Inst. Rom* xl, 43ff. Falaieff crater – S. Drougou, *AA* 1979, 265ff. Lebes gamikos – F. Harl-Schaller, *OJh* I, Beibl. 151ff. Phialai – C. Cardon, *Getty Mus. Journal* vi/vii, 131ff. Plemochoe – F. Brommer, *AA* 1980, 546ff. Pyxis – S.R. Roberts, *The Attic Pyxis* (1978). Rhyta – H. Hoffmann, *Attic Red-figured Rhyta* (1962). Skyphoi (cor. shape) – J.H. Oakley, *Hesp* lvii, 165ff.

LIST OF ILLUSTRATIONS

Frontispiece See 109

1 Bologna 268, from Bologna. *ARV* 598,1.
2 Palermo G 1283, from Gela. *ARV* 599,2.
3 Boston 33.56, from Italy. *ARV* 600,12. After *Boston* ii.
4 Louvre G 431, from Orvieto. *ARV* 601,22. After FR pl. 108.
5 London E 467, from Altamura. *ARV* 601,23.
6 Ferrara 2891 (T.313), from Spina. *ARV* 602,24.
7 Oxford 280, from Nola. *ARV* 604,56. After Gardner.
8 Bochum Univ. S 1060. *LIMC* Alexandros no. 92.
9 Basel inv. Ludwig 51. *Para* 396,7bis.
10 London E 469, from Altamura. *ARV* 589,1.
11 Palermo V 780. *ARV* 592,32.
12 New York 07.286.84, from Numana. *ARV* 613,1. After FR pls. 116/7.
13 Louvre CA 3482. *ARV* 613,3.
14 Palermo. *ARV* 613,4.
15 Ferrara 3031 (T.579), from Spina. *ARV* 612,1.
16 Basel BS 486. *ARV* 612,2.
17 Geneva MF 238. *ARV* 615,1. After FR ii, 314.
18 Louvre G 482. *ARV* 615.
19 New York 07.286.66, from Agrigento. *ARV* 617,2. After Richter/Hall.
20 Oxford 1973.1. *JHS* xciv, pl. 17a.
21 Rome, Villa Giulia 909, from Falerii. *ARV* 618,1.
22 London E 492, from Nola. *ARV* 619,16.
23 Oxford 524. *ARV* 620,30.
24 Boston 90.155. *ARV* 621,34.
25 Oxford 535, from Gela. *ARV* 624, 76.
26 Cracow 1081. *ARV* 629,14.
27 Cape Town, S. African Mus. H 4810. J. Boardman and M. Pope, *Greek Vases in Cape Town* (1961) no. 14.
28 Lecce 570, from Rugge. *ARV* 629,23. After FR pl. 66.2.
29 Boston 13.196, from Gela. *ARV* 631.38.
30 Munich 2345, from Vulci. *ARV* 496,2.
31 Zurich Univ. L 5. *ARV* 1656,2bis. C. Isler-Kerenyi, *Lieblinge der Meermädchen* (1973).
32 London E 377, from Nola. *ARV* 501,35.
33 London E 539, from Capua. *ARV* 776,2.
34 London E 178. *ARV* 503,20.
35 Louvre G 164. *ARV* 504,1.
36 Bologna 230, from Bologna. *ARV* 504,8.
37 Harrow School 50, from Vitorchiano. *ARV* 516,5.
38 Copenhagen Nat. Mus. inv. 9195. *ARV* 519,21.
39 Los Angeles A 5933.50.12. *ARV* 518,2.
40 Copenhagen Nat. Mus. inv. 9165, from Greece. *ARV* 514,2.
41 Geneva, Hellas et Roma 64.
42 Naples 3369. *ARV* 523,9.
43 New York 34.11.7. *ARV* 524,28.
44 Munich 2325, from Nola? *ARV* 530,19.
45 London E 318, from Nola. *ARV* 530,20.
46 Boston 95.39, from Eretria. *ARV* 533,58.
47 Berlin inv.30035, from near Taranto. *ARV* 532,57.
48 Ferrara 2739 (T.749), from Spina. *ARV* 536,1.
49 New York 96.19.1. *ARV* 536,5. After Richter/Hall.
50 Florence 3997. *ARV* 541,1.
51 Munich 2685, from Vulci. *ARV* 837,9.
52 Honolulu Acad. of Arts 2892, from Greece. *ARV* 844,153.
53 London market, Sotheby's 17.7.1985, lot 244.
54 Boston 20.187. *ARV* 857,2.
55 London E 316. *ARV* 857,6.
56 Richmond, Virginia Mus. of Art 82.205.
57 London market. *Para* 406,154ter.
58 Würzburg H 4978, from Spata. *ARV* 686,204.
59 Oxford 1965.129, from Attica. *ARV* 687,221.
60 Oxford 536, from Gela. *ARV* 714,170.
61 Basel market. *Para* 409,189bis.
62 Basel market. *ARV* 717,230.
63 Cambridge 138, from Athens. *ARV* 735,98.
64 Athens, Acr.439. *ARV* 860,2. After *Akr.Vasen*.
65 Taranto, from Locri. *ARV* 860,3.
66 Louvre G 108, from Vulci. *ARV* 860,9.
67 London D 2, from Camirus. *ARV* 862,22.
68 Schwerin Mus., from Cerveteri. *ARV* 862,30.
69 Athens 2192, from Athens. *ARV* 863,32.
70 Oxford 320. *ARV* 864,13.
71 Oxford 1924.2. *ARV* 865,1.
72 Basel inv. Kä 415. *ARV* 868,45.
73 London D 4, from Nola. *ARV* 869,55.
74 Würzburg H4937. *ARV* 871,95.
75 Aberdeen Univ. 748. *ARV* 871,9.
76 Naples, from Cumae. *ARV* 874,2.
77 Basel, Cahn Coll. 9. *ARV* 874,3.
78 Florence 4224. *ARV* 875,16.
79 Adolphseck 134. *ARV* 875,17.
80 Munich 2688, from Vulci. *ARV* 879,1.
81 Ferrara 44885 (T.18 CVP), from Spina. *ARV* 882,35.
82 Ferrara 9351 (T.212 BVP), from Spina. *ARV* 880,12.
83 Hamburg, Mus. fur Kunst und Gewerbe 1900.164, from Nola. *ARV* 880,4.
84 Oxford 1931.12. *ARV* 884,73.
85 Munich 03.815, from Suessula. *ARV* 887,145.
86 Boston 01.8032, from Vico Equense. *ARV* 888,155.

87 Ferrara 2501 (T559), from Spina. *ARV* 919,1.
88 Boston 03.820, from Suessula. *ARV* 919,3.
89 Louvre L 55, from Athens. *ARV* 924,33.
90 Columbia, Univ. Missouri. *Para* 432,66bis.
91 Toledo Mus. of Art. *Para* 434,94bis.
92 Vienna 3711, from Cerveteri. *ARV* 972,3.
93 Cambridge, Corpus Christi College, from Capua. *ARV* 973,15.
94 Vatican. *ARV* 974,28.
95 Basel BS 426. *Para* 436,38.
96 Mykonos Mus. *EADelos* xxi, no. 112.
97 Oxford 1927.4331. *Para* 437.
98 Bologna PU 351, from Etruria. *ARV* 982,2.
99 Edinburgh Nat. Mus. of Scotland 1881.44.18.
100 Boston 98.886, from Athens. *ARV* 722,d.
101 Louvre CA 3825. *Para* 416.
102 London D 6, from Athens. *ARV* 763,1.
103 London D 7, from Athens. *ARV* 763,3.
104 Paris, Petit Palais 349, from Capua. *ARV* 764,10.
105 London E 804, from Aegina. *ARV* 765,20.
106 London E 788, from Capua. *ARV* 764,8.
107 Compiègne, Mus. Vivenel 898, from Nola. *ARV* 767,16.
108 Brussels, Mus. Royaux A 891, from Athens. *ARV* 771,2.
109 Vatican, from Vulci. *ARV* 987,1.
110 Paris, Cab. Med. 372, from Vulci. *ARV* 987,4. After *Mon. Ined.* ii, pl. 14.
111 Boston 06.2447. *ARV* 989,26.
112 London E 331, from Nola. *ARV* 989,31.
113 Philadelphia Univ. 30.4.1. *ARV* 990,45.
114 New York 07.286.81. *ARV* 991,61.
115 London E 448, from Vulci. *ARV* 992,65.
116 Wurzburg 540, from Vulci. *ARV* 992,69.
117 Basel BS 485. *ARV* 1677, 77bis.
118 Brussels, Mus. Royaux A 1379. *ARV* 994,97.
119 London E 336, from Capua. *ARV* 1010,4.
120 Boston 76.45, from Capua. *ARV* 1011,13.
121 New York 28.57.23. *ARV* 1012,1.

122 Basel inv. Ludwig 56. *Para* 441,2bis.
123 London E 334, from Nola. *ARV* 1014,4.
124 Boston 98.883, from Cerveteri. *ARV* 1017,46. After *Boston* i.
125 Agrigento, from Agrigento. *ARV* 1017,53.
126 Vatican, from Vulci. *ARV* 1017,54.
127 Oxford 1917.62. *ARV* 1018,75.
128 Boston 97.371, from near Sunium. *ARV* 1023,146.
129 Brussels, Mus. Royaux A 134, from Vulci. *ARV* 1027,1.
130 Oxford 1916.68. *ARV* 1028,6.
131 Florence 4227, from Chiusi. *ARV* 1028,11.
132 Ferrara T.411, from Spina. *ARV* 1029,21.
133 Jerusalem, Israel Mus. 124/1. *Eye of Greece* pl. 5a.
134 Toronto 635, from near Athens. *ARV* 1031,51.
135 Syracuse 23507, from Gela. *ARV* 1032,53. After *Mon. Ant.* xvii, pl. 43.
136 New York 45.11.1 (Rogers Fund 1945), from S. Italy. *ARV* 1032,55.
137 Ferrara T.271, from Spina. *ARV* 1032,58.
138 Naples 3232, from Nola. *ARV* 1032,61.
139 London E 447, from Chiusi. *ARV* 1035,3.
140 Vatican 16570, from Vulci. *ARV* 1036,1.
141 Munich 2412, from Vulci. *ARV* 1036,5.
142 Ferrara T.617, from Spina. *ARV* 1038,1.
143 Ferrara T.404, from Spina. *ARV* 1039,9.
144 London E 271, from Vulci. *ARV* 1039,13.
145 Naples RC 157, from Cumae. *ARV* 1042,3.
146 Harvard, Fogg Mus. 1925.30.40, from Curti. *ARV* 1042,1.
147 Vatican, from Vulci. *ARV* 1043,1.
148 Brussels, Mus. Royaux R 302. *ARV* 1044,7.
149 Plovdiv Mus., from Brezovo. *ARV* 1044,9.
150 Boston 34.79. *ARV* 1045,2. After *JHS* liv, pl. 11.
151 Warsaw, Nat. Mus. 142355. *ARV* 1045,6. After Beazley, *Greek Vases in Poland* pl. 25.
152 Boston 00.346, from Vico Equense. *ARV* 1045,7.
153 Naples Stg 281, from Sorrento. *ARV* 1045,9.

154 Malibu, Getty Mus. 71.AE.250. *ARV* 1047,24.
155 Syracuse 22934, from Camarina. *ARV* 1050,4.
156 Munich 2411, from Vulci. *ARV* 1051,18.
157 Ferrara 2897 (T.128), from Spina. *ARV* 1052,25.
158 Mulgrave Castle, Lord Normanby. *Para* 442.
159 London 99.7–21.5, from Agrigento. *ARV* 1052,29. After FR pl. 58.
160 Stockholm Nat. Mus. 6, from S. Italy. *ARV* 1053,40.
161 Bologna 288bis, from Bologna. *ARV* 1056,86. After Pfuhl, fig. 557.
162 Munich 2384, from Sicily. *ARV* 1057,98. After FR pl. 7.
163 Tarquinia RC 4197, from Tarquinia. *ARV* 1057,96.
164 New York 56.171.48, from Locri. *ARV* 1057,104.
165 Oxford 530, from Greece. *ARV* 1061,152.
166 London E 169, from Vulci. *ARV* 1062.
167 Ferrara 44893, from Spina. *ARV* 1680.
168 Once Nostell Priory. *ARV* 1064,1.
169 Boston 63.6223. Webster/Trendall III.2.2.
170 Oxford G 275. *CVA* i pl. 21.1–2.
171 Ferrara T.57 CVP, from Spina. *ARV* 1143,1.
172 Munich 2415, from Vulci. *ARV* 1143,2.
173 Copenhagen, Ny Carlsberg Glyptotek 2693, from Orvieto. *ARV* 1144,8.
174 Copenhagen Nat. Mus. inv. 13817. *ARV* 1145,35.
175 Boston 03.793, from Athens. *ARV* 1145,37.
176 Athens 1700. *ARV* 1146,50.
177 Naples 2419, from Nocera de'Pagani. *ARV* 1151,2. After FR pls. 36/7.
178 Berlin 2402, from Athens. *ARV* 1152,3. After Furtwängler, *Sabouroff Coll.* pl. 57.
179 Bologna 300, from Bologna. *ARV* 1152,7.
180 Vienna 1024. *ARV* 1152,8.
181 Oxford 1937.983. *AVR* 1153,13.
182 London F 65, from Capua. *ARV* 1154,35.
183 Boston 95.24, from Capua. *ARV* 1159.
184 New York 08.258.21. *ARV* 1086,1.
185 Vienna 1026. *ARV* 1087,2.

186 Louvre G 367, from Nola. *ARV* 1088,1.
187 Vatican. *ARV* 1091,63.
188 Munich 2429, from Vulci. *ARV* 1094,102.
189 Hamburg, Mus. fur Kunst und Gewerbe 1968.79. *Para* 450,21ter.
190 Bochum Univ. *Para* 450,55bis.
191 London 1923. 1–18.1. *ARV* 1103,1.
192 Ferrara, from Spina. *ARV* 1104,4.
193 New York 17.230.15. *ARV* 1104,16. After Richter/Hall.
194 Munich 2322, from Vulci. *ARV* 1107,2. After FR pl. 138,1.
195 Once Castle Ashby. *ARV* 1107,4.
196 New York 25.28, from Capua. *ARV* 1110,41. After Richter/Hall.
197 Richmond, Virginia Mus. of Art 62.1.1. *Para* 452,48bis.
198 London 1923.10–16.10. *ARV* 1112,5.
199 Paris, Cab. Med. 444, from Nola. *ARV* 1112,3. After Pfuhl, fig. 518.
200 Once Berlin inv. 3199, from Gela. *ARV* 1114,9.
201 London E 477. *ARV* 1114,15.
202 Lecce 600, from Rugge. *ARV* 1115,20.
203 London E 360, from Camirus. *ARV* 1116,37.
204 Ferrara T.581 BVP, from Spina. *ARV* 1117,10.
205 Naples Stg 270, from Capua. *ARV* 1161,1.
206 Munich 2362, from S. Italy. *ARV* 1162,14.
207 New York 16.73. *ARV* 1126,6. After Richter/Hall.
208 Louvre G 549, from Nola? *ARV* 1128,106.
209 Copenhagen Nat. Mus. 153, from Nola. *ARV* 1131,161.
210 Berlin 2394, from Nola. *ARV* 1131,172.
211 London, Victoria and Albert C.2500.1910. *ARV* 1132,182.
212 London E 370, from Nola. *ARV* 1134,7.
213 London E 819, from Nola. *ARV* 1137,25.
214 Boston 99.539, from Sorrento. *ARV* 1142,1.
215 Würzburg 555, from Sicily. *ARV* 1198,8.
216 Basel inv. Kä 404. *Para* 447,2bis.
217 Bologna 325, from Bologna. *ARV* 1069,2.
218 Lost. *ARV* 1073,4. After *Arch.Zeitung* 1852, pl. 42.
219 London E 555, from Cerveteri. *ARV* 1065,1.
220 Vatican inv. 16536, from Vulci.

ARV 1065,8. After FR pl. 168,1.
221 Kassel, Staatliche Kunstsammlungen T 43. *ARV* 1206,1.
222 Ferrara 5029 (T.133A), from Spina. *ARV* 1206,5.
223 Adolphseck 67. *ARV* 1207,26.
224 Berlin 2414, from Locri. *ARV* 1208,41.
225 London E 157, from Camirus. *ARV* 1213,2.
226 Oxford 533, from Nola. *ARV* 1263.
227 Brussels, Mus. Royaux A 1021. *ARV* 1213,3.
228 Athens, Vlasto. *ARV* 1215,1. After *JHS* lxv, pl. 5.
229 Berlin (E) 2471, from Attica. *ARV* 1247,1. After Furtwängler, *Sabouroff Coll.* pl. 55.
230 Boston 95.48, from Athens. *ARV* 1248,2. After *Boston* i.
231 New York 31.11.13 (Rogers Fund 1931), from Athens. *ARV* 1248,9.
232 Oxford 537. *ARV* 1248,10.
233 Athens, Vlasto, from Anavysos. *ARV* 1249,13.
234 London E 774, from Athens. *ARV* 1250,32. After FR pl. 57,3.
235 Athens 1629, from Eretria. *ARV* 1250,34.
236 Naples 2613, from Nola. *ARV* 1252,50.
237 Louvre G 457, from Cerveteri. *ARV* 1254,80.
238 Berlin 2537, from Tarquinia. *ARV* 1268,2.
239 London E 82, from Vulci. *ARV* 1269,3.
240 London E 84, from Vulci. *ARV* 1269,4. After *JHS* xli, 144.
241 Cape Town, S. African Mus. H 4811. *ARV* 1272,46.
242 Oxford 1942.3. *ARV* 1276,2.
243 London 1920.12–21.1, from Greece. *ARV* 1277,23; 1282,1.
244 Berlin 2536, from Nola. *ARV* 1287,1.
245 London E 104, from Vulci. *ARV* 1293,1.
246 Berlin 2588, from Tarquinia. *ARV* 1300,1.
247 Chiusi 1831, from Chiusi. *ARV* 1300,2. After FR pl. 142.
248 Louvre G 372, from Nola. *ARV* 1300,4.
249 Berlin (E) 2589, from Chiusi. *ARV* 1301,7. After FR pl. 125.
250 London E 372, from Camirus. *ARV* 1218,1.
251 Würzburg H 4803, from Nola. *ARV* 1219,1.
252 Athens 1927, from Eretria. *ARV* 743,5.

253 London 1928.2–13.1, from Gela. *ARV* 746,4.
254 Berlin inv.3262, from Greece. *ARV* 845,168.
255 Athens 1926. *ARV* 846,193. After Riezler, pl. 44a.
256 London D 62, from Eretria. *ARV* 851,273. After Murray/Smith, pl. 7.
257 Madrid 19497. *ARV* 748,1.
258 Louvre MNB 3059. *ARV* 754,14.
259 Oxford 547, from Greece. *ARV* 756,64.
260 Jena Univ. 338. *ARV* 760,41.
261 Berlin 2443, from Pikrodaphni. *ARV* 995,118. After Riezler, pl. 2.
262 Munich, Schoen 80, from Greece. *ARV* 997,155.
263 Boston 13.201, from Gela. *ARV* 997,156.
264 Athens 1818, from Eretria. *ARV* 998,161.
265 London D 51, from Marion. *ARV* 1000,201.
266 Munich 2797, from Oropos. *ARV* 1022,138.
267 Athens 19355, from Anavysos. *ARV* 1022,139bis.
268 New York 09.221.44. *ARV* 1168,128.
269 Athens 1935, from Eretria. *ARV* 1227,1. After Riezler, pl. 23.
270 Berlin inv. 3291, from Athens. *ARV* 1227,9.
271 London D 58, from Ampelokepoi. *ARV* 1228,12.
272 London D 60, from Ampelokepoi. *ARV* 1230,37. After Murray/Smith, pl. 6.
273 Boston 01.8080, from Athens. *ARV* 1231.
274 Marburg Univ. 1016. *ARV* 1233,19.
275 Athens 12783, from Eretria. *ARV* 1237,11. After Karousou, *TWL* 24.
276 Athens 1956, from Eretria. *ARV* 1372,3.
277 Athens 14517. *ARV* 1374,18.
278 London D 61, from Athens. *ARV* 1377,15. After Murray/Smith, pl. 12.
279 Louvre S 1161. *ARV* 1382,134.
280 Athens 1817, from Eretria. *ARV* 1383,11.
281 Athens 1816, from Eretria. *ARV* 1383,12. After Riezler, pl. 90.
282 Louvre CA 537, from Eretria. *ARV* 1384,18.
283 London 1905.7–10.11. *ARV* 1384,22.
284 Madrid 11194, from Greece. *ARV* 1390,5.

285 Florence 81948, from Populonia. *ARV* 1312,1. After Pfuhl, fig. 594.
286 Florence 81947, from Populonia. *ARV* 1312,2.
287 London E 224. *ARV* 1313,5.
288 New York 75.2.11, from Athens. *ARV* 1313,11. After Richter/Hall.
289 Berlin 2531, from Vulci. *ARV* 1318,1.
290 Boston 00.344, from Tarquinia. *ARV* 1319,2.
291 Boston 00.345, from Tarquinia. *ARV* 1319,3.
292 Madrid 11265. *ARV* 1174,1.
293 Naples RC 239, from Cumae. *ARV* 1174,6.
294 Karlsruhe, Badisches Landesmus. 259, from Ruvo. *ARV* 1315,1. After FR pl. 30.
295 Athens 1388, from Tanagra. *ARV* 1317,1. After Hahland, *Vasen um Meidias* pl. 4.
296 Vienna 1771, from Orvieto. *ARV* 1318.
297 Frankfurt, Liebighaus 538. *ARV* 1317,1.
298 Athens 1454. *ARV* 1178,1.
299 Louvre CA 1679, from Greece. *ARV* 1179,3.
300 Palermo from Agrigento? *ARV* 1321,9.
301 Budapest, Mus. of Fine Arts T 754. *ARV* 1324,41bis.
302 London E 697, from Athens. *ARV* 1324,45.
303 London E 696, from Marion. *ARV* 1325,49.
304 London E 775, from Eretria. *ARV* 1328,92.
305 Leuwen, private. *AA* 1978,67–73.
306 Ferrara T.127, from Spina. *ARV* 1171,1.
307 Oxford 1957.31. *ARV* 1172,19.
308 Berlin inv. 30036, from Greece. *ARV* 1173,1. After FR pl. 170,2.
309 Vatican inv. 16535, from Vulci. *ARV* 1173. After FR pl. 170,1.
310 Ruvo, Jatta 1093, from Ruvo. *ARV* 1184,1.
311 Munich 2360, from Vulci. *ARV* 1186,30. After FR pl. 109,2.
312 Plovdiv Mus., from Duvanli. *ARV* 1187,36.
313 Vienna 1144, from Armento. *ARV* 1188.
314 Malibu 82.AE.83. *Getty Vases* ii, 95ff.
315 London E 183, from Nola. *ARV* 1191,1.
316 Ruvo, Jatta 1346, from Ruvo. *ARV* 1401,2.
317 Louvre G 446. *Jdl* lxxi, 63.
318 Tübingen Univ. S/10.1347. *CVA* 5, pl. 21,1–2.
319 London 98.7–16.6, from Greece. *ARV* 1333,1.
320 Harvard, Fogg Mus. 1925.30.11. *ARV* 1334,25.
321 Louvre N 3408, from Cyrenaica. *ARV* 1335,34.
322 Richmond, Virginia Mus. of Arts 81.70. *Apollo* cxx, 430.
323 Naples 3240, from Ruvo. *ARV* 1336,1.
324 Ruvo, Jatta 1501, from Ruvo. *ARV* 1338,1.
325 Amsterdam inv.2474, from Athens. *ARV* 1339,4.
326 Athens 1333, from Tanagra. *ARV* 1337,8.
327 Naples 2883, from Ruvo. *ARV* 1338.
328 Boston 10.187, from Greece. *ARV* 1337,10.
329 Louvre S 1677. *ARV* 1344,1. After FR pls.96/7.
330 Würzburg H 4729, from Taranto. *ARV* 1346.
331 Athens, Acr.594. *ARV* 1341,1. After *Akr. Vasen.*
332 Rome, Villa Giulia. *ARV* 1343.
333 Berkeley, Univ. 8.3316, from Greece? *ARV* 1343,1.
334 Adolphseck 78. *ARV* 1346,2.
335 London 1917.7–25.2. *ARV* 1410,16.
336 Toronto 388. *ARV* 1411,40.
337 London E 129, from Nola. *ARV* 1414,89.
338 London 1917.7–26.3. *ARV* 1414,92.
339 New York 06.1021.140, from Capua. *ARV* 1408,2.
340 Leningrad St 1790, from Kerch. *ARV* 1407,1.
341 Liverpool. *Para* 491,22bis.
342 Oxford 1917.61. *ARV* 1428,1.
343 Sydney, Nicholson Mus. 46.39. *ARV* 1429,3.
344 London 1950.4–26.1. *ARV* 1431,3.
345 Mannheim, Reiss Mus. 123, from Bocotia. *ARV* 1435.
346 Louvre G 508. *ARV* 1436,1.
347 Cape Town, S. African Mus. H 4814. J. Boardman and M. Pope, *Greek Vases in Cape Town* (1961) no. 16.
348 Bologna 318, from Bologna. *ARV* 1437,4.
349 Naples 3243, from S. Agata de'Goti. *ARV* 1439,2.
350 Ferrara 3032 (T.1145), from Spina. *ARV* 1440,1.
351 Naples 2200, from S. Agata de'Goti. *ARV* 1440,1. After FR pl. 146.
352 Once Hattatt and London market.
353 Once Nostell Priory and London market. *ARV* 1419,10.
354 Ruvo, Jatta 422, from Ruvo. *ARV* 1420,4.
355 London 1924.7–16.1. *ARV* 1420,6.
356 Jena Univ. 382. Hahland, *Vasen um Meidias* pl. 16a.
357 Berlin inv. 3974. Trendall/ Webster, III.3.47.
358 Jena Univ. 390, from Athens. *ARV* 1511,1.
359 Jena Univ. 394, from Athens. *ARV* 1511,6.
360 Würzburg 492. *ARV* 1512,18.
361 Exeter Univ. *ARV* 1516,80.
362 Berlin inv.3768, from Rhodes. *ARV* 1516,81.
363 Oxford 1931.39, from Apulia. *ARV* 1516,1.
364 Texas, McCoy Coll. (once Castle Ashby). *CVA* Castle Ashby pl. 40.
365 Boston 00.354, from Tanagra. *ARV* 1516.
366 Vienna 96. *ARV* 1518,4.
367 Oxford 1946.52. *ARV* 1518,5.
368 London 67.5–12.33, from Benghazi. *ARV* 1519,21.
369 London E 536. van Hoorn, *Choes* no. 640.
370 New York 24.97.34. van Hoorn, *Choes* no. 757.
371 Chicago Art Inst. 1889.98. McPhee/Trendall, *Fish Plates* col. pl. A.
372 London F 68, from S. Agata de'Goti. *ARV* 1446,1.
373 Berlin inv. 31094. *ARV* 1446,2.
374 London F 74. *ARV* 1448,5.
375 Louvre G 528.
376 London E 432, from S. Agata de'Goti. *ARV* 1472,2.
377 Brussels Mus. Royaux R 286, from Capua. *ARV* 1472,4.
378 New York 08.258.20. *ARV* 1472,1.
379 Louvre MNB 1036, from Cyrenaica. *ARV* 1472,3.
380 Texas, McCoy Coll. (once Castle Ashby). *CVA* Castle Ashby pl. 44.
381 Munich 2388.
382 London E 228. *KV* pl. 8.
383 Leningrad B 4125. *UKV* pl. 9.2.
384 Leningrad B 4528. *UKV* pl. 6.
385 Athens 14902.
386 London E 230, from Cyrenaica. *ARV* 1481,2.
387 Oxford 1939.599, from Al Mina. *JHS* lix, 35–44.
388 Leningrad inv.15592, from Kerch. *ARV* 1475,1.
389 Leningrad St 1795, from Kerch. *ARV* 1475,3.

390 London E 424, from Camirus. *ARV* 1475,4.
391 Leningrad St 1858, from Kerch. *ARV* 1475,7.
392 Leningrad St 1792, from Kerch. *ARV* 1476,1. After FR pl. 70.
393 Leningrad St 1793, from Kerch. *ARV* 1476,2. After FR pl. 69.
394 New York 25.190. Richter/Hall no. 169.
395 New York. Richter/Hall no. 170.
396 Leningrad inv. 16878. *KV* pl. 15a.
397 Toronto 451. *ARV* 1497,14.
398 London F 138, from Apulia. *ARV* 1498,2.
399 Berlin inv. 3373. *JdI* xv, pl. 2; *UKV* no. 581.
400 Philadephia Univ. MS 5462. *AJA* xxi, 455.
401 London 1866.4–15.40. *ARV* 1501,4.
402 Vienna 3721, from Greece? *ARV* 1501,4.
403 London 1927.7–14.1.
404 London E 241, from Cyrenaica. *ARV* 1482,1.
405 Berlin (E) inv.3248, from Apollonia (Thrace). *ARV* 1482,5.
406 Amsterdam inv. 957, from Kerch. *ARV* 1478,1.
407 Leningrad KAB 65e, from S. Russia. *ARV* 1479,24.
408 Madrid 11210, from Cyrenaica. *ARV* 1464,39.
409 Brussels Mus. Royaux A 3452,

from S. Italy. *ARV* 1464,57.
410 Louvre MN 750, from Cyrenaica, *ARV* 1465,75.
411 Leningrad KAB 51e, from Kerch. *ARV* 1466,106.
412 Stuttgart Mus. *ARV* 1467,117.
413 Munich 2396, from Sicily. *ARV* 1468,139.
414 Louvre G 530. *ARV* 1469,161.
415 London E 233, from Cyrenaica. *ARV* 1471,3.
416 Cambridge, Fitzwilliam Mus. GR.6.1943. *ARV* 1454,23.
417 London F 5, from Telos. *ARV* 1455,3.
418 Athens 12544. *ARV* 1456,1.
419 Athens 12542. *ARV* 1456,4.
420 Paris, Petit Palais 327, from Boeotia. *ARV* 1457,8.
421 Athens 12541. *ARV* 1457,10.
422 Athens 1376, from Boeotia. *ARV* 1458,34.
423 Oxford 299. *ARV* 1487,111.
424 London 1814.7–4.525. *ARV* 1490,172.
425 Vienna 202. *ARV* 1523,1.
426 Cambridge, Fitzwilliam Mus. X34. *ARV* 1505,1.
427 London E 778, from Athens. *ARV* 1503,2.
428 Munich 2439, from Alexandria. Simon, *Gr.Vasen* pl. 240.
429 Athens, Agora P 23907, from Athens. After *Hesperia* xxiv, pl. 36a.

HEAD DETAILS IN TEXT

Niobid Painter (p. 13) *ARV* nos. 9, 24, 14, 24, 67; Villa Giulia Painter (p. 15) *ARV* nos. 3, 18, 16, 41, 50; Pistoxenos Painter (p. 38) *ARV* nos. 9, 3, 22, 2, 32; Achilles Painter (p. 61) *ARV* nos. 2, 4, 156, 168, 26; Polygnotos (p. 62) *ARV* nos. 3, 15bis, 16, 21, 28; Kleophon Painter (p. 63) *ARV* nos. 2, 8, 28, 36, 44; Dinos Painter (p. 96) *ARV* nos. 2, 3, 8, 33, 43; Meidias Painter (p. 146) *ARV* nos. 1, 2, 5, 6, 10.

The drawings of [*100, 101*] are by Marion Cox.

Dimensions of some complete vases are given in centimetres in the captions.

PHOTOGRAPH CREDITS

The author and publisher are deeply grateful to the many museums and collectors named in the above list for their kindness in supplying photographs and granting permission to publish them. The following other sources of photographs are also gratefully acknowledged: Hirmer Verlag [*2, 4, 11, 15, 87, 109, 126, 129, 157, 171, 262, 287, 293, 323, 327, 329, 390*]; German Institute, Athens [*235*]; Christies [*168*]; Arts of Mankind [*4, 138, 156, 264, 280, 323, 326*]; R. L. Wilkins [*195, 364, 380*]; the author [*37, 53, 75, 341*].

INDEX OF ARTISTS AND GROUPS

Figure numbers are in italics. P = Painter; Gp = Group

Aberdeen P, 87–8
Achilles P, 61, 129, 132; frontisp, 109–18, 261–5
Aegisthus P, 37; 35–6
Aischines P, 37, 129; 60–2
Aison, 147, 167; 292–3
Alexandre Gp, 97; 225
Alkimachos P, 37; 44–7
Altamura P, 14; 10–11
Amazon P, 193; 406–7
Ancona P, 78–9
Apollonia Gp, 193; 404–5
Aristophanes, 146, 167; 289–91
Athena P, 37
Athens 1237, P of, 71
Athens 1454, P of, 298–9
Athens 1826, P of, 130; 253
Athens Wedding, P of, 147; 295–6

Barclay P, 97; 216
Beldam P, 130
Berlin P, 61
Berlin 2415, Gp of, 33
Berlin 2536, P of, 244
Bird P, 132; 274
Black Thyrsus P, 169; 344
Bologna 279, P of, 14; 15–16
Bosanquet P, 132; 269–70
Boreas P, 37; 48–9
Bowdoin P, 37, 129; 56–9
Budapest Gp, 349

Cambridge Askos Gp, 426
Carlsruhe P, 37, 129; 63
Carlsruhe Paris, P of, 147; 294
Chalki Gp, 427
Chicago P, 15; 26–9
Chrysis P, 183
Cleveland P, 37
Christie P, 63; 154
Codrus P, 98; 238–41
Coghill P, 62; 145
Copenhagen P, 37; 31
Curti P, 146
Curtius P, 90
Czartoryski kantharos, 98

Deepdene P, 32
Dinos P, 96, 147; 177–82
Diomed P, 169; 363–5
Duomo P, 204
Dwarf P, 61; 119–20

Eleusinian P, 192; 392–3
Epimedes P, 62; 148–9
Erbach P, 353
Eretria P, 97, 146; 229–37

Erichthonios P, 98; 250
Erotostasia P, 193
Euemporos, 168
Euphronios, 38
Eupolis P, 97; 218

F.B. Gp, 193; 423–4
Filottrano P, 193; 416–7
Florence P, 37; 50
Florence 4021, P of, 76–7
Frankfurt lekythos, P of, 297

G Gp, 193; 408–15
Geneva P, 17–18
Guglielmi P, 147

Hasselmann P, 2123
Hector P, 62; 140–1
Heimarmene P, 167; 308–9
Helena P, 191
Hephaistos P, 97; 200–3
Herakles P, 191; 376–7

Inscription P, 130; 257
Iphigeneia P, 169; 350

Jena P, 169–70, 234; 358–62

Kadmos P, 167; 310–3
Kekrops P, 168; 334
Kerch style, 7, 190, 192, 219
Kleophon P, 63, 96, 147; 171–6
Kleophrades P, 14
Klugmann P, 215

L.C. Gp, 193; 418–22
Lewis P, 39; 92–5
Lid P, 98; 243
London 1923, P of, 191
London D 12, P of, 91
London E 105, P of, 245
London E 183, P of, 315
London E 230, Gp of, 191
London F 64, P of, 354–5
Louvre Centauromachy, P of, 186–8
Louvre G 508, P of, 346
Lykaon P, 63; 150–3

Makron, 229
Mannerists, 13, 37, 96
Mannheim P, 97; 219–20
Marlay P, 98; 242–3
Marsyas P, 190–2; 388–91
Meidias P, 132, 144, 146–7, 167, 219; 285–8, 300–5
Meleager P, 168; 335–8
Midas P, 62; 139

Mikion P, 168; 331
Munich 2335, P of, 97, 132; 205–6, 268
Munich 2365, P of, 380
Mykonos P, 40

Naples P, 189–90
Nausicaa P, 96; 194–7
Nekyia P, 96; 184–5
New York Centauromachy, P of, 169; 339
Nikias P, 167; 319–21
Niobid P, 12–15; 1–9

Oinomaos P, 169; 351
Orchard P, 41–3
Oreithyia P, 37; 30
Orestes P, 198
Orpheus P, 192–3
Otchet Gp, 193; 397–8
Owl skyphoi, 39; 96–7
Oxford Grypomachy, P of, 169; 342

Panathenaic amphorae, 9, 61, 235
Panathenaic oinochoai, 170
Pantoxena P, 63; 155
Pasithea P, 191; 378–9
Peleus P, 62; 142–4
Penelope P, 98; 246–9
Penthesilea P, 38–9; 80–6
Persephone P, 61; 121
Perseus Dance, Gp of, 228
Phiale P, 61–2, 132; 122–8, 266–7
Phintias, 147
Pistoxenos P, 38, 129; 64–70
Polion, 167; 306–7
Polydektes P, 217
Polygnotos, 62–3, 234; 129–38
Polygnotan Gp, 156–65
Pompe P, 192; 394
Pourtales P, 190; 372–3
Pronomos P, 167–8, 222–3; 323, 326–8

Q P, 170; 366–8
Quadrate P, 132; 275

R Gp, 132; 280–3
Reading lekanis, P of, 401
Reed P, 132; 278–9
Retorted P, 169; 343
Rodin 1060, P of, 352
Ruvo 1346, P of, 316

Sabouroff P, 37, 130; 51–3, 254–6
Saint Valentin Gp, 39; 99
Semele P, 9, 168; 333

Shuvalov P, 97; *221–4*
Sotades, 39, 40, 129, 235; *100–1*
Sotades P, 40; *102–8*
Spreckels P, *19*
Suessula P, 9, 168; *329*
Syracuse P, *38–9*

Talos P, 167–8; *324–5*
Tarquinia P, 38, 129; *72–5*
Tarquinia 707, P. of, *199*
Telos P, 169; *341*

Thanatos P, 132; *271–3*
Timokrates P, 130; *252*
Toya P, 190; *374*
Trophy P, 36; *54–5*
Tymbos P, Gp, 130; *258–60*

Upsala P, *348*

Vienna lekanis, P of, *402*
Villa Giulia P, 15, 129; *20–5*

Washing P, 97; *207–12*
Wedding P, *89*
Wedding Procession, P of, *192*
Woman P, 132; *276–7*
Woolly Satyrs, P of, 14; *12–14*
Würzburg Camel, P of, 98; *251*

Xenophantos P, 169; *340*
Xenotimos P, *214*

Yale oinochoe, P of, *34*
YZ Gp, 193; *425*

INDEX OF MYTHOLOGICAL SUBJECTS

Figure numbers are in italics

Achilles, 14, 38, 62, 97–8, 229; *frontisp.*, *2, 8, 18, 31, 80, 109, 200, 231*
Adonis, 193, 219, 221, 226; *285*
Aigeus, *164*
Aigina, 224; *49*
Aigisthos, 229; *36*
Aithra, 229; *1*
Ajax, 97; *184, 200*
Aktaion, 63, 226; *12, 152*
Alkestis, 219; *235*
Amazons, -omachy, 14, 62, 193, 227; *12, 16–17, 94, 132–3, 135, 147, 159, 223, 225, 230–1, 236, 293*
Amphiaraos, *15*
Amymone, 223, 225; *316, 383*
Andromeda, 63, 222, 230; *125, 166, 169*
Aphrodite, 219, 221, 226, 230; *67, 86, 161, 179, 285–6, 300, 304, 309, 377*
Apollo, 96, 221, 224–6, 229, 230; *4, 6, 8, 23, 25, 35, 45, 53, 87, 171, 206, 301, 310, 335, 341, 353, 355, 376, 389*
Argos, 225; *76*
Arimasps, 193, 227; *see* Grypomachy
Artemis, 63, 221, 225–6; *4, 6, 9, 12, 25, 152, 215*
Asklepios, 147, 225; *305*
Atalanta, 62, 169, 229; *88, 143, 179, 216, 336, 384*
Athanasia, 229, 230; *218*
Athena, 37, 96, 98, 168, 221, 224–6, 228–9; *9, 10, 15, 59, 73, 92, 158, 196, 199, 218, 248, 331, 334, 374, 393, 419*

Bellerophon, 230; *317, 349*
Bendis, 221; *318*
Boreas, 37, 230; *30*
Bousiris, *15*

Cassandra, 229; *1*
Centauromachy, 14, 96, 227; *50, 185–7*

Charon, 130, 230; *255, 259, 268, 278, 282*
Chryse, 228; *313*
Cybele, 63; *157*

Danae, 223, 230; *127*
Danaos, *188*
Deianeira, 228; *212*
Diomedes, 229; *363*
Dionysos, 15, 96, 98, 167–9, 191–3, 219, 223–8; *10, 22, 24, 46, 126, 146, 158, 163, 177, 180, 229, 233, 323, 332–3, 347, 356, 379, 392, 394, 414, 422*
Dioskouroi, 227; *130, 167, 287, 312, 372, 416*

Electra, *361*
Elpenor, 63; *150, 184*
Eos, 230; *61, 93, 112*
Epidauros, 225; *305*
Epimetheus, *170*
Erichthonios, 226; *238, 322*
Eriphyle, 229; *28*
Eris, *147; 294*
Eros, 96, 97, 145, 193, 219, 221, 224, 226, 230; *179, 309, 345, 364, 374*
Eudaimonia, 225; *305*
Eukleia, *301*
Eunomia, *301*
Euphorbos, *110*
Europa, 224; *123*
Eutychia, *147; 294*

Ganymede, 224; *77, 82*
Ge, 225–6; *35, 289; see* Gigantomachy
Gigantomachy, 14, 168; *6, 9, 10, 158, 289, 326–7, 329, 330*
Grypomachy, 227; *342, 380, 408, 414*

Hades, *184, 239, 315*
Hebe, 227–8; *400*
Hector, 62; *140*

Helen, 167, 229; *119, 244, 308–9, 362, 381*
Helios, 168, 230; *145, 243*
Helle, 230; *367*
Hephaistos, 167, 225–6; *73, 162, 306*
Hera, 167; *51, 306, 396*
Herakles, 14, 98, 169, 219, 221, 223, 225–8; *2, 9, 10, 14, 15, 41, 45, 47, 68–9, 131, 184, 196, 212, 245, 287, 290–1, 311, 313, 321, 323, 346, 348, 353–5, 372–4, 378, 385, 392, 400, 419, 420*
Hermes, 63, 130, 168, 225; *22, 76, 126, 184, 255, 260, 266*
Hesperides, 223, 228; *33, 287, 378, 420*
Hippomenes, *143, 179*

Ino, *205*
Ion, *221*
Iolaos, *14*
Iphigeneia, 229; *350*
Iphikles, *196*
Iris, *227*

Jason, 229; *43*

Kadmos, 229; *19, 103*
Kaineus, 227; *37, 129*
Kephalos, 230; *112*
Kekrops, *106, 334*
Kore, 15, 226; *20, 121, 184, 239*
Kreousa, *221*

Leto, *225*
Linos, 225; *237*
Lykourgos, 230; *332*
Lyssa, 63; *152*

Marsyas, 167, 225, 230; *310, 387*
Medea, 63, 229; *164, 324*
Medusa, 97, 230; *136, 197*
Meleager, 169, 230; *336*
Menelaos, 167, 229; *119, 309*

Midas, 62, 230; *139*
Minotaur, 228; *81, 338, 421*
Mousaios, 225; *144, 237*
Muses, 132, 225, 230; *23, 144, 206, 262*

Nausicaa, 97, 229; *194*
Nereus, *69*
Nessos, *290–1*
Nike, 37, 61–2, 221, 223, 226–8; *106, 141, 149, 321, 354, 382, 416*
Niobids, 225; *4*

Odysseus, 63, 97, 98, 229; *150, 194, 246–7*
Oidipus, 229; *110–1, 303*
Oinomaos, 230; *351*
Orestes, 229; *36, 198, 350, 357, 361*
Orpheus, 230; *64, 122, 189*

Palaimon, 228; *373*
Pan, 63, 227, 230; *5, 86, 378*
Pandora, 63, 223, 227; *5, 73, 170*
Paris, 147, 194, 229; *8, 34, 244, 294, 296, 308, 362, 381–2, 428*
Patroklos, 98; *231*

Peirithoos, 228; *47, 184, 214*
Peitho, 167, 230; *309*
Peleus, 191, 229; *88–9, 137, 142–3, 390*
Pelias games, 62, 229; *143*
Penelope, 229; *247*
Persephone, *see* Kore
Perseus, 230; *125, 127, 136, 197, 217, 228*
Phaon, 226; *161, 300*
Phineus, 229
Pholos, *2*
Phrixos, 230; *205*
Phyle, 230; *345*
Plouton, *see* Hades
Polydektes, 230; *217*
Pompe, 192; *394*
Poseidon, 168, 223, 225–6; *289, 316, 383*
Pothos, 226; *304*
Priam, 62; *140*
Prokris, *201*
Prometheus, 222–3, 228; *181*
Pygmies, 230; *107, 148, 411*

Sabazios, 63, 221; *157*

Selene, 230; *243*
Semele, 168, 225; *333*
Seven against Thebes, *15*
Silenos, 225, 230; *126, 139*
Sparte, 10, 230; *365*

Talos, 168, 229; *324*
Telephos, 229; *357*
Thamyras, 230; *165*
Thanatos, 130, 230; *271, 275*
Themis, 192, 224; *318, 393*
Theseus, 39, 63, 147, 223, 227–9; *44, 50, 81, 133, 159, 164, 181, 184, 225, 230, 240, 292, 334, 338, 421*
Thetis, 191, 229; *18, 31, 89, 137, 142, 390*
Tithonos, 230; *61, 93*
Tityos, 225; *35*
Triptolemos, 226; *10, 315, 372, 392*
Tydeus, 229; *218*

Underworld, 96; *184*

Zeus 147, 192, 224, 226, 228; *6, 9, 10, 46, 49, 77, 82, 92, 152, 158, 170, 376, 393, 396*

GENERAL INDEX

Alexandria, 10, 194
Beazley, 7–10, 190
Dithyramb, 225
Dress, 12, 145, 219, 223
Homer, 63
Kalos names, 10; Axiopeithes, 61; Diphilos, 61; Dromippos, 61; Euaion, 10, 61–2; Glaukon, 10, 38; Kleinias, 61; Leagros, 10, 38; Lichas, 61

Metalwork, 169, 192, 231, 238
Parrhasios, 167
Parthenon, 7, 9, 60, 96, 225
Persians, 14–5, 218–20
Personifications, 63, 230
Polygnotos, 8, 11–2, 145
Pronomos, 10, 167, 223
Red figure, non-Attic, 7–8
Replicas, 146, 168, 235
Schefold, 190

Sculpture, 9, 12, 60–1, 96–7, 131–3, 147, 168, 192
Technique, 11, ch. 8; colour, 38, 96, 130, 145, 168, 190–2, 223, 232; coral red, 40, 232; tinning, 15; white ground, 38, 40, ch. 4, 232
Women, 97–8, 219
Zeuxis, 167